A Century of Art and Design Education

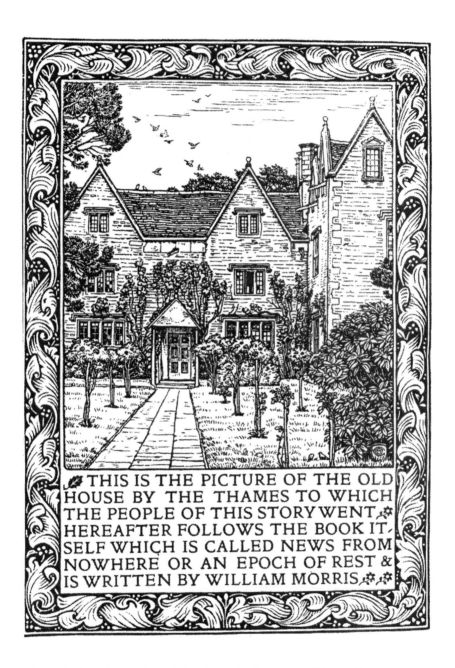

THIS IS THE PICTURE OF THE OLD HOUSE BY THE THAMES TO WHICH THE PEOPLE OF THIS STORY WENT. HEREAFTER FOLLOWS THE BOOK ITSELF WHICH IS CALLED NEWS FROM NOWHERE OR AN EPOCH OF REST & IS WRITTEN BY WILLIAM MORRIS.

Frontispiece: News from Nowhere, *Kelmscott edition 1892*

A Century of Art and Design Education

From Arts and Crafts to Conceptual Art

Stuart Macdonald

The Lutterworth Press

The Lutterworth Press
P.O. Box 60
Cambridge
CB1 2NT

www.lutterworth.com
publishing@lutterworth.com

ISBN (10): 0 7188 3048 2
ISBN (13): 978 0 7188 3048 9

British Library Cataloguing in Publication Data
A record is available from the British Library

Copyright © Stuart Macdonald, 2005

First Published in 2005

Contents

Plates

Preface

William Morris died at Kelmscott House, Hammersmith, London, on Thursday 3 October, 1896, and on the following Saturday the show put on by the Arts and Crafts Exhibition Society in Regent Street gave notice to the London public that a great new movement inspired by the teachings of Ruskin and Morris was firmly in place.

During the research for my earlier book *The History and Philosophy of Art Education* I became very much aware that this Arts and Crafts Movement, established by the disciples of Morris, had transformed narrow-minded Schools of Art of Britain into thriving Schools of Arts and Crafts to such an extent that by the end of the nineteenth-century German and Austrian teachers were looking at the L.C.C. Central School and the Glasgow School of Art as the leading institutions in Europe for education in design and crafts.

Most of this present book, subtitled From Arts and Crafts to Conceptual Art, is devoted to the careers and ideas of the notable teachers who followed Morris, Crane and Lethaby, in their belief in the unity and equality of all arts and crafts. Drawing from memory was found to be an essential skill by these teachers, and its developments are traced from Catterson-Smith's 'shut-eye drawing' (c. 1903–1920) to the time of the Ministry of Education's Intermediate Exam in the 1950s.

Memory Composition of the contemporary scene, including figures, in which Lowry excelled, is discussed in the last Chapter, and the final pages are concerned with the abrupt switch to 'Modern Art' under its Pope, Sir Herbert Read, and the onset of Conceptual Art.

I wish to acknowledge the valuable information, and strong encouragement for the production of this book given to me by the following members of The Editorial Board of the *Journal of Art & Design Education*: Brian Allison, Rosalind Billingham, Ivan K. Davies, Anthony Dyson, Anthony Hobson, Sheila Paine, Stroud Cornock, Rachel Mason, E. Milton Smith, John Steers, David Thistlewood, and Michael Yeomans. Much type space would be taken up, if one listed all their degrees and publications, but I am sure that, like the brother guildsmen of the Arts and Crafts movement, they will be satisfied to be named.

In recent years I have collected rare old photographs taken many

years ago at Schools of Art, and I am grateful to the following for permission to reproduce them, namely Christopher Wood, Dean of the Faculty of Art and Design at the University of Manchester; Roger Wilson, Dean of Art and Design at Manchester Metropolitan University; and David Knight, Dean of Art and Design at the University of Central England; also Victoria Tandy, Director of the City of Manchester Art Gallery, Ruth Shrigley, Curator of the same; Nicola Power, Heritage Services Manager, Salford Art Gallery; Rowena Celik, Head of School of Art and Design, University of Salford. The photograph of the lamps in the Glasgow School of Art Library appears by permission of Phaidon Press, London.

Among others from whom I received encouragement and help were John Archer, Lecturer in Architecture at Manchester University, and Joan Archer, M.B.E., Tutor in F.E., also Robert Mann, John Lennon, and Arnold Brownsett.

This book was produced due to the enthusiasm for its research expressed by Sir Christopher Frayling of the Royal College of Art, Professor Ron George of Bath Spa University, and Bruce Holdsworth, Art bookseller of St Leonards on Sea. The author's thanks are also owed to Leonard Bartle, Central Administrator of the National Arts Education Archive, Bretton Hall, for his assistance with source references.

Introduction

'You must either make a tool of the creature or a man of him' asserted John Ruskin. For Ruskin, it was, as usual, a matter of morality.[1]

The prophet of the Arts and Crafts Movement was born in London on 8 February 1819, the only child of John James Ruskin, sherry merchant, and his wife, Margaret. It was to be expected that young John would inherit the strict moral code of the Victorian middle class, with the assistance of an occasional whipping from his Calvinist mother, and heavy Bible reading. Young people were taught that hard work was a solemn duty, and that if they sweated at the tiresome business long enough, they would eventually enter heaven, and leave their heirs a tidy sum.

Young John, after a wide aesthetic education touring ancient churches and the Swiss mountains with his parents, and learning to draw and paint from Copley Fielding and J.D. Harding, graduated at Oxford University in 1842, and in the following year published his first book, *Modern Painters*, but it was not until 1851 that his first volume of *The Stones of Venice* appeared and expanded his view given in *The Seven Lamps of Architecture* that art is the expression of a people's religion and morality. His belief that work should be pleasure, rather than solemn and miserable duty was a revolutionary tenet held by his disciples in the Arts and Crafts Movement. 'It is not that men are ill fed,' Ruskin wrote, 'but that they have no pleasure in the work by which they make their bread, and therefore look to wealth as the only means of pleasure.'[2]

Today in our tower office, tower flat, university, and poly, which have growed an' growed an awful size, and awfully similar; or tonight as the nation squat passive round the glowing oracle, which tempts us with the promise of prizes of huge sums of money, we may experience unease at the degradation of the creative human individual, the same unease experienced by mankind when herded into factories on the promise of a regular pittance, indeed the same unease which stimulated the moral foundation of the Arts and Crafts Movement.

One April day in 1830 William Cobbett was in Boston, Lincolnshire, brooding on the recent departure of some barge loads of young emigrant

craftsmen. He recalled that previously, at Great Yarmouth, there had been

> four hundred persons, generally young men, labourers, carpenters, wheelwrights, millwrights, smiths and bricklayers; most of them with some money, and some farmers and others with good round sums. These people were going to Quebec by land into the United States.[3]

The rural communities were breaking up. The days of the self-sufficing village with its own creative craftsmen and cottage industry were numbered. Those artisans who still had the funds to preserve their independence were emigrating.

The Arts and Crafts movement was primarily a moral movement, most clearly expressed by Ruskin. Fertile ground had been provided by 'the nonconformist conscience,' roused by the degradation and dehumanisation of our craftsmen. In the early years of the 19th century the British took pride in the delusion that their Protestant Jerusalem was inhabited by sturdy independent yeoman farmers and craftsmen, as opposed to the slaves on the Continent. The delusion was shattered and the conscience roused by Cobbett's reports of the degradation of the English countryman, his farm swallowed up by the park and domain of the aristocrat and stock-jobber, his station reduced to servile labourer or parish pauper, his sons deprived of their natural right to hunt wild game, and his daughters 'very pretty girls, but ragged as colts and pale as ashes.'[4] Poverty for the farming classes ensured no business for the country craftsman. If one had funds, emigration was the answer. The alternative for many of the youth of Albion was the factory:

> ...wheel without wheel
> To perplex youth in their outgoings & to bind to labours in Albion
> Of day and night the myriads of eternity: that they may grind
> And polish brass & iron hour after hour, laborious task,
> Kept ignorant of its use: that they might spend the days of wisdom
> In sorrowful drudgery to obtain a scanty pittance of bread,
> In ignorance to view a small portion & to think that All.[5]

It seems fitting that it was a craftsman, William Blake who expressed so forcibly the deprivation of his class, when separated from personal work and an intelligent interest in it '...ground in our rumbling Mills, for bread of the Sons of Albion.'[6]

The same images of the grinding of men and the mindless polishing of metal were used by Ruskin half a century later in *The Stones of Venice*. He wrote of

men – broken into small fragments and crumbs of life; so that all the little piece of intelligence that is left in a man is not enough to make a pin, but exhausts itself in making the point of a pin . . . if we could only see with what crystal sand their points were polished – sand of the human soul.[7]

Blake's onslaught on 'Wheels rising up poisonous against Albion' made little impact on his contemporaries. For them, his Albion was a phantom of the overheated brain. Cobbett's first-hand reporting was a different matter. What particularly upset Englishmen was his evidence of the human degradation in the southern counties. Satanic mills in the North and starvation in Ireland involved classes of people that the upper and middle classes had no time for. The distress and exodus of the traditional classes of yeoman farmer and country craftsman caused deep concern, for it was an article of faith, a moral fact, for the 19th century English, particularly for the Nonconformist, that a skilled, industrious, and Protestant artisan was assured of material success.

Another link in the chain of printed protest was the *Contrasts* of Augustus Welby Northmore Pugin published in 1836 and 1841. The beauties of the Gothic town are illustrated alongside the horrors of the industrial. The latter include the New Jail, the Gas Works, the Lunatic Asylum, the Iron Works, and the Poor House (containing a master with a knout, and 'a variety of subjects always ready for medical students').[8]

Pugin anticipated Ruskin's moral view of architecture and craftwork, in short that they reflect the morals and creative spirit of their makers. '. . . I feel thoroughly convinced,' he argued, 'that it is only by similar glorious feelings, that similar glorious results can be obtained.'[9] But Pugin was not the man to persuade Protestant England to start a moral crusade for the creative craftsman. He had come to the conclusion that the common man had been in happier circumstances before the Reformation. 'Catholic England was merry England, at least for the humbler classes. . .' wrote Pugin.[10] Cobbett had come to the same conclusion on his rural rides to Beaulieu and Ely, but had been careful to describe himself as 'a monstrous good Protestant.' Pugin's conversion to the Roman Catholicism limited his influence.

Unlike Pugin, John Ruskin had just the right religion and upbringing to appeal to the morality of both the evangelical middle class and the paternal high Tories. He reported of his private education:

my mother having it deeply in her heart to make an evangelical clergyman of me. Fortunately, I had an aunt more evangelical than

my mother; and my aunt gave me cold mutton for Sunday's dinner. . .

Cold Scotch mutton cooled his appetite for a Church career, but a forced diet of great slices of Bunyan and select cuts of the Bible, 'every syllable by heart', nourished the morality which later pervaded his books.[11] Additional to evangelical morality, Ruskin's morality included strong romantic concepts of 'the noble' and 'the heroic' derived from Walter Scott and Homer respectively, the authors of his own childhood choice.

His conviction that man should be noble, in search of noble beauty, caused Ruskin to turn his attention to the degraded artisan and to set in motion the Arts and Crafts movement. The workman must be elevated, 'ennobled,' changed to the ideal craftsman. Ruskin had little sympathy with the thoughts of the actual artisan, nor even an interest in such a vulgar business. In October, 1881, writing in defence of Scott's 'heroic and radiantly ideal' characters, he bitterly attacked George Eliot's acute descriptions of ordinary folk in the *Mill on the Floss*. 'There is not a single person in the book of the smallest importance to anybody in the world but themselves,' Ruskin wrote,

> There is no girl alive, fairly clever, half-educated, and unluckily related, whose life has not at least as much in it as Maggie's. . . . Tom is a clumsy and cruel lout, with the making of better things in him (and the same may be said of nearly every Englishman at present smoking and elbowing his way through the ugly world his blunders have contributed to the making of); while the rest of the characters are simply the sweepings out of a Pentonville omnibus.[12]

Ruskin could perceive no advantage in dwelling on the common moral defeats of ordinary folk, such as Maggie Tulliver. To him it seemed negative, vulgar, and a waste of time. He could not accept Elliott's view that people were permanently trapped by their psychological make-up and circumstances. No crusader for the artisan could accept this view, the view that has earned Elliott the title of 'the first modern novelist.' Fashionable jargonauts, 'at this moment in time' (now), would judge that Ruskin was possessed by 'middle class elitist values' (any values ever approved by any educated class). An impartial observer of a future era may judge that Ruskin was obsessed with levelling up to the ideal, whereas we were obsessed with levelling down to the vulgar.

Ruskin wrote of his early manhood 'I felt myself somehow called to imitate Christian in *Pilgrim's Progress*.'[13] Had horses not been allergic to Ruskin, he could have written, with equal justification that he rode out to tilt against the mills of England. Like the knight of La Mancha his head was stuffed with idyllic notions derived from books, in Ruskin's case those of Byron, Scott, indeed from Cervantes himself. Ruskin's

moral approach to art was revealed in *Modern Painters* (1843–1860) a defence, and an analysis of landscape, liberally interspersed with preachings on ethics. In the fifth and last volume he wrote, 'the preference accorded finally to one school over another, is founded on a comparison of their influences on the life of the workman.'[14] In *The Seven Lamps of Architecture* (1849), this moral criterion is maintained, but is also inverted into the argument that the art, craftwork, and architecture of a people are the expression of their morality.

This train of thought led Ruskin to define 'the characteristics or moral elements of Gothic' in Chapter 6 of the second volume of *The Stones of Venice* (1853). This chapter, *The Nature of Gothic*, clearly reveals the moral principle of the Arts and Crafts Movement in education, in short, that personal creative work is essential for the human individual. Carlyle described Ruskin's book as 'a sermon in stones', and some forty years on, Morris wrote in the preface of his Kelmscott Chaucer that Chapter 6 'in future days will be considered one of the very necessary and inevitable utterances of the century. To some of us, when we first read it, many years ago, it seemed to point out a new road on which the world should travel. . . .'

To sum up Ruskin's sermon, which appears in paragraphs 12 to 21 of his book, we must make a man of the worker, as in the Middle Ages, when he was given the liberty to decide the form of the stone images they carved on our cathedrals. No article must be manufactured 'in the production of which *Invention* has no share'. The architect and master-mason must work with their men, and the distinction between one man and another be only in experience and skill, and the authority and wealth which these must naturally and justly obtain.[15]

The *Stones of Venice* contained the essential inspiration for all adherents of the Arts and Crafts movement, including educationists. It is clear that his message is primarily moral. The book did not complete Ruskin's contribution. He had yet to suggest his concept of education for the artisan, and the need for arts and crafts communities. The publication of four essays in the *Cornhill Magazine* in 1860 marked Ruskin's new direction. The essays are social as much as moral, being mainly an attack on free-for-all political economics based on supply and demand, the economics put forward by J.S. Mill and especially favoured by the Manchester and Birmingham Liberals.

The essays, to use Ruskin's words 'were reprobated in a violent manner' and Thackeray, then the editor, was forced to discontinue them. Two years later Ruskin had the four essays published together as *Unto This Last* (1862), and in his preface he proposed training schools for youths in connection with workshops 'for the production and sale of every necessary

of life and for the exercise of every useful art.'[16]

Ruskin's message for the Arts and Crafts movement was completed by his *Letters to the Workmen and Labourers of Great Britain* entitled *Fors Clavigera*. The fifth letter, of May 1871, suggested that self-sufficing and self-educating rural communities should be established, an endeavour which Ruskin partly and unsuccessfully attempted through the medium of his St. George's Guild.[17]

These later ideas of Ruskin are stated in detail in Chapter 2 when consideration is given to the education work of C.R. Ashbee, Ruskin's closest disciple, a man who, unlike Morris, attempted to put these ideas into practice. As one can deduce from the next chapter, Morris was not really interested in education, and was reasonably satisfied with the status quo in that field.

Sources

1. Ruskin, John, *The Stones of Venice*, (1851) George Allen, London, 1906 ed,. (Vol.2 Ch. 6 para.l2).
2. *Ibid.* para. 15.
3. Cobbett, William, *Selections from Cobbett's Rural Rides*, (1821–1830) edited by Guy Boas. Macmillan & Co, London, 1926 (p. 135).
4. *Ibid.* (p. 20).
5. Blake, William, *The Complete Writings of . . .* , edited by Geoffrey Keynes, Oxford University Press, London, New York, Toronto, 1966 (p. 700) 'Jerusalem' (Ch 3 Plate 65).
6. *Ibid.* (p. 673) 'Jerusalem' (Ch 2 Plate 43).
7. Ruskin, John, *op. cit.* (Vol 2. Ch 6. para 16 p. 163).
8. Pugin, A. Welby, *Contrasts or A Parallel Between The Noble Edifices Of The Fourteenth And Fifteenth Centuries And Similar Buildings Of The Present Day Showing The Present Decay Of Taste*, Charles Dolman, London, 1841.
9. *Ibid.* 1836 edition (Preface).
10. Pugin, A. Welby, *The True Principles of Pointed or Christian Architecture*, London, 1841.
11. Ruskin, John, *Praeterita: Outlines of Scenes and Thoughts perhaps Worthy of Memory in My Past Life*, George Allen, Sunnyside, Orpington, Kent, 1886 (Vol 1 pp.1–3).
12. Ruskin, John, Fiction, Fair and Foul: five papers in the *Nineteenth Century*, 1880–1881. Paper 2, October, 1881.
13. Ruskin, John, *Praeterita*, (Vol. 1. p. 348).
14. Ruskin, John, *Modern Painters*, (1843–1860) Smith, Elder & Co, London. Autograph Edition 1873 (Vol 5, part IX, ch 1. 7).
15. Ruskin, John, *The Stones of Venice*, (1851) George Allen, London 1906 ed. (Vol. 2 Ch.6 paras 12–21 pp. 159–167).
16. Ruskin, John, *Sesame and Lilies, Unto this Last, etc*, Cassell and Co, London, Paris, New York, Toronto & Melbourne 1907 (p. 105).
17. Ruskin, John, *Fors Clavigera – Letters to the Workmen and Labourers of Great Britain*, Smith, Elder & Co, London. and G. Allen, Keston, Kent 1871–1884 Letter 5, May 1871 (pp.23–4) and Letter 9 Sept 1871 (pp. 19–20).

Morris and the Guildsmen

The Government Schools of Art are Commended by Morris

In the early afternoon of 20 October, 1882, the city fathers of Manchester eased their waistcoats and settled back to hear the words of their distinguished guests, especially those of that rum revolutionary card, William Morris Esq. The occasion was a luncheon held in St. James' Hall, Piccadilly, to celebrate the opening of the Manchester Fine Art and Industrial Exhibition by Thomas, second Earl of Wilton. The noble lord, hot from his seat at Heaton, had glimpsed the exhibits with almost indecent haste, and now led with a toast of 'Success to the Exhibition'. William Woodall M.P. then proposed the toast of 'English Decorative Art', waxing eloquent and expedient about 'the enormous service which had been rendered by the establishment of schools of design throughout the country'.

Woodall's words came sweet and soothing as the port, but they must certainly have soured at least one diner, namely Charles Rowley, Manchester councillor and friend of Walter Crane. This associate and patron of the Pre-Raphaelites had been campaigning vigorously against the ghastly and elementary type of work being produced in the local Government School of Art. Rowley, who also knew Morris, had been eagerly waiting for the designer to put the politician right.

'Yet certainly,' Morris asserted, responding to the toasts on behalf of the exhibitors and English decorative art, 'that advance has been made . . . in what we technically call the decorative arts, and this new Renaissance has been helped in this country by many agencies, not least among which has been the steady endeavour on the part of the Department for Science and Art to spread artistic education among the public in general.'[1]

Here was Ruskin's most famous disciple praising the Department for its contribution to a new Renaissance in the decorative arts! Yet only five years earlier Ruskin had written that the South Kensington system of art education had been corrupted 'into a state of abortion and falsehood from this it will take twenty years to recover.'[2]

Councillor Rowley was entirely in agreement with Ruskin. He had first-hand experience of the system. In 1871 he had enrolled at Manchester School of Art to gather some knowledge which would prove useful to him in his business of picture dealing. He had spent

considerable time at the School, eventually becoming an advanced student 'devoting my leisure time for five nights a week to the study of anatomy and drawing from the life.'[3] Rowley was bitterly disappointed. None of the staff seemed capable of imparting any knowledge of the aesthetics of art and design.

The councillor had been goaded into print in February, 1877, by the politic praise bestowed on the current Manchester School of Art exhibition by G.D. Leslie A.R.A., and George Wallis, former master of the Manchester School of Design (1843–1845) and now Keeper at the South Kensington Museum. Rowley responded by writing a series of letters to the *Manchester Guardian*. In the first (7/2/1877) he disagreed strongly with these gentlemen's compliments. He asserted that

> the students' exhibition now on view at the Royal Institution says all that can be said on the other side. A more melancholy show cannot be imagined save the larger gatherings of the same kind which are held periodically at South Kensington. . . . It is evident, on either a casual or careful examination that these students have either no art capacity, or that that capacity has been crushed out of them by this vicious system.[4]

George Wallis replied in the *Guardian*, but made no real case for the system. He contented himself with a rather rude attack on Rowley, and stressed the longer service of the headmaster at Manchester, William Jabez Muckley, who had, Wallis wrote 'for 24 years been headmaster of three schools of art, all under the system of the Department.'[5] It is sad to think that George Wallis, whom I have described elsewhere as a pioneer of design education, had by this date, fallen so much under the influence of Henry Cole and Richard Redgrave.[6]

Rowley was stimulated to reply. The most devastating point was made by quoting a remark of Richard Burchett, who had taken part in the initial planning of the National Course of Instruction, and had served for many years under Cole and Redgrave as headmaster at the National Art Training School.

From the beginning of public art education in Britain, Royal Academicians had been appointed to control its policy, and from 1852 to 1875 Richard Redgrave R.A. had supervised the Schools of Art, being succeeded in 1875 by Edward J. Poynter A.R.A. Rowley quoted Burchett as saying at Oxford

> We wish to teach art, but to teach it in a way that it should not interfere with that kind of art which comes within the province of the Royal Academy.[7]

The 'kind of art' which the Academy feared as 'interference' was only practised by a few advanced students at South Kensington, who had survived long enough to reach Stage 8c) of the National Course of Instruction, which required a drawing from the nude model. The highly realistic shaded drawings in chalk, produced by smooth fudging, convinced the Victorian examiners that the highest of High Art was being created.

Morris himself did not like the fudging and stippling and favoured sharp direct outline in the mediaeval manner. He much approved of Stage 8d) which involved drawing from a draped model, as he found the orderly drapery very suitable for book illustrations, and as most of the Stages involved careful copying within outline, Morris was prepared to say kind things about the Department of Science and Art and its system, as he did when giving evidence before the Royal Commission on Technical Instruction. Rowley would not have known all this. The Report of the Commission had not been published at the time of the Manchester Banquet.

The Government Schools of Art

Before judging Morris's evidence, we need knowledge of the Schools of Art of his time. It is convenient to take the year 1884, in which the 2nd Report of the Royal Commission on Technical Instruction was published.

At that time there were 188 Schools of Art and 14 Branch Schools run in connection with the Department of Science and Art of the Committee of Council on Education. The uniform national art education practised in them was supervised by Thomas Armstrong, who in 1881 had succeeded Edward John Poynter as Director of the Art Division of the Department.

Right at the top of this uniform system one found, appropriately, a uniform, that of Colonel J.F.D. Donnelly R.E., Assistant Secretary of the Education Department and Director of the Science Division, in charge of all major strategy by virtue of the fact that, as Assistant Secretary he was senior officer of the executive at H.Q. in South Kensington. (Donnelly, Gilbert's 'very model of a modern major-general', ended his arduous administrative campaigns as Major-General Sir John Donnelly, and Walter Crane pictured him at the laying of the foundation stone of the Victoria and Albert Museum 'gorgeous in the scarlet and gold of a major-general'.)[8]

Sir Henry Cole, who had moulded the 'cast-iron' system of art education, had died in April, 1882, but his system, 'the South Kensington system,' still flourished. It is simple therefore to deduce how much design and craftwork was being taught and practised in the Schools of Art in the session 1883–4 from the exercises submitted for examination at South Kensington.

The vast majority of the wretched students did not progress beyond

Second Grade Drawing in Outline from the flat copy. In 1884 from all the Schools of Art 13,372 students submitted Second Grade works for examination, and 6,235 passed. Clear proof of the lack of students attempting designing or advanced drawing can be deduced from the following. In that same year 37,033 students were taught in the Schools of Art, only 754 papers were submitted at Third Grade (some by the same candidates) of which 303 were passed, averaging less than 2 per School of Art, and 55 Schools had not one successful Third Grade candidate.[9]

Floral designs in the Redgrave tradition were attempted for Third grade, but in general, if we ignore the painting done in special ladies' classes, it would have been accurate to have called the schools 'Drawing Schools.'

Work in the media of crafts, the very work Morris loved most, such as bookbinding, printing, metalwork, wood and stone carving, cabinet making, etc. was not attempted. Clay modelling was carried out in a few schools in connection with local industries, the Birmingham, Sheffield, and Potteries' schools being most notable. This practice was exceptional: in 1885, for example, only 10 Schools of Art out of 198 submitted work for the Department's Elementary Modelling examination.

Donnelly was particularly opposed to the introduction of trades and artistic craftwork into state art education. The aspect of art education which appealed to him, and to the various engineer officers employed by the Department, was exact outline drawing, whether geometric, perspective, or freehand from the model or flat copy, as practised on a national scale in the public day schools and the elementary classes of the Schools of Art. The army officers who served as school inspectors could understand this. In 1884 an art master, W.E. Crowther commented on inspections:

> The staff employed for doing this work consists almost solely of the military officers stationed in the neighbourhood of the classes they are asked to inspect, and all teachers know from experience how absurdly the system works.[10]

A decade later T.R. Ablett in his *Practical Hints on the Management of the Examination*, meaning the school art examination, wrote of the inspectors that

> smartness, in the military sense of the word, is much appreciated by them . . . scholars should be encouraged to come to school as clean and tidy as soldiers for a parade.[11]

Most art students attempting examinations sat for the Second Grade papers in Freehand, Geometry, Perspective, and Model Drawing. The most popular subjects with Third Grade candidates were drawing (in stippled chalk or sepia wash) either the full figure or a head from the Antique (cast).

Some designs intended for use on various materials were submitted for the National Competition at South Kensington, for example 26 designs from Manchester students won prizes in 1884, but these were all 'designs on paper.' A correspondent to the *Art Journal*, A. Harris, complained in the same year that the regulations of the Department 'virtually exclude the student's employment upon material.'[12]

So much for the Department of Science and Art's contribution in the provinces to what Morris called the 'new Renaissance', but what of the most advanced school of the Department, that in the metropolis?

The National Art Training School at South Kensington had become almost exclusively a training institution for art teachers, and the Royal Commissioner on Technical Instruction reported that

> there has been a great departure in this respect from the intention with which the 'Schools of Design' were originally founded, viz. the practical application of a knowledge of ornamental Art to the improvement of manufacture.

The visit of the Commissioners to the National Art Training School was reported as follows:

> The Commissioners, accompanied by the principal, Mr Sparkes, inspected the various class-rooms, and examined the work in progress. The most advanced students draw and model from the antique and from life. We were present at a lecture by Mr Stannus on decorative art, and on a subsequent visit, when we were accompanied by the Director of Art, Mr T. Armstrong, we were shown the designs for industrial purposes made by the students of the training class, among which were specimens of designs for metal work, goldsmith's work, and the interior decoration of buildings. These designs are worked out in the competition (the National Competition) among the students.[13]

These designs were not part of the planned course of the students in the training class for art masters, who were working for either their first or second Art Master's Certificate; they were designs done by a few of the most talented of the class for the previous annual National Competition, and these students could obtain no experience of the materials they were designing for.

An ex-student of the Training School, in an article for the *Art Journal* of 1884 under the nom-de-plume of 'Textile,' stated:

> There may have been a few who proposed to become designers, but they were not of much account; they were mere youths sent by

their parents without any idea of what branch of decorative Art they were going to follow. Consequently they worked aimlessly, without the masters taking much notice of them.[14]

In his evidence to the Royal Commissioners, Donnelly explained away the fact that the students had no practical experience of specific branches of decorative art or craft in these words:

> In the art division, for instance, several experiments have been made in giving instruction in purely technical matters, and not having succeeded, have been given up, for instance, wood-cutting was taught at one time, and at another time metal-chasing, and one or two other branches of purely technical or applied art of that kind. It was found that the Department could not successfully give instruction in those subjects, that is to say, that it could not find an outlet for the students, and after the experiments had been tried a short time, they were given up.[15]

Donnelly added that it was better if a 'non-government body', such as the City and Guilds, did the 'purely technical applications'. For Donnelly art was art, and craft was craft, and the twain only met when art was applied to craft. It is difficult to see how, if carried out in separate institutions.

Morris and Legros and the Royal Commissioners

Morris had arrived at South Kensington to give his evidence to the Royal Commission on 17 March, 1882, seemingly at ease, but ill prepared to answer questions upon the instruction given at Schools of Art as the following extracts demonstrate.

> 1592 (Chairman) How would you organize a provincial school of art with a view to instruction in design?
> (Morris) That is a very wide question. I must say in the first place, I think a man who is going to be a designer wants to be taught to draw thoroughly. In all these manufacturing towns there are departmental schools of art, and we may assume that a man goes through his course there, which, as far as I can understand, is a good course on the whole.[16]

Morris was assuming too much. When pressed, he admitted that he did not know 'with any degree of nicety' what the training was. His ignorance was surprising, in view of the fact that the national Course of Instruction and the Grade Examinations had been carried out in an identical manner by all the Government Schools of Art in the United Kingdom for the thirty years preceding the Commission. It was even

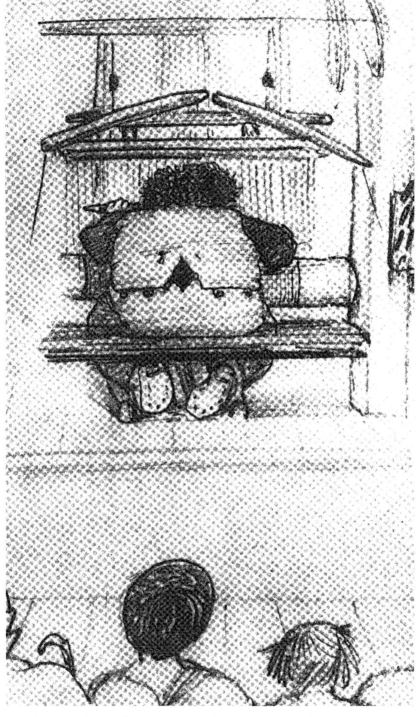

William Morris lecturing on weaving, drawn by Edward Burne-Jones, c.1880

more surprising because he frequently visited the headquarters of the system, mainly to study the historical artefacts in the South Kensington Museum, occasionally to judge the 'applied designs' of Third Grade prize winners in order to select some for higher awards of medals and scholarships. Morris did not even know whether practising designers had examined and selected the work of the Third Grade prize winners that was put before him.

'The competition in which I have been judge,' Morris said, 'has been in things that have already received the third grade prizes; whether somebody would be required to be added to the staff of judges for the first examination I do not know.'[17]

During his evidence Morris did give some positive views on educating the designer.

> There are two chief things that would have to be thought of, in providing facilities for the study for the art of design. However original a man may be, he cannot afford to disregard the works of art that have been produced in times past when design was flourishing; he is bound to study old examples, but he is also bound to supplement that by a careful study of nature. . . .[18]

He agreed that every School of Art should have a museum of historic examples appertaining to local industries and of other beautiful objects. 'I do not see how they could get on without it,' he said; moreover he believed that design students would profit from carefully copying these exhibits, for 'the drawing of these things is such capital education for the student.'

Morris's passion for ancient artefacts seemed to astonish the science-minded commissioners, especially when he got on to old lace.

'Examples of old lace?' queried a startled Professor Roscoe, breaking in on the chairman's interrogation.

'Either examples, or drawings, or prints of old lace,' replied Morris, unabashed. 'In lace there are many books printed between 1530 and 1630 full of designs of lace, and things of that sort.'[19]

Roscoe may have doubted what sixteenth and seventeenth century lace had to do with technical progress.

When asked about the desirability of industrial craftwork in the Schools of Art, Morris was indecisive. His hesitation was due to two factors. The first was that Morris loved the old handicrafts and simple hand and foot machines, and detested modern industrial machinery. A year earlier he had told the pottery designers and craftsmen who were studying at the Schools of Science and Art of the Wedgwood Institute, 'Set yourself as much as possible against all machine-work.'[20] The following passage of evidence is relevant:

1640 (Chairman) Could you introduce looms into the art schools?
– You could of course; they do not take up a vast amount of
room; but the Jacquard loom for figure weaving is distinctly a
machine; therefore it might seem that there would be no very
great advantage in putting a Jacquard loom into an art school.[21]

Morris suggested that a designer should 'see weaving going on,' and that
'He ought to weave himself', meaning with the old hand and foot loom.

The second factor was that Morris was unsure how a loom, or any
other industrial machinery, could be used for instruction in an art school,
as the next passage shows:

1641 (Chairman) Do you think that (weaving) would be better
taught him in the art school than in the factory? – I am not sure
whether it would be difficult to teach it in the school. There
would be considerable difficulties in the way; there would be no
objection to it if the difficulties could be got over. There would
be one advantage in learning it in the school, in the fact that the
learner would not be so much hurried over the work as he would
in a factory.[22]

Morris could not bring himself to strongly recommend that
Government institutions should contain craft workshops. Such a
development would have run counter to his concept of art-workmen
training under masters in independent workshops. It was out of character
for Morris to admit that there might be an advantage in learning a craft
in a School of Art. For Morris only a professional workshop could
produce a professional designer/craftsman. Five years later, he made a
statement that was far more in character:

The sum of my opinion is that it is not and cannot be the proper
business of the Schools of Art, as now established in the country, to
create professional painters or designers, but to teach people to draw
and paint, and to give them information as to the history of the arts, so
as thereby to further the genuine taste for and appreciation of Art, the
wide-spread feeling of which can alone produce true artists.[23]

Morris considered that a student should learn to be an artist first, then a
craftsman. This had been the sequence of his own experience, for after
quitting the architectural office of George Edmund Street for an art
career in 1857, he had taken up painting under the guidance of Dante
Gabriel Rossetti. It was not until the building of the Red House in 1860
that he had begun designing, if we except a little painted decoration.
Lastly he became a practising craftsman.

The most outright adherents of the Arts and Crafts movement in education, William Lethaby, Eric Gill, and R. Catterson-Smith for example did not believe in this sequence. They maintained that a youth should practise a craft as early as possible, simultaneous with his art. For them art was not a basis for craft, rather the reverse, as Crane put it, 'the true root and basis of all art lies in the handicrafts. . . .'[24] It can be seen later how Catterson-Smith commenced the designer's education with the use of simple tools on his materials.

Morris differed, and never changed his views on the sequence, as can be judged from an address delivered to Birmingham students two years before his death. he declared,

> So, I say, make yourself sure that you have in you the essentials of an artist before you study Art as a handicraft by which to earn your bread. But again if you are able to do this, and become a genuine handicraftsman, I congratulate you on your position, whatever else may happen to you, for you then belong to the only group of people in civilisation which is really happy: persons whose necessary daily work is inseparable from their greatest pleasure.[25]

Morris may have been satisfied with the Schools of Art when he appeared before the Royal Commission, but Alphonse Legros, Slade Professor of University College, certainly was not. According to the professor, the Schools did not even teach pupils to draw. He told the Commissioners that

> the system of teaching which holds good in England is slow vicious, feeble, and antiquated. What takes place in the English schools is that the students are set to work to copy an apple or a sphere, or a cone, on which they spend a year; a second year is spent in copying a bad torso, and thus the student reaches 30 years of age and knows nothing.

Legros also mentioned the system of stippling with the point,

> and if there are not men driven mad by it in England, I cannot tell the reason . . . spending, as they do, six weeks or a month shading a sphere they get no ideas into their brains.

Having condemned the system of drawing, Legros then showed that, unlike Morris, he was sure that students in the Schools of Art must practice craftwork.

'Could you suggest any special method of training,' he was asked, 'which should qualify and induce artists to take up a particular industrial line?' Legros replied

You must make them design a fabric which shall be actually made. If their designs are only on paper, the artists are like generals who have never fought – you must make repoussé work in repoussé, or carving in actual work, and not merely sketches on paper.[26]

Morris on the South Kensington System

Morris did not propose any radical changes in the Schools of Art. His sympathy with the 'South Kensington system' could be partly explained by the circumstances that some of his basic methods for designing were similar to those required for the Design Stages of the Course of Instruction. 'Common sense would surely point to people engaged in teaching drawing,' Morris argued, 'that the first thing to be done is to get the pupil into a habit of accuracy, to discourage anything like sloppiness or vagueness. . . .' How the Government art masters would have agreed! 'If you look at the pieces of colouring that most delight you in ornamental work,' he told the students at Birmingham School of Art, 'you . . . will be surprised at the simplicity of it . . . and therewithal the cleanliness and precision of the boundary lines.'[27] How the 'well-drilled South Kensington teacher' of Ornamental Arrangement would have agreed!

The precise 'freehand' outlines required for the First and Second Grade Examinations were pleasing to Morris, so too was the precise type of linear work required for Stages 14 and 22 of the Course of Instruction, 'Painting Flowers without Background' and 'Elementary Design in Colour (from a flowering plant) to fill a Given Space.' It is generally accepted that Morris's own designs owed much to books approved by the South Kensington Circle, especially to Owen Jones's *Grammar of Ornament*.

Undoubtedly Morris's greatest regard for the Department stemmed from his love and constant use of its great museum of applied art, from 'the myriad delights of the South Kensington Museum', as his admirer Rowley put it. Morris declared he had been 'filled with wonder and gratitude at the beauty which has been born from the brain of man' at the Museum.[28]

It was due to Morris and his disciples, especially his daughter, May, that from the 1890s to the First World War, the Arts and Crafts museum gradually replaced the gallery of antique casts as the central point of reference in the Schools of Art, and that 'Museum Studies' became such an important part of the Design courses.

Morris advocated the study of historic art to comprehend its traditional elements, but was against students learning a style or becoming mannered. 'The corrective to overmuch manner,' he said, 'is, first diligent study of Nature, and secondly, intelligent study of the

work of the ages of Art.'[29] Unfortunately his second corrective did not seem to work. A student under the thrall of Morris and Burne-Jones tended to use the museum exhibits to develop a hard-edged mediaeval style. Their influence was greatest at the Birmingham School of Art, and William Rothenstein, who examined the School's work in 1908, reported,

> I was conscious of an underlying mannerism due, I believed, to an element of pseudo-mediaevalism acquired through a natural admiration for the genius of the great Birmingham artist, Sir Edward Burne-Jones, and for his friend William Morris.[30]

The same mannerism prevailed at the Royal College of Art when the Design School was under the museum-loving Lethaby.

An important element of the decorative work of Morris, Crane, and the Pre-Raphaelites was the robed figure. 'Do not spare yourselves in drawing from the living model,' Morris urged the Birmingham students, 'draped as well as undraped, in fact draw drapery continually, for remember that the beauty of your design must largely depend on the design of the drapery.' He then drew their attention to the Renaissance tapestries in the solar of Hampton Court, remarking that 'each piece is quite stuffed with beautifully draped figures.'[31]

Drapery studies were already practised as Stages of Art Instruction at the time Morris recommended them. To be precise 'Drawing drapery arranged on the antique cast' and 'Drawing drapery on the living model' were two alternatives in Stage 8d, and 'painting in oil' of either alternative formed Stage 14c, though these were not usually done in the clear 'mediaeval' outline Morris favoured, but in soft chalk, owing to the influence of E.J. Poynter, R.A.

As a result of the impact of Morris and his associates, especially in the field of book illustration, studies of drapery on the living model and 'time studies' of the same became increasingly popular. At Birmingham a school of book illustration arose in the 1890s based largely on the draped figure in clear outline.

Morris's advice to the Schools of Art was disjointed and its author unsure: 'As to how you are to set to work,' he told the Birmingham students, 'I can but give you a few disjointed hints as to my opinions, which kindly take for what they are worth.[32]

Five of the addresses of William Morris given to audiences of students, staff, governors and supporters of Schools of Art have been published. The earliest were given, on 19 February, 1879, and 19 February, 1880, to the Birmingham Society of Arts and School of Design; the next on 13 October, 1881, at the twelfth annual meeting and prize-giving of the Schools of Science and Art run in connection with the Wedgwood Institute; another

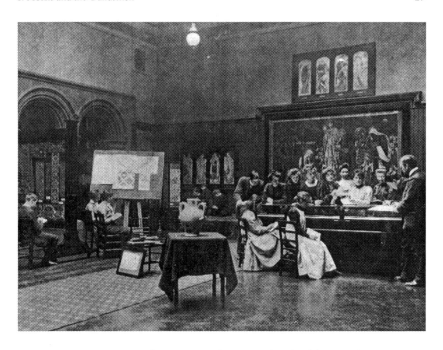

'Museum Studies' at Manchester School of Art, c.1900

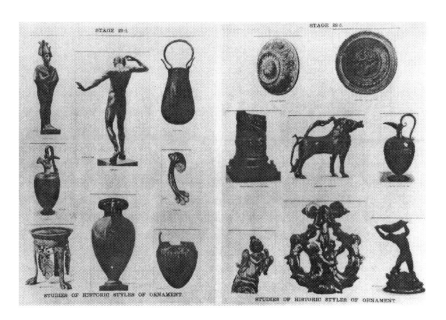

*Museum Studies of Historic Styles of Ornament, Stage 22 d. of the
National Course of Instruction submitted to South Kensington
for the National Competition, 1890.*

at Leek School of Art on 12 December, 1882, and the last, which we have discussed, at Birmingham, on 21 February, 1894.

The addresses contain little direct comment on the Schools of Art or art education. The main content concerned society and art in a wider sense, 'Art and Labour,' as he put it. His version of Socialism often predominated to the dismay of the wealthy subscribers to the Schools of Art. Walter Crane related that after the 'Congress of the National Association of Art in Relation to Industry' at Edinburgh in 1889, at which Morris spoke, there were complaints that the Socialists had 'spoiled the Congress.' W.E. Henley, who conducted the *Scots Observer* at the time, bitterly attacked Morris and Crane.[33] Often audiences who had expected an address on design appreciation or art education found themselves listening to Morris's views on society, art-workmen, and the Middle Ages. Morris confessed in 1883, writing to Charles Rowley, then a governor of Manchester School of Art, 'I have only one subject to lecture on, the relation of Art to Labour.'[34]

Morris may have been uncertain of what, if anything, should be done to change the Schools of Art, but, as we shall now see, other disciples of Ruskin were determined to transform them into schools of arts and crafts.

A Muster of Guildsmen

> The whole movement, while it produced some good design in all fields, was first and foremost an attempt at social reform with an emphasis on group work in guilds by craftsmen.
>
> Elizabeth Aslin[35]

Although Aslin's judgment on the Arts and Crafts movement is generally accepted, it is questionable. It was first and foremost a moral movement. All the close adherents mentioned in this book were strongly committed to the views of Ruskin and Morris on the morality of art-workmanship: far less to leaders' brands of social reform. Many prosperous architects and fine artists, especially in the Art-Workers' Guild, were not interested 'first and foremost' in social reform, but rather in art reform, in the cooperation of all artists and art-workers, in art-brotherhood or 'art socialism,' their guiding principle being 'the Unity of Art,' as Selwyn Image, Master of the Art-Workers' Guild in 1900, put it. It was perhaps significant that when the founders were discussing the formation of the Guild, John Sedding's proposal that Morris should be approached for his ideas was not pursued.[36]

Several of the most prominent reformers of art education were Socialists, namely Ashbee, Crane, Catterson-Smith, and Lethaby. Sir Reginald Blomfield, a prominent member of the Art-Workers' Guild, himself no Socialist, wrote that Richard Norman Shaw, whose pupils founded the Guild,

certainly disliked Morris and misunderstood him. . . . He regarded Morris just as a tradesman whose only object was to make money, and as for his Socialism, that it was just a pose.[37]

The Art-Workers' Guild, the powerhouse of the Arts and Crafts movement in education draw its early membership from three previous groups: 'The Fifteen,' the Century Guild, and the St. George's Art Society. These were the earliest professional associations of English designers. 'The Fifteen' came first.

During the second half of the 19th century a new class of artists, designers for industry, was gaining recognition due to the works of the masterly Victorian book illustrators, and the applied designs of the Pre-Raphaelites and Morris. Most of them did not work in the materials of a craft, as Morris did: their art was applied to industrial products such as wallpapers, furniture, stained glass, prints and metalwork. They were referred to as 'decorative artists.' Such were 'The Fifteen.'

Lewis Forman Day (1845–1910) was the originator of 'The Fifteen', formed in 1881 'to discuss subjects of common interest to themselves and bearing upon various branches of design.' Walter Crane reported, '

> The first meeting was at Mr Lewis Day's house in Mecklenburg Square, on a certain Tuesday in January, I think – known as 'Hurricane Tuesday.' In fact, Beaumont Lodge was almost buried in the drifts of snow, and the blizzard was so severe that I did not turn out. However there were a dauntless few who made a quorum and started the Society. . . . We used to meet at each other's houses or studios about once a month from October to May, the host of the evening being responsible for the refreshment of both the outer and the inner man, and he had to provide a paper or open a discussion on some subject or question of decorative art.

Crane stated that the meetings continued for two or three years until 'the ultimate but natural absorption of our members' into the Art-Workers' Guild. Of the original members of 'The Fifteen,' thirteen became members of the Guild and four of these – namely Lewis Day, Walter Crane, John D. Sedding, and George Blackall Simonds – Masters.[38]

The next group of the guild movement was the Century Guild of Artists founded in 1882 by Arthur Heygate Mackmurdo and Selwyn Image, who had attended Professor Ruskin's lectures in his Drawing School at Oxford. Mackmurdo, whom Pevsner has credited with the earliest work in the Art Nouveau style, had worked as assistant to James Brook, an architect driven to despair by the lack of artistic designer/craftsmen to carry out the details and furnishings of his churches. As a result of this experience, and

of his knowledge of Ruskin, whom he accompanied to Italy in 1874, Macmurdo became convinced that every architect and craftsman should be an artist. Thus the aim of the Guild was

> to render all branches of art the sphere no longer of the tradesman but of the artist. It would restore building, decoration, glass painting, pottery, woodcarving and metal to their right place beside painting and sculpture.[39]

Following the precedent of Morris, Marshall, Faulkner & Co, the members of the Guild often combined to produce each object. Elizabeth Aslin wrote, 'A cabinet designed by Mackmurdo might have carved ornament designed by Herbert Horne a painted panel by Selwyn Image, and hinges by Bernard Creswick, but the whole would be attributed to the Guild.'[40] This practice of several artist/craftsmen carrying out a design was typical of the whole movement and was followed later by the members of the Art-Workers' Guild, the Arts and Crafts Exhibition Society, and the Home Arts and Industries Association. One could take as a typical example an armchair exhibited at the New Grafton Gallery in 1893 by the Arts and Crafts Exhibition Society. The chair was designed by the architect Reginald Blomfield, and the needlework by Heywood Sumner. Their designs were executed by A. Mason who made the chair, and Una Taylor, who carried out the needlework.[41] Selwyn Image of the Century Guild was a typical designer of the movement. A painter and illustrator, he designed type, mosaic, stained glass, and embroidery.

In 1888 Mackmurdo disbanded the Century Guild and joined the Art-Workers' Guild. Selwyn Image had already joined the A-W.G. at its foundation and became Master of the Guild in 1900. In that year a third prominent former member of the Century Guild, Clement Heaton, mosaicist and enameller, joined the A-W.G. The Century Guild had done some educational work with its quarterly *Hobby Horse*, first published in April 1884. Mackmurdo and Herbert Horne, its editors, insisted that the magazine provide an example of aesthetic layout and typography. Mackmurdo had also taken a deep interest in the educational role of the Home Arts and Industries Association from its foundation in 1884. Selwyn Image, the scholar of the group, did much to encourage Arts and Crafts in education by his pronouncements and gained the Slade chair of Fine Art at Oxford (1910–1916).

The third group, the St. George's Art Society, was founded in 1883 by five architects who had been pupils of Richard Norman Shaw (1831–1912) in the 1870s, namely Edward S. Prior (1852–1932), Mervyn E. Macartney (1853–1931), Ernest Newton (1856–1922), W.R. Lethaby (1857–1931), and Gerald C. Horsley (1862–1917).

*A sheet of drawings of national foliage by Sir Richard Redgrave,
Art Superintendant at the National Art Training School*

Bruce Allsopp's inaugural address asMaster of the A-WG, stated:

> To our Victorian founders the Art Philistine (spelt with capital A,
> Capital P), was a dragon and the Art Workers' Guild a St. George.
> Indeed its first name was 'St. George's Art Society,' though the
> ostensible reason for this was that it met under the shadow of St.
> George's Church, Bloomsbury.'[42]

The founders also thought the name appropriate because of its similarity
to the St. George's Guild, founded twenty-two years earlier by Ruskin.

The above five architects, known as 'The Family' were all involved in the
Domestic Revival (1860–1900), a movement initiated by Webb's Red House
at Bexleyheath, and strengthened by the success of Norman Shaw's practice.
Both Webb and Shaw had worked for George Edmund Street, the leading
Gothic Revival architect of the 1860s and and 1870s, but on setting up their
own practices had rejected Gothic for architecture which owed much to the
domestic architecture of the Tudor, Stuart, and Queen Anne Periods. The
fresh and exciting use of these styles (dubbed 'Queen Anne-tics' by
contemporaries) carried out with fine taste in local materials, not only
demanded artist/architects, but also made it impossible for them to rely on
the ordinary Victorian designers and craftsmen, especially for interior work.
It became necessary for the architects to become designers for the whole
house, including the furniture, or to associate themselves with the few creative
designers and decorative artists of their day. Norman Shaw instructed the
group, 'The architects of this generation must make the future for themselves
and knock at the door of Art until they are admitted.'[43]

The Foundation of the A-W.G.

Inspired by Shaw's words, the Committee of the St. George's Society,
consisting of five of his pupils and another architect, E.J. May, passed a
resolution on 22 October, 1883,

> to invite by means of a prospectus, the cooperation of eminent
> Artists, Sculptors, and Architects, in forming with this Committee
> a new Society for promoting more intimate relations between
> Painters, Sculptors, and Architects, and these working in the Arts
> of Design, with the view of advancing the Arts of Painting,
> Sculpture, Architecture, and Design.[44]

Letters were circulated, friends canvassed, and twenty one intending
members met at the Charing Cross Hotel on 15 January, 1884. Edward
Prior proposed that 'the Society should consist of Handicraftsmen and
Designers in the Arts' and this, seconded by Lewis Day, was carried
unanimously. At the next meeting, on 11 March, Prior successfully

proposed the title 'The Art-Workers' Guild.' On the same evening meetings of three kinds were proposed:

1st, practical expositions of different Art methods, and handwork such as etching, mezzotint, wood-engraving, metal-work, glass-painting, carving, etc.

2nd, more social gatherings for conversation and discussion, with a paper occasionally read by a member, or some eminent authority, on any Art topic;

3rd, small exhibitions of old and modern objects of beautiful workmanship, as well as of pictures and drawings.[45]

The architect John Belcher (R.A., 1909) further proposed 'that the Members attending this meeting, and those who attended the meeting of 15 January, incorporate themselves into the Art-Workers' Guild.' These proposals being carried, the Art-Workers' Guild came into existence on Tuesday, 11 March, 1884, and consisted of twenty-five members, four of whom had been founder members of 'The Fifteen,' and five of whom had been on the committee of the St. George's Society. A further four members of 'The Fifteen', including Walter Crane, were elected by the committee of the A-W.G. on 5 May, and the first meeting of the Guild was held on 11 May, 1884.[46]

A list of 'The Fifteen,' and the full membership of the Guild at its first meeting is given in Appendix A.

The Guild's Attitude to Art Education

Ten years after the foundation of the Guild, its master, Heywood Sumner, could claim that 'the authorities are beginning to recognize that if you want a good man for a public post connected with the Arts, the A-W.G. is the place to come to for the purpose.'[47] Five years on, in 1901, when the Government appointed the Council of Advice for Art, the art councillors were drawn exclusively from the Guild, similarly with the Departmental Committee on the Royal College of Art (1911).

Public art education was not a declared aim of the Guild. The brethren intended their Guild to be strictly private, and there were no rigidly defined aims. But underlying aims there were, as we can judge from the consistent and congruous statements of its members, in short: the unity and equality of all the arts and crafts, including architecture; the cooperation of all art-workers, and the return of artistic standard for the everyday object. Walter Crane (Master for 1888 and 1889) was the most vocal and prolific exponent of the first of these objects, indeed he devoted a book to its exposition, *The Claims of Decorative Art* (1892). Charles Robert Ashbee (Master, 1929) pursued the cooperative aim and the return of 'Standard,' as he called

it, most strongly both by practical example and by his writings.

John D. Sedding, Master in 1886 wished the Guild to take an interest in practical art education. 'No one can enjoy and get more profit out of our monthly meeting than I do,' he said, 'yet I foresee that unless we can establish a school for practical work of some sort, either within or beyond the lines of the Guild as now constructed, we shall not only be incapable of effective proselytism, but shall fail in any attempt at public existence and end by gradual exhaustion.[48]

The committee did establish a junior guild in October, 1896, on the proposal of T.G. Jackson, A.R.A., but the Art Students' Guild, as it was called, was not a success from an educational standpoint. It became a club, so much so that the 'students' did not wish to leave their friends, and in 1901 the society was renamed the Junior Art-Workers' Guild. Older members remained indefinitely, and in 1903 Harrison Townsend, Master of the A-W.G., forecast that the junior guild would become defunct. Actually it dragged on its existence, but served little purpose, save social.

The lack of success of the junior guild was due to the opposition of the A-W.G. to any concerted action, publicity, and professionalism. One of the first motions carried by its committee was 'That at present the proposed Society shall not aim at publicity,' H.J.L.J. Massé, assistant secretary to the Guild for over forty years, stated that one tradition was 'absolute privacy'.

The reader may wonder then how such a private guild made a great impact on art education. The answer lies partly in the fact that the Government from the foundation of public art education in 1835 had been seeking teachers who believed in the designer/craftsman. All members elected to the Guild were near the top of their profession and their craft, unlike the Government art teachers, most of whom were mere drawing masters. The very privacy of the Guild ensured that support for applications for senior posts in art education could be efficiently organized, and it was very unusual from the 1890s to the First World War for any non-member to secure such a post. Edward Warren, Master in 1913, said,

> Each member learns from each, by mere easy moral attrition, by genial contention and serious comradeship. So, ultimately, we do teach the world and give our Professors of Art to the Ancient Universities, our Architects to be custodians of great Cathedrals, our Painters and Sculptors to the Royal Academy, leaders and teachers to every craft and School of Crafts.[49]

The Guild members may have courted privacy for their deliberations, but they propagated their convictions on art-work through the Arts and Crafts Exhibition Society, influenceing the type of work in Schools of Art, especially that produced for the National Competition.

The Arts and Crafts Exhibition Society

The Arts and Crafts Exhibition Society, founded in 1888, chiefly by Walter Crane and W.A.S. Benson, was the A-W.G. presented to the public under another name for exhibition purposes. Sir Emery Walker, Guild Master in 1904, stated,

> Well do I remember that all or practically all of the first Committee were members of the Guild. Indeed the Society originated in a proposal that the Guild . . . should hold an Exhibition of the work of its members.

Small exhibitions had been held to coincide with the meetings during the Guild's first two years' existence, and at the annual general meeting in December, 1885, George Blackall Simonds, retiring Master, declared 'It is obvious that at present we can hardly do more than we have done, unless we could see our way to secure permanent premises where our Exhibitions could remain from one evening to another.'[50] However, most of the Guild did not relish being regularly invaded by the public, so other solutions were sought.

In the following year an initiative came from another quarter. There was in Crane's words

> more than the usual crop of rejections at the Royal Academy that year, and the group of artists who then formed the leading spirits of the New English Art Club felt that something ought to be done – if only to bring their own forms of art more prominently to the public.

These leading spirits were George Clausen, Frederick Brown (Slade Professor, University College, 1892–1919), H.H. La Thangue, and S.J. Solomon.

Clausen wrote to Crane in May, 1886, asking him if he would be

> disposed to join in and give influence to a movement which will help to place art matters – or rather the exhibition of pictures and sculpture – on a better footing than they now have . . . an exhibition open to all artists.

Crane was disposed and he, Clausen and Holman Hunt invited friends and supporters of the idea to attend meetings at the studio of J.H. Thomas (1 Wentworth Studios, Manresa Road, Chelsea).

The 'Chelsea Conspirators', as the group were labelled, could not reach agreement about the nature of the proposed national art exhibition. Crane wanted an exhibition of all arts and crafts, but the fine artists did not relish being associated with a display of the 'lower branches of art,' nor, now that they were getting over their injured pride, were they keen on a rival exhibition

to the Academy. In Crane's words these artists 'when it came to the point were not willing to forego their own chances of election to the privileged body they had made a show of opposing.'

The members of the A-W.G. who had attended at Manresa Road were more determined. Crane wrote,

> Perceiving the temporising policy in the ascendant, we withdrew in a body, and took counsel together as to the steps to be taken to, at least, give practical shape to our aspirations for the recognition of the Arts and Crafts among the Fine Arts.

The secessionists from the Conspirators then held a meeting in the Charing Cross Hotel, formed a provisional committee and elected Crane as chairman. The new society adopted the name 'The Combined Arts' at the suggestion of W.A.S. Benson but changed it to 'Arts and Crafts Exhibition Society' before the first show on the advice of T.J. Cobden-Sanderson. Sanderson's suggestion was a stroke of genius. 'Arts and Crafts' became the title of the whole movement, in art and art education. In three words the main idea of the movement was suggested: that arts and crafts were work on the same level. Using the plural 'arts' made this very obvious. The title itself was propaganda, the public loved it. Within a year of the first exhibition 'Arts and Crafts' was a well understood phrase throughout the country.

In the spring of 1888 Crane drafted a circular to obtain guarantors for the first exhibition, a circular which clearly outlines the aims of the Arts and Crafts movement, as the following extract demonstrates:

> Art exhibitions have hitherto tended to foster the prevalent notion that the term 'Art' is limited to the more expensive kinds of portable picture-painting, unmindful of the truth that the test of the condition of the arts of any age must be sought in the state of the crafts of design.
>
> It is little good nourishing the tree at the head if it is dying at the root. . . .
>
> The Arts and Crafts Exhibition Society has been formed with these convictions, and with the aims (1) of taking measures for organising an exhibition of the decorative arts, which shall show (2) as far as possible the inventive and executive powers of the designers and makers of the various works that may be exhibited, such as textiles, tapestry, and needle-work, carvings, metal-work including goldsmith's work, bookbinding, painted glass, painted furniture, etc. etc., to illustrate the relation of the arts in application to different materials and uses, without, however, excluding paintings or sculptures less directly of a decorative kind when space is available for showing them in proper relation. . . .

It is obvious from such a programme that the projected exhibition will occupy entirely new ground, with distinct aims, and objects differing from any existing exhibition.[51]

This circular was subscribed with the names of Crane, the president, W.A.S. Benson, the secretary and treasurer and the rest of the committee of the Society. Only five of twenty-five subscribers were not members of the A-W.G. at the time.

Morris Raises Objections

William Morris took no more part in the foundation of the Exhibition Society than he had taken in that of the Art-Workers' Guild. J.W. Mackail related, 'The project had taken form in the latter months of 1887'. Morris, though for it, as for the whole movement out of which it sprang, was so largely the ultimate source, but had no share in its origination and was at first, with his strong common sense, inclined to lay stress on the difficulties that stood in the way. On 31 December, 1887, he wrote,

> One thing will have to be made clear, i.e. who is to find the money. I can't help thinking on reflection that some money will have to be dropped upon it; for I don't think (again on reflection) that you will find commercial exhibitors willing to pay rent for space, and the shilling at the door will not, I fear, come to much after the first week or two: the general public don't care one damn about the arts and crafts; and our customers can come to our shops to look at our kind of goods; and the other kind of exhibits would be some of Walter Crane's works and one or two of Burne-Jones: those would be the things worth looking at: the rest would tend to be of an amateurish nature. . . .[52]

I do not agree with Mackail that Morris was 'for it' and merely stressing difficulties. Morris was hoping the exhibition project would be abandoned. As for Morris's 'strong common sense,' opinions differ. Sir Reginald Blomfield, a contemporary who knew Morris well, declared 'Morris was impetuous and fanciful, he was not called "Topsy" by his friends without reason.'[53] A man who both loved and bit furniture, ground his teeth openly on crowded railway stations, and threw ill-cooked foods out of windows, seems to fit Blomfield's description rather than Mackail's.

Morris followed his fanciful intuition and strong convictions rather than strong common sense. Though he wrote 'I rather dread the said exhibition,' he could not bring himself to outrightly oppose the project when so many of his friends were involved.

When the committee proposed the exhibition should take place in 1888, Morris wrote again,

I am convinced that the only time of the year available for the exhibition is from the middle of March to the middle of August. Any other time it would only be visited by the few who are really interested in the subject. Isn't it now too late to get the thing afoot during this period this year?[54]

In both letters Morris displayed a lack of faith in the public's interest in arts and crafts, in spite of the enthusiasm manifested by the rapid growth of the Home Arts and Industries Association and various guilds. He seemed to prefer to regard life as a battle against the Philistines. In the first letter he obviously doubted the ability of the members of the A-W.G. to put on a really attractive show. With Walter Crane enthusiastic, he should have known better. Crane was a highly successful commercial artist and a great public relations man, who hardly put his hand to anything that was not a thumping success. Unlike Morris, he never enjoyed a private income.

Morris revealed his real reservations when he argued that 'our customers can come to our shops.' He preferred the traditional private buying from a craftsman's shop. Walter Shaw Sparrow, who interviewed many artists and craftsmen on behalf of *The Studio* in the 1890s, wrote

Among some craftsmen there was a great fear of advertising. Yet these same men were firm believers in the need for reuniting the arts and crafts with the people's life! I used to ask them whether fine work unknown, or but little known, could be a missionary to their creed; but the word 'advertising' continued to alarm them. Christopher Whall [elected to the A-W.G. on 7 July,1889] great as a designer and craftsman in stained glass, never allowed me to have a photograph taken of his beautiful work.[55]

Walter Crane had no such inhibitions.

It is relevant to remember the reservations Morris had about crafts being propagated by public art education. For Morris, the place to learn the craft, practise the craft, and sell the craft was the craftsman's shop.

The Educational Role

The first Arts and Crafts Exhibition took place in the New Gallery, Regent Street, in 1888 from the beginning of October to the end of November. The exhibition was held in 1889 and 1890 during the same months, but then a triennial plan was adopted because of the work entailed in producing the exhibits; thus exhibitions followed in 1893, 1896, 1899 etc.

T.J. Cobden-Sanderson, a barrister turned bookbinder, arranged lectures by members of the A-W.G., including Morris, Crane, Simonds, Emery Walker, and Sanderson himself, during the first exhibition. Crane wrote of the first show

The exhibition was, however, most successful, and the novelty of its aims attracted much attention. A feature of our catalogue was a series of papers on different arts and crafts, by various members of our Society, and a series of lectures were arranged which were given on certain evenings in the Gallery. These again were quite successful, and so crowded that the lecturer of the evening sometimes had considerable difficulty in getting to the platform.[56]

So much for Morris's opinion that the public did not care one damn about the arts and crafts!

These lectures on arts and crafts by Guild members were the precedent for many lectures given by them in the Schools of Art during the 1890s. The Schools of Art also followed suit by organizing courses of public lectures by local craftsmen on their crafts for their students and for art-workmen in industry. These courses were very popular up to the First World War, especially at Birmingham, Manchester, and Glasgow.

The most direct effect of the Arts and Crafts Exhibitions on the Schools was the demonstration of what contemporary craftsmen could achieve. Students and staff not only learnt this from viewing exhibits, but also from photographs of them in journals like *The Studio*. It became a habit of city fathers, notably those of the Liberal faction in Liverpool, Birmingham, and Manchester to purchase examples of work by Guild members and to present them to their Schools. The result of all this was twofold: firstly the standard of design rose rapidly in the Schools, secondly the style of work designed by the students for the National Competition became identical with the Arts and Crafts style. Morris, Burne-Jones, and Crane became the gods of student-designers, and implicitly, Dante Gabriel Rossetti, whose style had shaped the careers of the trio.

To understand the development of the Arts and Crafts movement in education it is essential to realise that both the Art-Workers' Guild and the Arts and Crafts Exhibition Society were in the main local London societies. The monthly meetings of the Guild were held in the Century Club, Pall Mall up to 1888, then in Barnards Inn, Holborn until 1894, from which date the Guild rented Cliffords Inn Hall, Fleet Street for twenty years. The final move came in 1914 when the Guild transferred to its own present premises at 6 Queen Square.

Members of the Guild were usually denizens of London and its environs at the time of their election, with an occasional exception such as Frederick Burridge, whom can be seen later was elected while head at Liverpool. He had come up from London and several prominent members of the Guild, including his friend Charles J. Allen, had emigrated to teach in that city. Scottish membership was practically

non-existent, with the notable exception of Oscar Paterson, the Glasgow glass painter, who was elected in 1897 after showing in Arts and Crafts Exhibition of 1896. Some art-workers' guilds sprang up in the provinces i.e. Liverpool (1886), Manchester (1894), Northern (1896), Birmingham (1902), Edinburgh (1905); but all these were completely independent of the London body and comparatively unimportant.

In the United States Philadelphia took the lead in the guild movement, appropriately as the first academy of art – the Drexel Institute of Art, Science, and Industry, where one could study nearly every craft from metalwork to millinery, had opened in 1891, giving impetus to the American movement. In 1892 the Art Workers' Guild was founded there, with Blomfield Bare, a Liverpool architect, as secretary.

Since the Arts and Crafts movement in education was generated from London it is there we will make a start.

Sources

1. *Manchester Guardian*, Friday, 20 October, 1882 (p.5 col.4), and Saturday, 21 October, 1882 (p.5 cols. 1–2).
2. Ruskin, John, *Fors Clavigera: Letters to the Workmen and Labourers of Great Britain.* Smith, Elder & Co, London and G. Allen, Keston, Kent, 1871–1884, Letter 79.
3. *Manchester Guardian*, Monday, 26 February, 1877 (p.7 cols. 3–4).
4. *Ibid.* Wednesday 7 February, 1877 (p.6 col.4).
5. *Ibid.* Tuesday, 13 February, 1877 (p.6, cols 5–6).
6. Macdonald, Stuart, *History and Philosophy of Art Education*, (1970), Lutterworth Press, Cambridge, 2003 (pp. 90–92).
7. *Manchester Guardian*, Monday, 19 February, 1877 (p.8 cols. 3–4).
8. Crane, Walter, *An Artist's Reminiscences*, 1907 (p. 466).
9. Dept. of Science and Art, *Art Form No 796* for 1885.
10. *Art Journal* New Series, London, 1884 (p. 80).
11. Ablett, T.R.
12. *Art Journal*, New Series, London, 1884 (p. 312).
13. *2nd Report of the Royal Commission on Technical Instruction 1884* (Vol. 3, pp. 399–400).
14. *Art Journal*, New Series 1884 (p. 366).
15. *2nd Report of the Royal Commission* (Vol 3 pp. 283 and 287).
16. *Ibid.* (Vol. 3 p. 153).
17. *Ibid.* (Vol. 3 p. 161).
18. *Ibid.* (Vol. 3 p. 153).
19. *Ibid.* (Vol. 3 pp. 161 and 154).

20. Morris, W., 'Art and the Beauty of the Earth'. A lecture delivered at Burslem Town Hall on 13 October, 1881. *Collected Works of William Morris,* Longmans Green and Co, London, New York etc (1910–1915), 1914 (Vol. 22 p. 169).

21. *2nd Report of Royal Commission* . . . (Vol III p. 158).

22. *Ibid.*

23. Morris, W., 'The Aims of Education in Art' (1887), *Calendar of the Municipal School of Art, Manchester 1911–1912* (p. 12).

24. Crane, Walter, *The Claims of Decorative Art,* Lawrence and Bullen, London, 1892 (p. 186).

25. Morris, W., An Address delivered by William Morris at the Distribution of Prizes to Students of the Birmingham Municipal School of Art on February 21st 1894. Longmans & Co, London, 1898 (p. 20).

26. *2nd Report of the Royal Commission on Technical Instruction* 1884 (Vol. 3 pp. 199–201).

27. Morris, W., 'The Aims of Education in Art' (1887) *Calendar of the Municipal School of Art, Manchester 1911–1912* (p. 12), and Morris, W., An Address. . . 1894 (p. 23).

28. Morris, W., 'The Art of the People'. An Address delivered before the Birmingham Society of Arts and School of Design, 19 February, 1879. *Collected Works of William Morris,* Longmans Green & Co., London, New York etc. (1910–1915) 1914 (Vol. 22 p.40).

29. Morris, W., An Address delivered by William Morris . . . 1894 (p. 22).

30. Rothenstein, W., Report on the Work of the Birmingham School of Art July, 1911 (referring to a previous inspection of 1908), published in *Drawing from Memory and Mind Picturing* by R. Catterson Smith, Sir Isaac Pitman and Sons, London . . . 1921 (p.46).

31. Morris, W. An Address . . . 1894 (pp. 23–24).

32. *Ibid.*

33. Crane, Walter., *An Artist's Reminiscences* Methuen, London (September, 1907), 2nd edition October, 1907 (p. 325).

34. Morris, W., Letter of 25/10/1883 to Charles Rowley, quoted in *A Handlist of the Public Addresses of William Morris.* . . , William Morris Society, London, 1961 (p. 4).

35. Aslin, Elizabeth, *Nineteenth-Century English Furniture,* Faber and Faber, London, 1962 (p. 68).

36. Massé, H.J.L.J. *The Art-Workers Guild,* Shakespeare Head Press, Oxford, 1935 (pp. 11 and 16).

37. Blomfield, Sir Reginald, R.A. *Richard Norman Shaw, R.A. – Architect, 1831–1912,* B.T. Batsford, London, 1940 (p. 12).

38. Crane, Walter. *An Artist's Reminiscences,* 1907.

39. Pevsner, Nikolaus, *Pioneers of Modern Design,* London, 1936 (pp. 54 and 156–7).

40. Aslin, E. *op.cit.* (p. 68).

41. *The Studio* October, 1893–March, 1894 (Vol. 2 p. 15).

42. Allsopp, Bruce, *The Professional Artist in a Changing Society,* Art Workers Guild, London; Oriel Press, Newcastle upon Tyne, 1970 (p. 3).

43. Massé, H.J.L.J., *op. cit.* (p. 7).

44. *Ibid.* (p. 8).

45. *Ibid.* (pp. 11–13).

46. *Ibid.* (p. 13), and Crane, Walter, *op. cit.* (p. 223).

47. Massé, H.J.L.J., *op. cit.* (p. 3).

48. *Ibid.* (p. 1).

49. *Ibid.* (p. 4).

50. *Ibid.* (pp. 25–6).
51. Crane, Walter *op. cit.* (pp. 286, 288, and 296).
52. Mackail, J.W., *The Life of William Morris* (1899), Oxford University Press, 1950 (Vol. 2 pp. 212–213).
53. Blomfield, Sir Reginald, R.A., *op. cit.* (p. 13).
54. Mackail, J.W., *op. cit.* (p. 213).
55. Sparrow, Walter Shaw, *Memories of Life and Art,* John Lane, The Bodley Head, London, 1925 (p. 253).
56. Crane, Walter, *op. cit.* (pp. 301–302).

Early Craft Education and
the Endeavour of C.R. Ashbee

The Society of Arts and the School of Art Wood-Carving

It could be argued that 1884 was the most significant year in the development of the Arts and Crafts movement, for in that year both the Art-Workers' Guild and the Home Arts and Industries Association were founded; but institutions encouraging higher education in crafts already existed By 1884 the Royal School of Art Needlework was established on Exhibition Road, and the School of Art Wood-Carving in rooms at the Albert Hall; both the Society of Arts and the City and Guilds of London Institute were already awarding grants and prizes for students of artistic crafts.

The Society of Arts had as far back as 1758, within four years of its foundation, offered prizes for designs for weaving, calico-printing, cabinet-making, coachwork, iron and brasswork, china, earthenware or 'any other Mechanic Trade that requires Taste.' The public response was disappointing 'with the result that, by 1778, nearly all the technical subjects had dropped out,' and the competitions were restricted to subjects normally performed by fine artists, such as drawing, painting, engraving, modelling, and carving.[1] The Society of Arts' awards were quite generous, and this early failure to interest the public in artistic craftwork presaged the difficulties that were to beset the Arts and Crafts movement.

The Society's next attempt to encourage designers in the crafts was due to the enthusiasm of Prince Albert who advised: 'To wed mechanical skill with high art is a task worthy of the Society of Arts.' A competition for designers was organized in 1846, and entries from this, and a similar competition in the following year formed the nucleus of the Society's first 'exhibition of select specimens of British manufactures and decorative art' held during March, 1847. A series of exhibitions organized by Henry Cole ensued, leading up to the Great Exhibition of 1851. Other large exhibitions, notably that of 1862, followed, but little was done to assist or to educate the artist craftsman or designer. The Schools of Design (1837–1857) and the Schools of Art were, it was generally agreed, a complete failure in this respect.[2]

The Society of Arts continued to sponsor minor exhibitions with the intention of encouraging designers and craftsmen, for example in 1861 it

collaborated with the Company of Paper Stainers in an exhibition of the decorative arts, and in 1863 with the Society of Woodcarvers in an exhibition of wood-carving. From the time of this second show until 1870 the Society of Arts awarded annual art-workmanship prizes for chased, repoussé, and hammered metalwork, carving, enamel and porcelain painting etc., but again the response was small, leading to the cessation of the awards. The Society's annual report of 1871 declared:

> These competitions have now been carried on for several years but the Council regret to observe that, in spite of the large amount of prizes offered, there is still wanting anything like an adequate response on the part of manufacturers, designers, or workmen. The result is, that although no doubt the articles rewarded are of a very satisfactory character, showing great skill and taste, yet the competition is small, and the amount of money awarded is far less than that which was offered, and which it was hoped would be claimed.

To the Society was, nevertheless, due the foundation of the first public institution for training male and female craft workers, namely the School of Art Wood-Carving. With the aid of some funds provided for technical education by the Drapers' Company, the Society established the school in 1878 at Portman Square under the supervision of Signor Bulletti, noted for his carvings at Alnwick Castle. In the following year the school was provided with rooms in the Albert Hall by the Royal Commissioners for the Great Exhibition of 1851, and found successive homes in the City and Guilds College, in the Royal School of Art Needlework, and lastly in its own premises in Thurloe Place where it eventually succumbed.[3]

The development of the School should have served as a warning to Crane, Lethaby, Ashbee, and other members of the Art-Workers' Guild who later held out the hope to students of a decent place in society for the educated hand-craftsmen. The provision of such a school was an anachronistic attempt to revive a dying craft which had little place in a modern economy, a venture kept afloat by the same temporary enthusiasm of the upper classes for things aesthetic and traditional as later sustained the Arts and Crafts movement.

Sir John Donnelly was chairman of the School from its foundation until his death in 1902, which may seem strange to the reader, taking into account his strong disapproval of craftwork in the Schools of Art, but Donnelly's viewpoint was clear. Art was art: craft was craft. Government Schools of Art should provide art, and craft schools supported by master tradesmen, manufacturers, and the Guilds of London should provide crafts.

At first under Bulletti the number of students at the School was small and had only risen to 42 by 1881, his last year as manager. It thrived better

under his successor Miss Eleanor Rowe as the Arts and Crafts movement gathered momentum and during 1892 there were 375 on the roll. The aims of the School were outlined in the *Art-Workers' Quarterly* as follows:

> In the first place it undertakes to train a certain number of young students of both sexes (who have shown artistic aptitude) entirely free of charge as wood carvers and teachers. . . . Among the teachers employed by the various County Councils throughout the country are many women who were free students at the School. . . .
>
> The second aim of the School is to help those who are already professional wood carvers and teachers and the small grants given by the London County Council Technical Education Board and the Worshipful Company of Drapers are chiefly devoted to this end. . . .
>
> The third part of the School work lies among amateurs, who, having joined the classes for a short period, return again and again. . . .
>
> The classes are open every working day from 10 a.m. to 5 p.m., and the fee paid entitles the student to stay all day . . . and from time to time orders given by artists and others are executed by the students as part of their training.[4]

It is significant that the first paragraph of these aims refers to the teachers employed by the County Councils as 'many women.' *The Studio* magazine also stressed the School's suitability for females. It reported that:

> For women, the opening as teachers of carving is a very good one. The remuneration varies from £1 to £5 a week according to the energy and ability of the teacher. For young men, in addition to the opening as teachers there is the workshop, where they will do far better in their early years, than going about the country teaching elementary wood-carving.[5]

It is also significant that the third paragraph of the aims mentions the amateurs who 'return again and again.' Both the free students, whose fees were paid for by the City and Guilds of London Institute, and the amateurs, were mostly female; also the manager who followed Bulletti and her successor were both female. The School had become what the Female School of Design and the Female School of Art (Bloomsbury) had become in the 1840s and 1850s, namely an establishment catering mainly for 'reduced gentlewomen' seeking a pittance, and enthusiastic lady amateurs eager to present some of their work to a distinguished relation or friend or to show it at a Home Crafts and Industries exhibition; lady amateurs described by C.R. Ashbee, a member of the A-W. G., as 'dear Emilys.'

Fine wood carving or 'the art of wood carving as a branch of the

Fine Arts,' as an advertisement for the School put it, was a time-consuming craft, and could only obtain ample reward for a male or independent female if sold to the rich. It was significant that the staff and students of the School carried out work for H.R.H. Princess Louise, the Earls of Wharncliffe and Shrewsbury, Lord Brassey, the Rajah of Koosh-Behar, and various members of the British and German aristocracy.

The Royal School of Art Needlework

The Royal School of Art Needlework, South Kensington is not as significant for this history of the Arts and Crafts movement in education as the above school, since some form of education in needlework has been with us from at least Anglo-Saxon days, and such a functional subject will no doubt be taught indefinitely, but it deserves mention between it was the first public institution established in London specifically for an artistic craft; moreover this School and the School of Art-Woodcarving were the only two such public institutions at the time that the Art-Workers' Guild was founded, and were strongly supported by the Guild, especially through the pages of the *Art Workers' Quarterly*.

The Royal School of Art Needlework was founded in Sloane Street in 1872 by H.R.H. Princess Christian of Schleswig-Holstein with the help of Lady Marion Alford, Lady Welby, and others 'with the twofold objects of reviving decorative needlework and finding profitable employment to needy educated women.' In 1875 it moved into buildings in Exhibition Road remaining from the Exhibition of 1862, and finally into its own building at the corner of Imperial Institute Road and Exhibition Road in 1903.

Needlework was of course unlike any of the other crafts for which the Art Workers' Guild supported. In an age of opulent dress and drapery the School thrived, and the students had no difficulty in obtaining employment in industry or teaching. A large amount of ceremonial robes for church and state was produced and the *Art Workers' Quarterly* reported:

> A considerable stock of embroidery is also maintained, the sale of which has generally proved satisfactory; the School therefore has been self-supporting, and has carried on its work without any public grant or subsidy.[6]

Schools of the City and Guilds

Thus it can be seen that there were in London at the time of the foundation of the Art-Workers Guild two educational institutions exclusively for artistic craftwork, one for art wood-carving, surviving by virtue of grants from the City and Guilds, from the Drapers' Company, and from wealthy patrons; and the other for needlework, thriving on contracts from the Court, Church and Government. The only other educational institutions in London which

were providing practical experience of artistic craftwork were the City and Guilds South London Technical Art School, Kennington Park Road, Lambeth and the Finsbury Technical College.

The members of the City and Guilds Institute had from its foundation by the London City Livery Companies in 1880 taken an interest in artistic crafts, which were regarded before the crusade by the A-W.G. as 'technical subjects,' and the Institute were later to provide an important incentive to artisans through its examinations. The artistic crafts were not however much practised at the Finsbury College which the City and Guilds established in 1883. There was an art department taken by a designer Arthur F. Brophy, who later joined the A-W.G., in which the students studied drawing, painting, modelling, and design, but the only craft which might have been considered artistic in this 'model trade school', as it was termed, was cabinet-making which was carried out on a large scale along with joinery in the evening trade classes.

The City and Guilds South London Technical Art School was more inclined to the artistic crafts. The School had been established by the Guilds in connection with Lambeth School of Art at the suggestion of J.C.L. Sparkes, headmaster of the National Art Training School from 1876–1897, formerly head at Lambeth, in order to provide classes in modelling, china painting, and enamelling for the purpose of Doulton's, the famous potters, and for Farmer and Brindley's great marble works. In 1884, design lectures were given at the School by Hugh Stannus, design lecturer at the National Art Training School and teacher of Architectural Ornament and Modelling at the R.A. Schools, who on 5 May of that year became the first member of the A-W.G. to be elected by its committee.

In addition to the above artistic crafts and drawing and painting, the Technical Art School had daily classes in wood engraving under C. Roberts. The Royal Commissioners on Technical Instruction witnessed a lecture there in 1883 on the design of ceramic tiles by Stannus, and visited the day class for wood engraving, and reported:

> The students, 11 in number, at the time of our visit, were engaged in practical work at circular tables specially fitted for the purpose.[7]

Only 15 students attended the design lecture, a contrast to the attendance at life drawing from the nude. The Commissioners reported of the latter:

> The room was almost inconveniently crowded. Some of the students there seemed to have scarcely sufficient power of drawing to be working from the nude.[8]

This situation was typical. Fine art classes in drawing and painting were widespread and well attended owing to the great art boom of the 1880s.

Classes in the artistic crafts of in 'the lower branches of ornament' were nothing like as popular. As we now move from these early technical schools to the central institution of art education it will be seen that it was even worse in this respect until Walter Crane of the A-W.G. intervened.

Design and Crafts at South Kensington

In 1884 the metropolitan or central school of art of the Department of Science and Art was the National Art Training School located in the precincts of the South Kensington Museum (now the Victoria and Albert Museum). The type of art education pursued in the Training School was determined by Major-General Donnelly, Assistant Secretary of the Education Department, and Chief Executive at South Kensington, and Thomas Armstrong, Director for Art of the Department of Science and Art. As has been mentioned Donnelly was opposed to the introduction of craftwork, and the regulations for examinations of the Department discouraged any employment on craft materials.

The first attempt to introduce practical craftwork into the central art institution had been made as early as December, 1838, when a Monsieur Trenel had been appointed to visit the Normal School of Design twice a week to give lessons in weaving and the application of patterns to ruled paper. These lessons had been discontinued within a year owing to poor attendance and lack of sound organization by the Superintendent Professor, William Dyce.[9]

A more successful endeavour had taken place from 1852 when Henry Cole established Special Technical Classes at Marlborough House for advanced students to cast in plaster, enamel, engrave and print, but these classes had been abandoned after the departure of their chief instructor, Professor Gottfried Semper for Zurich, and on the School moving to South Kensington in 1857.[10] A further venture into the field of advanced practical work had been made in 1858, when Cole set up the South Kensington Workshops for the staff and students to design and decorate the new buildings there, but these ateliers had been closed in 1877 during the directorship of Edward J. Poynter on the grounds of economy.[11]

Edmund Potter, President of the Manchester School of Art, had complained after the departure of Professor Semper that 'The School was virtually converted into a normal training institute for teachers,' and his complaint was even more applicable in 1884, since in Thomas Armstrong's first year as director (1881–1882), the Department had reduced the number of day students from 621 to 426 by allowing only intending teachers to enrol.[12] The Training School's courses were all planned for intending Government teachers of drawing, not for teachers of practical design or craftwork, nor for intending designers or craftsmen, although these last

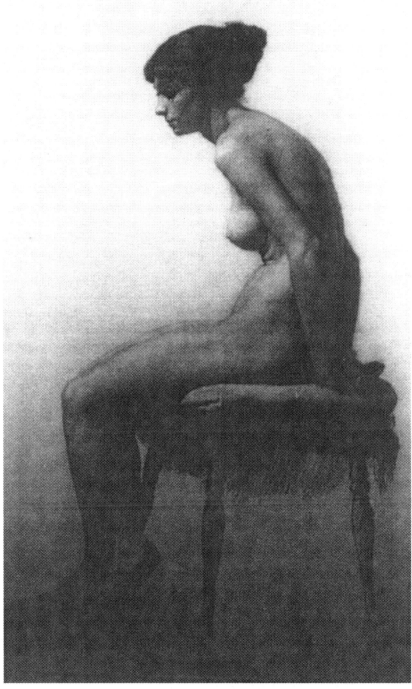

Stage 8c of the National Course of Instruction –
shaded drawing from the nude model, 1897

two categories of teachers and practitioners were those for which the Government art education had been originally founded.

The National Art Training School's preoccupation in 1884 with drawing and fine art, to the exclusion of design and industrial crafts, is clearly shown in the list of the School's day classes for teacher training and night classes for artisans given by John C.L. Sparkes, headmaster of the School in that year. The list given in his paper on 'The Schools of Art' is freehand, architectural, and mechanical drawing; practical geometry and perspective; painting in oil, tempera, and water colours; modelling, moulding and casting; antique, life and anatomy.[13]

Donnelly could not see that designing in a craft material or any form of practical craftwork was relevant for a government art teacher. A few sporadic and unsuccessful attempts were made to introduce craft classes at South Kensington, but these were separate from the official third-grade course and examinations for art teachers, and regarded by Donnelly as a provision for students who sought another outlet for their activities, such as a career as a craftsman, or as an instructor of craftsmen. This attitude is clear from his evidence to the Royal Commission on Technical Instruction.[14] Donnelly further stated that it was better if a 'non-government Body' like the City and Guilds of London did the technological studies or 'purely technical applications'. An article in the Art Journal of 1884 under the nom-de-plume of 'Textile', reiterated this.[15]

The furthest a student at South Kensington approached to designing for materials was when preparing his outline drawings for Stages 22 and 23 of the national Course of Instruction, Elementary and Applied Design respectively. Only a very small proportion of the students worked towards the Applied Design Stage, which did not require applying design to actual material. The students had merely to draw, paint, or model a design, which could be applied to material and was judged by their teachers and examiners – results that proved unacceptable to most manufacturers and designers.

The staff and examiners were incompetent to judge Applied Design. The headmaster of the Nottingham School of Art in his report for 1883–4 referred to a design for a hand-made flounce, to which a silver medal was awarded, which the examiners at South Kensington called 'a machine-made lace curtain.' He complained: 'If the examiners have, on the same principle, been judging the designs for machine-made lace curtains sent from Nottingham as hand-made laces, the reason we no longer receive gold medals for them is readily found.'[16] The headmaster of Halifax School of Art had a similar complaint about the impracticability of the carpet designs which received high awards.

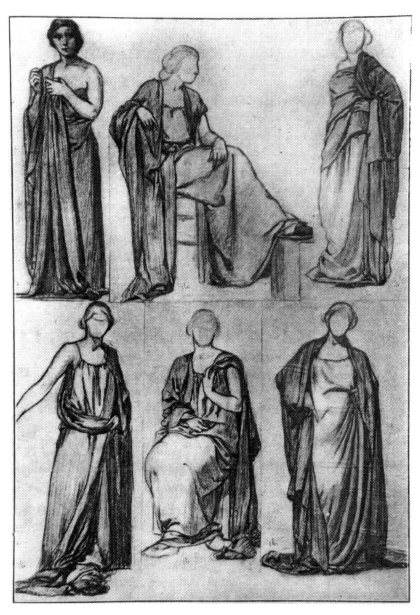

Studies of Drapery on the living model by a Manchester student, 1910

The correspondent to the *Art Journal* mentioned above wrote that

no Art master in the country . . . would be worth £1 a week as a designer in the business with which I am connected; and I suspect it would be much the same in others . . . because his designs would be artistically worthless for want of knowledge and practice.

The only students who were constantly taught designing were the twelve or so National Scholars at South Kensington. National Scholarships were the highest art awards of the Department of Science and Art, open only to those who had won meals in the National Competition for the Design Stages of the Course of Instruction. These students were instructed in architectural decoration in the Renaissance style by F.W. Moody of the South Kensington Museum staff.

The rest of the students could attend occasional lectures on ornament by Moody or H.H. Stannus, but these lectures were confined to architectural decoration and historic ornament, and were poorly attended.

The visit of the Commissioners on Technical Instruction to the National Art Training Schools in 1882 was reported as follows.

The Commissioners, accompanied by the principle, Mr Sparkes, inspected the various class-rooms, and examined the work in progress. The more advanced students draw and model from the antique and from life. We were present at a lecture by Mr Stannus on decorative art, and on a subsequent visit, when we were accompanied by the Director of Art, Mr T. Armstrong, we were shown the designs for industrial purposes made by the students of the training class, among which were specimens of designs for metal work, wood carving, goldsmith's work, and the interior decoration of buildings. These designs are worked out in the competition (the National Competition) among the students.[17]

These designs were not part of the planned course of the students in the training class for art masters, who were mostly working to obtain the first or second art master's certificate of the Department; they were designs done for the previous annual National Competition, and the students could obtain no experience in the Training School of the materials they were designing for. The Commissioners were not so naive as to be impressed by these designs and the Conclusions of their 2nd Report emphasised the necessity for the students to gain experience of craft materials:

On the subject of the teaching of industrial design, we are of the opinion that the Science and Art Department may with advantage depart from their principle as at first laid down, of granting

encouragement to design only – so far as to award grants for specimens of applied art-workmanship in the materials themselves, as a test of the applicability of the design and as a reward for success in overcoming the technical difficulties of the manufacture. It seems scarcely fair that well executed art-work by a student, say a richly chased piece of silver plate should obtain only the same recompense as the design for the same object on paper.[18]

In their Recommendations the Commissioners urged:

That in the awards for industrial design more attention be paid by the Department, than is the case at present, to the applicability of the design to the material in which it is to be executed, and that special grants be made for the actual execution of designs under proper safeguards. . . .

There has been a great departure in this respect from the intention with which the 'Schools of Design' were originally founded, viz. the practical application of a knowledge of ornamental Art to the improvement of manufactures.[19]

The publication and circulation of the Report of the Commission in 1884 strengthened the hand of Thomas Armstrong, Director for Art against his chief Major-General Donnelly, and in the following year he approached Walter Crane, at that time on the committee of the A-WG, to assist in the National Art Training Schools. Crane related:

At this period, at the suggestion of Mr Thomas Armstrong, who had succeeded Sir E.J. Poynter as Art Director at South Kensington, I undertook a series of lectures and demonstrations in various crafts allied to decorative design in which I had had personal experience, such as gesso and plaster relief-work, sgraffito, tempera painting, stencilling, designing for embroidery, repoussé metal work. I gave a short introduction, and having the tools and materials at hand proceeded to give practical demonstrations of the methods of working. These lectures were mostly given in the Lecture Theatre, but the one on modelling in plaster was given in the lecture-room in the school. Osmund Weeks was my assistant with the materials, mixing the gesso, etc. I believe they were the first lectures of the kind at South Kensington – forerunners of the time when craft classes became part of the ordinary college course in design. . . . To Mr Armstrong's initiation, also, was due the first classes in enamelling, at the school, as he secured the services of M. Dalpeyrat to give a series of demonstrations in the art to selected students, one of whom was Mr Alexander Fisher, who revived enamelling so successfully.[20]

Indeed that same South Kensington student, later a member of the A-W.G., was destined to become a great educator in his craft. Eighteen years later the *Art Workers' Quarterly* commented:

> Nearly all the enamellers in this country at the present day were pupils in Mr Fisher's enamel classes, either at Finsbury College or Regent Street Central School of Arts and Crafts, or received private tuition from him.[21]

Returning to 1885, however, there was no further development at the National Art Training School towards design or craft education until Crane returned as Principal in 1898, shortly after the School had been reconstituted as the Royal College of Art. The next step forward in London was made at a private institution established by Charles Robert Ashbee.

Ashbee's Endeavour Towards the Teaching of John Ruskin and William Morris

The almost farcical failures of the St George's Guild, which had, on Ruskin's own admission, contributed to his brain disorder, might have dissuaded others from attempting to form a self-supporting guild of artisans; but precisely such an endeavour produced the first important progress in arts and crafts education following the formation of the A-W.G in early 1884.

In that year Toynbee Hall was opened to commemorate the University Extension lectures that Arnold Toynbee had given to the workmen of Whitechapel. Among the most enthusiastic educationists working in the settlement was a young architect, Charles Robert Ashbee (1863–1942). The architect's mother, Mrs E.J.J. Ashbee (1841–1919) held open house at Cheyne Walk, Chelsea, for progressive artists and educators. Ashbee related:

> Young men at Toynbee Hall not only believed they could redeem England by waving the cultured wand of Oxford and Cambridge over the East End – Charles Booth, Samuel Barnett, Arnold Toynbee, E. Carpenter, Octavia Hill, were proofs of accomplishment – but that they need only show the Arts to the poor and of their own glory they would prevail. . . . Whitechapel and the East End became a rallying point. Morris, Watts, W.B. Richmond, Herkomer, Alma Tadema, Walter Crane, Holman Hunt, Leighton, William de Morgan and many others, the masters of that age, they all came down into this underworld and made its battle theirs. Your 'Grannie' (Mrs E.J.J. Ashbee) was constantly among them.[22]

Several of the above were frequent guests at Mrs Ashbee's, as were also the members of the New English Art Club, and John Singer Sargent, Roger Fry, and Christopher Whall of the A-W.G.

Ashbee gave readings of Ruskin during 1886 and 1887 to a small class initiated by Sir Philip Magnus and the Rev. Samuel Barnett for the training of manual teachers[23] in Ashbee's own words:

> The reading of Ruskin led to an experiment of a more practical nature and out of *Fors Clavigera* and the *Crown of Wild Olive*, sprang a small class for the study of design. The class grew to thirty, some men, some boys; and then it was felt that design needed application to give the teaching fulfilment.

Ashbee then related how a piece of practical work was set for the class, and added that 'the outcome of their united work as dilettanti was the desire that permanence might be given to it by making it work for life and bread. From this sprang the idea of the present Guild and School.'[24]

The Guild and School of Handicraft

The Guild and School of Handicraft were inaugurated on 23 June, 1888, and rented the top floor of a warehouse in Commercial Street, Whitechapel for two years 'to serve as a workshop and school-room combined.' Thence they moved into Essex House 'an old 18th century hall with panelled rooms and spacious workshops and garden, in Mile End'.[25]

Ashbee's scheme was audacious: the Guild (productive), the School (educational), and a club (social); the whole activity of adults' work and children's education combined in an institution independent of the state system and as close to a mediaeval guild as possible. Financial independence was to be achieved by the Guild producing saleable craftwork of high quality, or 'Standard' as Ashbee called it, in the workshops. Some members of the School were expected to graduate to positions in the Guild as it waxed prosperous: others would go forth and 'guide in the formation of schools similar to the mother institution.'[26] Thus a network of guilds, as advocated by Ruskin and Morris, would spring up throughout the land and transform society.

The senior committee of the institution, the Committee of the Guild, was permanent and consisted of Ashbee (chairman) and leading craftsmen of the Guild. The Education Committee was elected annually by those whom Ashbee had persuaded to give financial support to the School and also consisted of craftsmen; thus Ashbee was virtually director of all the institution's activities.

The logical way to have started the scheme on a sound financial footing, or rather to have attempted to do so, would have been to first establish a 'shop' producing work of the high standard Ashbee desired, to see if the Guilds could make sufficient profit to keep its members and to form a

school. Instead, from the outset, the Guild and School accepted funds from philanthropists and public bodies, and fees from amateurs. The Guild itself was run as a company and shares were purchased by craft-loving philanthropists, by the Guild's craftsmen, and by a few businessmen misguided enough to expect a sizable profit.

The craftsmen of the Guild spent up to half their working week instructing in the School, their pupils consisting of lady and gentlemen amateurs, art, technical, and elementary teachers, and young craftsmen. By 1892 there were 80 teachers on the roll, due to the inauguration of Science and Art Department grants in 1890 of six shillings per elementary school pupil receiving manual instruction, and to the introduction of 1892 of certificates for Manual Training teachers by the City and Guilds. These teachers, studying at the School of Handicraft, were employed by the Technical Instruction Committees of councils, thus serving the state system, which Ashbee condemned. By training them he had departed from his Guild principle, as indeed he also did by instructing amateurs. Neither the teachers nor the craftsmen trained at the School went forth to set up Guilds as Ashbee had intended; not even the Guild members who left did so. They even abandoned their crafts. Ashbee wrote of these

> three or four hold prominent posts at, or are the heads of Technical Institutes, several are the trusted instructors under County Councils in different parts of England . . . circumstances in one way or another compelled them to leave, and leaving has meant in almost every case abandoning the craft.[27]

Crafts carried out by the Guild and School included cabinet making, woodcarving, joinery, metalwork, bookbinding and printing, and the institution at Essex House filled a gap in educational provision up to the School's closure in 1895, for, as we have seen, the Schools of Art avoided training a designer or a craftsman in the use of materials. Ashbee argued:

> In the training of handicraft we hold that it cannot be taught – in the manner of the ordinary art school – by making drawings, by making designs, by 'stippling from the antique', and so forth; . . . A designer cannot be taught on paper; he must be taught in wood, in clay, in leather, in metal, in wax, in the actual substance in which he is to design. This is the workshop principle applied to education and, in so far as we enter our protest against the paper designer, we would do so indirectly also against the artist of the art school. We say, let him become a handicraftsman – he will do

better so; let him leave the landscape painting and the portraiture, and study design in its relation to something more immediately productive.[28]

The public service the School provided can be judged from a circular sent out by Ashbee in September, 1891, entitled 'County Councils and Technical Education.' The circular advertised that the Guild would be willing to organize manual training in areas, to send elementary craft instructors, and to send inspectors. The Guild would also advise on any school building, equip workshops, advise on exhibits to be purchased, and provide practical 'bench lectures.'[29]

This service was accepted by eight counties including London, but as far as the Technical Instruction Committees were concerned this was a temporary expedient while they organized their own manual training centres and craft classes in the technical schools, art schools, and polytechnics. There was no point in paying fees to the School of Handicraft which could be used to support their own public institutions. After the closure of the School in 1895, Ashbee gave as the cause 'the failure of the Technical Education Board of the L.C.C. to keep its word with the School Committee and the impossibility of carrying on costly educational work in the teeth of state aided competition.'[30] The closure of the School was timely, for in the following year the London County Council established its Central School of Arts and Crafts in Regent Street under the supervision of W.R. Lethaby, a companion of Ashbee in the A-W.G.

The Guild of Handicraft did not cease with the closure of the School, in fact the membership increased and the workshops showed a small profit. But Ashbee longed to place his Guildsmen in rural England, and in 1902 has found the ideal location at Chipping Campden, Gloucestershire. As will be seen though, his peaceful new environment did not cause him to cease his attacks on the Schools of Art.

In the 1890s, while Ashbee was urging art students to become handicraftsmen and proclaiming, 'A designer cannot be taught on paper,' Walter Crane, a senior member of the A-W.G., was up at Manchester Municipal School of Art showing the students how to design on blackboard and paper.

Sources

1. Hudson, Derek, and Luckhurst, Kenneth, W., *The Royal Society of Arts*, John Murray, London, 1954 (pp. 41–42).
2. Cole, Sir Henry, *Fifty Years of Public Work*, George Bell, London, 1884 (Vol. 1 pp. 106, 114, 118, 203, 268).

3. *Art Workers' Quarterly*. Edited by W.G. Paulson Townsend (of the Art-Workers' Guild) Hazell, Watson, and Viney, London, April, 1903 (Vol. 2 No 6 pp. 90–91), and October, 1903 (Vol. 2 No. 8 p. 187); and *Studio*, April–August, 1893 (Vol. 1 p. 58).

4. *Art Workers' Quarterly*, April, 1903 (Vol. 2 No. 6 pp. 90–91).

5. *Studio*, April–August, 1893 (Vol. 1. p. 58).

6. *Art Workers' Quarterly*, October, 1903 (Vol. 2 No. 8 pp. 154–156).

7. Holme, C. (editor), *Arts and Crafts*. A review of the work executed by students in the leading art schools of Great Britain and Ireland. The Studio Ltd. London, Paris, New York, 1916 (pp. 15–16) and *2nd Report of the Royal Commissioners on Technical Instruction* (Vol. 1 pp. 403, 408, and 410).

8. *2nd Report* etc. ibid. (p. 410).

9. Sessional Papers 1849, *Select Committee on the School of Design* (p. 60), and Macdonald, Stuart, *History and Philosophy of Art Education*, (1970), Lutterworth Press, Cambridge, 2003, p. 81.

10. *1st Report of Dept. of Practical Art*, 1853 (p. 369), *Art Journal*, 1853 p. 322, and the *Engineer*, 1857 (Vol. 4 p. 423).

11. Cole, Sir Henry, *Fifty Years of Public Work* (Vol. 1. p. 330) History of the V. and A. Museum, H.M.S.O. 1958 (p. 17), *Art Journal*, 1878 (p. 125).

12. Burchett, R., 'Some of the Advantages Derived by Provincial Schools from the Central Training School. . . .' Printed copy of a letter to Edmund Potter, President of Manchester School of Art, referring to Report of Department of Science and Art of 1/1/1855. Printed letter is dated 1856. Birmingham Local Studies Library. Art C.9. (Collection of Art Papers) 14790 (p. 7), and Brown, Frank P. *South Kensington and its Art Training*, Longmans Green, London, 1912 (pp. 18–19).

13. Sparkes, John C.L., 'The Schools of Art,' *International Health Exhibition Literature 1884* (Vol. 7 p. 817).

14. *2nd Report of the Royal Commission on Technical Instruction* (pp. 283 + 287).

15. *Art Journal*, 1884 (p. 366).

16. *Annual Report of the Headmaster, Notts, School of Art for 1883–4*.

17. *2nd Report of the Royal Commission on Technical Instruction* (pp. 399–400).

18. *Ibid*. 2nd Report (p. 521).

19. *Ibid*. 2nd Report Recommendation II (p. 537).

20. Crane, Walter, *An Artist's Reminiscences*, Methuen, London, 1907 (pp. 307–8).

21. *Art Workers' Quarterly*, London, 1903 (Vol. 2 No. 6 p. 91).

22. Ashbee, C.R., 'Grannie': *A Victorian Cameo*, University Press, Oxford, 1939 (p. 64) (Printed for Ashbee's family and friends).

23. *Manual of the Guild and School of Handicraft*, Cassell & Co, London, Paris, Melbourne, 1892 (p. 37).

24. Ashbee, C.R., *An Endeavour towards the Teaching of John Ruskin and William Morris*, Essex House Press Limited edition of 350 copies. E. Arnold, London, 1901 (p. 2).

25. *Manual of the Guild and School of Handicrafts*, 1892 (p. 41).

26. *Ibid* (p. 18).

27. Ashbee, C.R., *Craftsmanship in Competitive Industry: being a record of the workshops of the Guild of Handicraft and some deductions from their twenty-one years' experience*, Guild of Handicraft, 1908 (pp. 83–84) Limited edition. Microfilm 361. Central Library, Manc. from National Library copy.

28. *Manual of the Guild and School of Handicraft 1892* (p. 19).

29. *Ibid*. (p. 21).

30. Ashbee, C.R., *An Endeavour towards the Teaching of John Ruskin and William Morris*, Edward Arnold, London, 1901 (p. 3).

Searching For a Director of Design

Crane is invited to Manchester

In December, 1892, Councillors Charles Rowley and James Hoy of Manchester called upon Walter Crane at his home in Holland St, Kensington to ask the artist 'to undertake the supervision of the art instruction controlled by the Art Committee' of the Manchester Technical Instruction Committee. The headmaster of the Municipal School of Art, R.H.A. Willis and his second master had 'almost immediately upon their return to the school after the summer vacation' given notice to the Committee to terminate their engagements at Christmas, and now Rowley, chairman of the Art Sub-Committee and the Municipal School of Art, with Hoy, chairman of the Technical Instruction Committee were taking great pains to secure a new staff and organization for the School. They had already visited Birmingham 'and there gleaned much valuable information in respect of the teaching staff, aims, methods, work, and results of the Birmingham Municipal School of Art'; and were now in London to consult Crane and Arthur F. Brophy (elected to the A-W.G. 6/10/1893), the headmaster of Finsbury Technical College.[1]

Crane would not take the job. In the words of the Report of the Technical Instruction Committee for 1892–93: 'Mr Crane expressed his appreciation of the confidence placed in him, but regretted that with his aims and predilections he could not undertake the duties suggested to him.' Crane's refusal was not surprising: he had previously been offered the full-time headship at Manchester 'through the medium of Mr Charles E. Halle' on the retirement of William Jabez Muckley in 1883, shortly after the erection of the present building in Cavendish St. Crane had declined then for the same reasons, namely his commitments as a professional designer. However he did not know his Rowley if he considered that a first refusal would deter the councillor.[2]

To understand why Rowley was so keen to employ Walter Crane to direct the Manchester School of Art, it is helpful to know something of his association with members of the Art-Workers' Guild, and of the campaign which the Councillor had been waging against the South Kensington system for the past fifteen years.

Rowley v. the South Kensington System

Charles Rowley (1839–1933), Councillor for New Cross Ward and chairman of both the Art Sub-Committee and the municipal school of art was a personal friend of Crane. The son of 'a Peterloo man' and 'a Radical of the first order', as he described himself, Rowley had attended meetings of Morris' Socialist League at Kelmscott House, Hammersmith.[3] His views on art were largely derived from the Pre-Raphaelites, Morris, Frederick Shields, and the Socialist artists/craftsmen he met at Hammersmith. Of these last he was friendly with Emery Walker, Walter Crane, T.J. Cobden-Sanderson, and R. Catterson-Smith, all members of the A-W.G.

Rowley had become well acquainted with Morris and the Pre-Raphaelites owing to several of his activities, firstly through 'Charles Rowley & Co.' the prosperous family picture framing business in Barton Arcade, Manchester,[4] secondly through his endeavours with T.C. Horsfall to establish 'Picture Museums' in that city, and lastly due to his interest in lectures at New Islington Hall, Ancoats, and at the Literary Club where he first met Morris. The 'Picture Museums' scheme, which was realized in 1885 when Horsfall opened one at Ancoats Hall, was of course based upon the St George's Guild Museum established by Ruskin for the workmen of Sheffield in 1875.[5]

In 1877, two years after his election to the City Council, Rowley had written a series of letters to the *Manchester Guardian*, attacking the South Kensington system. Although a councillor and thirty-eight years of age at the time, Rowley was an advanced student at Manchester School of Art, which was housed in rented rooms at the Royal Institution (now the City Art Gallery, Mosley St). The prosperous picture framer had first enrolled at the School in 1871 to improve his knowledge of art, and had been enthusiastic enough to spend considerable time at the School, in his own words 'devoting my leisure time for five nights a week to the study of anatomy and drawing from the life.'[6]

What had provoked Rowley to write to the *Guardian* was the politic praise bestowed upon the current School of Art exhibition in the Institution by G.D. Leslie A.R.A. and George Wallis, former master of the Manchester School of Design (1843–1845) and now Keeper at the South Kensington Museum.[7]

Rowley's first letter of the series on 7 February 1877, headed 'Art Teaching and Art Cant,' disagreed with these gentlemen's compliments. He argued that

> it must be said that the students' exhibition now on view at the Royal Institution says all that can be said on the other side. A more melancholy show cannot be imagined save the larger

gatherings of the same kind which are periodically held at South Kensington. To think that so admirable an artist and so excellent a man as Mr Muckley should have been spending his time in teaching with such results must be as sad to him as to all of us . . . it is evident, on either a casual or careful examination that these students have either no art capacity, or that that capacity has been crushed out of them by this vicious system. In the matter of pure design, the truest work of such schools, we find little but dullness and badness; and even in the studies from flowers . . . there is no sign that the students except in rare cases have appreciated the loveliness of either stem, leaf, bud, or flower.[8]

Rowley's reference to Mr Muckley as 'so admirable an artist and so excellent a man' was probably sarcastic. There exists a letter from Rowley's great friend, Frederick Shields, to C.J. Pooley, a close acquaintance of Rowley's on the Manchester Art Gallery Committee, which refers to a picture exhibited in the Gallery as 'that fearful performance by Munkugly'.[9] Rowley invariably shared Shield's opinions on art, and he certainly thought Muckley a ghastly teacher.

Rowley's criticism of the flower studies was a direct attack on the headmaster, who from his appointment in 1862 had paid special attention to still-life painting. The excuse for such studies was that 'the drawing of nature, foliage, and flowers, as the origin of almost every branch of ornamental design' and that the students were now being directed 'to studies bearing on their particular occupations' meaning the designing of textiles for Manchester manufacturers.

If such relevant work had been carried out and proved successful, not only would the Manchester manufacturers have been delighted, but also the authorities of South Kensington, for the 'ornamental arrangement' of plant forms was a much approved stage of the official Course of Instruction. In neither case, however, had this happened. Muckley became mainly preoccupied with teaching still-life painting from fruit and flowers to the Ladies' Classes, not with designing from such objects. His attitude was understandable, for the annual income of the school from private fees was about four times the payment on results from the Department of Science and Art, even during the years of the School's greatest successes in Government examinations.

Muckley had so neglected the Stages of the Course of Instruction, including drawing from the living model, that in 1864 the School had only received a total payment on results of £3 from the Department of Science and Art on account of 42 drawings submitted to South

Kensington for examination. Shocked by such paltry financial support the School's committee had enforced a change of policy so that by 1872 as many as 1,276 works were submitted and the Department paid out £238-8s-0d.[10]

Having tasted mammon, and the approbation of the Committee, Muckley became a firm devotee of the South Kensington system, his measure of merit becoming prizes and payments on results; thus, in the National Competition of 1873, the School obtained two national gold medals, two silver, four bronze, three Queen's Prizes, two Princess of Wales' scholarships, and thirteen 3rd grade prizes. Many of these awards, including the two gold medals, were for painting flowers and still-life groups.[11]

By 1879 the School was submitting over three thousand works to South Kensington, but the gold and silver medal successes had not been repeated. Mr Muckley at the annual prize-giving of that year in the Royal Institution had to justify the receipt of a solitary bronze medal, and declared, 'In my opinion we stand high compared with other schools, seeing that altogether 139 prizes and 'passes' have been obtained from an average attendance of 250 students, and the payment on the work by the Government averaging about £1 per student. It would have been gratifying to have received gold and silver medals; at the same time nothing can be more delusive than to suppose that such prizes represent the condition of a school.'[12]

Muckley was prevaricating, in matters both academic and mathematical. It is difficult to calculate how £180, the payment received from the Government, averaged 'about £1 per student' for 250 students, moreover, compared with other long-established Schools of Art in major cities, such as those at Birmingham and Glasgow, his School was at a very low ebb in terms of both attendance and Payment on Results. The shortcomings of the Manchester School of Art as a senior art institution were cruelly exposed in the *British Architect* in the same year, as follows:

> From Government however, it (Manchester Grammar School) earns £353 as payment for results, while the Royal Institution School (Manchester School of Art) receives £180. In the matter of prizes the Grammar School takes 70 second grade prizes, against 80 won by the Royal Institution. This year . . . the Grammar School outstripped the Royal Institution School in this particular, taking gold and silver medals, against a single bronze one gained by the Royal Institution.[13]

Life drawing was neglected in the Manchester School of Art mainly because Muckley was incapable of demonstrating the subject, as indeed

were most South Kensington trained drawing masters. William Rothenstein declared as late as 1918: 'In every art school which I have visited I have found inadequate life studies . . . nowhere is there a teacher with sufficient skill and power to carry out himself the work he wishes the student to execute.'[14]

Returning to 1877, George Wallis replied in the *Manchester Guardian* to Rowley's criticisms, but made no real case for the South Kensington system. He contented himself with a rather rude attack on Rowley, and stressed the long experience of Muckley, who, he wrote, had 'for 24 years been headmaster of three schools of art, all under the system of the Department.'[15] It is sad to think that George Wallis, whom I have described elsewhere as a pioneer of design education, had by this date fallen so much under the influence of Richard Redgrave's national system.[16]

Far from being deterred by Wallis's letter, Rowley replied with such a penetrating attack on the School of Art and the system that it is worth quoting at length. The most devastating point he made was by quoting a remark of Richard Burchett, who had taken part in the initial planning of the National Course of Instruction and had served for many years under Cole and Redgrave as headmaster of the National Art Training School. From the beginning of public art education in Britain, Royal Academicians had been appointed to control its policy. The Schools of Design had been mainly controlled by members of the Academy until 1852, and at that date Richard Redgrave R.A. had become Art Superintendent of the newly created Schools of Art. Redgrave had been succeeded in 1875 by Edward J. Poynter A.R.A.

Rowley quoted Burchett as saying at Oxford,

> We wish to teach art, but to teach it in a way that it should not interfere with that kind of art which comes within the province of the Royal Academy. . . . From what I can gather from the students, the principal information conveyed to them is that they should keep a good point to their pencil and their paper quite clean. I would ask whether there is anyone trained by the school (at Manchester) who can clearly define any principle or art precept which has been communicated to them during the last thirty years. The exception made by some was that the system might be defined as one of a thousand and one dots to the inch. An intelligent lady student recently remarked that no one would go to the school expecting to be taught to draw, the most they could expect to learn would be to stipple.

He then gave a vivid description of the practice of shading the human figure from the cast, Stage 8b of the Course of Instruction.

In the first place, without the remotest idea as to the proportion of the human figure, the rules of which might have been learnt in a quarter of an hour ... he takes paper and charcoal and scrawls away for a few days, sketching in and rubbing out, till he gets what is considered a tolerable outline of the figure. Then comes the wonderful and mysterious process of transferring which consists in blacking the back of the sketch until it is like unto a chimney sweep's bag, and laying it on a second sheet of paper, strained tight as a drum and spotless and pure, then selecting one of the blurred lines which represent the figure, transfers it to the paper on which the drawing is to be finished. Ten chances to one that the line transferred will be sure to deviate from the true one and in any case necessarily through being done in such a mechanical fashion it will lose much of the life and character of the sketch. After this comes the long and tedious process of shading in chalk, words fail to give any idea of the sickening misery of this. Every little spot, crack, or cast mark has every one to be put in and stippled up as smooth as a tea tray. Shading the figure in this foolish and meaningless manner is absurd enough but this stippled inanity must be relieved by a dark background of the same quality. We knew it was no good except as practice in fine texture abomination and I myself would willingly have gone on the treadmill for a few hours as a change to the miserable days spent in smoothing all this over and picking out the black spots with our detestable 'chewed' india rubber.[17]

Rowley wrote the final letter in the series on 26 February, stating that Mr Muckley excelled 'in still life and fruit painting' and asking, 'Would it not be worth while to have a master for figure who would work up the School into something better than a class of feminine still-life painters?'[18]

However, Muckley muddled on, doing his best to obtain as many awards as possible for the annual examinations of the Department. He had no power to change the South Kensington methods of drawing and designing. Muckley's experience had convinced him that designers would not come to the School, and that the students avoided design as a profession because of low pay.[19]

During the same week as Rowley commenced his attacks on the School of Art, its Committee had entertained a bevy of distinguished guests to luncheon in the Town Hall to invite support for the erection of a building for the School of Art, the Earl of Derby having promised £500 to set the ball rolling. Among the guests, who had visited the students' exhibition in the Royal Institution, was the Marquis of Huntly who proposed the

resolution for a new School of Art. This was seconded by G.D. Leslie A.R.A., and supported by George Wallis on behalf of the Department of Science and Art. Hugh Birley M.P. moved that the proposal be adopted and Oliver Heywood seconded the motion. Sir Henry Cole, late Secretary of the Department, further proposed a gallery of fine and industrial arts. Also present were Sir Joseph Whitworth, Professor Roscoe, Edmund Potter, and William Agnew.

Mr F.W. Grafton, treasurer of the School of Art's committee, declared that he had been 'conscious that for some time the idea prevailed that that school was intended chiefly for the instruction of designers for textile fabrics, but this view had long ceased to exist.'[20]

Grafton knew that, though Manchester was at that time the chief centre in the world for textile production, the wages for the designers producing their patterns on squared paper were low, and that only an artist capable of designing for different materials, such as Crane, was fit to take charge of the proposed new School.

The School was actually built in Cavendish Street in 1881, to the astonishment of the newspapers, who assured the public that it was 'a commodious structure' indeed 'a lordly Pleasure House', in short 'a splendid School of Art'. The gentlemen of the Press suspected that an institution full of young ladies painting for fun was a 'pleasure house', and the rumour that a model was available in the nude confirmed their fears.[21]

To make way for a staff for the new School, Muckley the flower and fruit painter had to resign, and, as Crane was not ready to take charge, the School's Committee from 2 March, 1883, engaged as Headmaster one R.H.A. Willis, a man who surely must have established a record for perseverance within the South Kensington system. He possessed two national gold medals, three silver medals, two bronze medals, four out of the seven possible art master's certificates, and portions of the remaining three, four Queen's Prizes, and six special prizes. Much more important though, from Rowley's viewpoint, he had studied life drawing under Alphonse Legros at the Slade, and had designed for many crafts.

A completely new staff was appointed with Willis to run the new School of Art, consisting of a second master, John Somerscales, an assistant manager, S.J. Mawson, and most significantly the first 'Master of Design', W.G. Thomas. There were also four 'assistant teachers' who were in fact still advanced students.

Design was encouraged by a present to the School of 'a valuable gift of patterns of Carpets, Hangings, Calico Prints, and Wall Hangings, designed by Mr William Morris and executed by Morris and Co.' These

were donated by C.P. Scott a member of the Council of the new School
in 1884, and in the same year the School forwarded for the National
Competition 'Designs for Calico Prints, Silk Damasks, Brocades, Tapestry,
Table Covers, Linen Damask, Examples of Decorative Art Furniture,
Art Metal Work, Stone Carving, Chromo Lithography, Heraldry etc.'
During this same year C. Procopides, an advanced student, was appointed
to the Design staff to teach Calico Design.[22]

Naturally with his South Kensington background, the new headmaster
did not neglect the Department's examinations and he soon trebled
Muckley's efforts. In 1886, for example, 10,833 works were forwarded to
London, and it was reported that: 'The Manchester School of Art has in
the last three years, taken the greatest number of National Medals ever
awarded to any London, local, or provincial school, whilst no school has,
in that period, been successful in a greater variety of subjects.' [23]

In the spring of 1891 the Arts and Crafts movement finally arrived in
Manchester, when the Corporation decided to hold 'an Exhibition of the
character now known as "The Arts and Crafts".' This was held during July
and August in the City Art Gallery and the students of the School contributed
'designs for printing art textiles, specimens of executed works in calico
printing, embroidery, decorative painting, modelling, etc.' (The calico printing
was carried out in factories, not in the School.)[24]

In the September of the following year, 1892, Willis, the
headmaster, and Somerscales, the second master, at the height of
their success, suddenly resigned. One wonders whether Rowley,
then chairman of the Art Sub-Committee of the Technical
Instruction Committee had informed them of his intention to place
a director over the headmaster, in the person of Walter Crane. If
so, it must have seemed unjust to them. Whether they knew of
Rowley's intention or not, they certainly knew that Rowley
disapproved both of the type of design in the Redgrave tradition
which Willis had been reared on, and of the whole South Kensington
system.

Crane Accepts the Directorship

Rowley's conversations with Walter Crane and William Morris during
the 1880s strengthened his convictions on art education. Crane had
been invited up to Manchester by Rowley and his colleagues on the
Ancoats Recreation Committee (later the Ancoats Brotherhood, 1889)
on several occasions to give lectures at the New Islington Hall.[25]
University extension lectures had been organized in Ancoats from 1878,
'six years before Toynbee Hall', as Rowley pointed out; and the first art
exhibition in the Hall was arranged by Rowley in 1880. Morris, Madox

Brown, and Crane had spoken on art at various meetings at the Hall, where on occasion up to a thousand citizens listened to George Bernard Shaw, Arthur Acland, G.K. Chesterton and other notables. Morris gave addresses in the Hall, at the invitation of Rowley, on 20 September, 1884, 26 September, 1886, and 1 October, 1891.[26]

Rowley was the leading opponent of the merging of art and science institutions in Manchester during 1891 and 1892. There is an interesting letter, preserved in Manchester Central Library Archives, to Rowley from Frederick Shields whose advice he sought about the appointment of a new headmaster for the School of Art. The relevant portion reads:

> My Dear Rowley,
> Since you ask my mind about the reorganization of the Manchester School of Art, I have so little time to state it that I must go straight to the point.
>
> It was a gigantic blunder from the first to ally Science and Art at South Kensington. It has, & still does, work ill. The Science Professors somewhat, the Science students altogether, regard with sublime contempt the Art Schools & their students, & manifest it openly — They are the benefactors of the world, the apostles of 'Progress'. Art is an obsolete toy & its students silly idlers. . . .
>
> No, keep the Fine Art School distinct, absolutely so & let the Students of Decorative art who need to gain familiarity with technical process & chemical affinities form a section of the Technical schools. I do trust that wisdom will prevail in this initial step —
>
> Now about a good master. Do get a man who has done something![27]

Shields recommended Arthur Hughes (1832–1915), the Pre-Raphaelite, but Rowley preferred Crane, and nothing ever seemed to deter Rowley from getting any person up to Manchester, no matter how distinguished. George Bernard Shaw, commenting on Rowley's activities, wrote that 99 percent of the deaths 'of public spirited men of this country are due to diseases of which the seeds were planted during untimely journeys to Manchester.'[28]

Despite Crane's refusal to take the appointment, Rowley persuaded him to visit Manchester on 2 March, 1893, to call at the School of Art and the Technical School, and to give an address on the 'Study and Practice of Art' at a soirée. The address was printed and circulated by the Technical Instruction Committee. In addition Crane wrote a report on the 'Aims and Methods of Industrial Art Teaching', which was printed and distributed to the members of the City Council. The subsequent consideration given to him by the Manchester councillors must have

impressed him, for during the summer he agreed to accept the post of part-time Director of Design at the School of Art, his appointment being confirmed by the City Council on 6 September, 1893.[29]

The Municipalisation of Manchester School of Art

Following the passing of the Bill for the Promotion of Technical Instruction in August 1889, the organization of art and science institutions in Manchester proved difficult. Affairs had been complicated by Sir Joseph Whitworth's bequest to technical education in 1887.

During his final illness in January of that year the great engineer was reported to have said to Robert Dukinfield Darbyshire: 'You know what I would like to do if I could, and I leave it all to Lady Whitworth, Mr Christie and yourself to do what you think best I would like to do.' He then bequeathed a fortune of over £1,000,000 according to the wishes of Darbyshire and the two other legatees, Lady Mary Louisa Whitworth and Richard Copley Christie.[30] The legatees eventually allocated the entire bequest to education within Manchester with the exception of some funds for the foundation of the Christie Cancer Hospital.

A committee of Manchester citizens was formed in 1887, under the chairmanship of Darbyshire, to establish a Whitworth Institute which would embrace all the technical and art education in the City. A sum of over £200,000 was allocated by the legatees for this purpose, and a further £10,194 was forthcoming from the guarantors of the Manchester Royal Jubilee Exhibition of 1887.[31] The Institute was intended to comprise the existing School of Art in Cavendish Street, a rebuilt Technical School, new fine art and industrial art galleries, and a public park.

A Royal Charter of Incorporation for the Whitworth Institute was obtained, signed and sealed on 2 October, 1889. Sixty Manchester citizens were appointed governors, and in 1891 the Technical Instruction Committee of the City Council handed them control of the School of Art and the Technical School.

Amalgamation in the Institute proved controversial. One suggestion of the governors was that the School of Art should quit its new building and join the art classes at the new Technical School to avoid duplication of the design classes, but the governors who had been closely connected with the School of Art disapproved; thus a Manchester Polytechnic did not come into being in 1891.

Another bone of contention was the nature of the intended exhibition galleries. The Charter of Incorporation had proposed 'The collection, exhibition and illustration of Works of Fine Art, and the study of and instruction in Fine Arts, by means of Galleries, Libraries, Lectures, Classes . . .' and 'The collection, exhibition and illustration of Works of

Mechanical and Industrial Arts, and of Science as applied to those arts. . .',[32] but the guarantors of the Jubilee Exhibition wished its profits to be used solely for art purposes, for studios, a theatre, and a fine art gallery – all attached to the existing School of Art.

Financial problems were soon revealed, for having assumed control of the School of Art and the Technical School, the Whitworth governors quickly discovered the difficulty of raising subscriptions and donations large enough to extend and maintain educational institutions. Subscribers were not forthcoming owing to the new attitude engendered by the Technical Instruction Act, the conviction that art schools and technical schools were now taken care of from the rates, the attitude being strengthened by the knowledge of impending Parliamentary grants of 'Whiskey Money'. The Technical Instruction Committee reported that the Whitworth governors

> felt that since provision had been so largely made by Parliament for the promotion of Technical Education, it had become practically impossible for them to raise independent funds from private donors to enable them to provide such buildings and equipment as the provision for efficient Technical Instruction for the district.[33]

Accordingly, the Whitworth governors decided to return the Technical School and the School of Art to the Corporation, generously granting these properties, the profits of the Jubilee Exhibition, and a sum of £13,434 to the Corporation conditional upon the City undertaking to maintain the existing premises and to erect new buildings. The Corporation accepted the offer, taking possession of these institutions on 31 March, 1892, when they were renamed the Municipal School of Art and the Municipal Technical School. The Schools were to remain separate, the art and architecture classes at the Technical School were to be transferred to the School of Art, and the governors of the Whitworth Institute were resolved to build their own gallery.

The School of Art was now placed under the Art Sub-Committee of the Technical Instruction Committee of the City Council. Rowley was elected chairman of the Sub-Committee and was naturally delighted with the turn of events, but, as we have seen Willis, the headmaster, and Somerscales, the second master gave in their notices in September of the same year to take effect from Christmas. Rowley quickly replaced Willis by appointing Richard Glazier, the head of the Art Division of the Technical School; as temporary headmaster of the School of Art, while he continued to press Crane to take the directorship, following Shield's advice to 'get a man who has *done* something.'[34] Crane was the obvious choice.

Walter Crane was then at the height of his fame as a designer of wallpapers, children's books, stained-glass, and gesso-work. His finest

works, the illustrations for children's sixpenny 'toy books', were a landmark in the development of book design. His output of decorative art was prodigious and Rowley certainly chose a man who had done something.

Sources

1. Crane, Walter, *An Artist's Reminiscences*. Methuen, London (September, 1907) 2nd Edition October, 1907 (p. 417) and *Report of the Proceedings of the Technical Instruction Committee of the City Council of Manchester*, April 1890–October, 1893 (pp. 14 and 15).
2. Crane, W., *ibid* (p. 416).
3. *Manchester City News*, Saturday, 13 April, 1907 (p. 5 col. 5), 'Men with Missions – Mr Charles Rowley,' and newspaper cutting 'A Tribute to Charles Rowley' not dated (Rowley 90 years old at the time, circa January 1929) Manchester Local History Library, Ref. F942-73942 Nel; also Rowley, C., *Fifty Years of Ancoats – Loss and Gain*, Paper read before the Toynbee Debating Society, Ancoats Brotherhood, Manchester, 1899 (p. 5).
4. *Label* off one of the firm's picture frames, affixed in cutting book, Manchester Local History Library, Biographical Index, Ref. F942-73942 NE1.
5. Manchester City News, *ibid.*, and Ruskin, J., *Fors Clavigera*, 1877 (Vol. 7 pp. 188 and 279) also Collingwood, W.G., *The Life of John Ruskin*, Methuen, London (1893), 5th edition 1905 (p. 316).
6. *Manchester Guardian*, Monday 26 February, 1877 (p. 7 cols. 3–4).
7. Macdonald, Stuart, *History and Philosophy of Art Education*, (1970), Lutterworth Press, Cambridge, 2003 (pp. 83, 90–95, 107, 120, 180, 264–5).
8. *Manchester Guardian*, Wednesday 7 February, 1877 (p. 6, col. 4) 'Art Teaching and Art Cant.' Letter of 3 February from Harpurhey, Manchester by C. Rowley Jnr.
9. Shields, Frederick, *Letter to C.J. Pooley Esq. of 18 May*, (year not given) Manchester Central Library. Archives MS 927.5 p. 111.
10. *Regional College of Art Centenary Diploma Day Programme 1953*, Stewart, Cecil, 'A Short History of the College' Manchester Education Committee (p. 23).
11. *British Architect*, January–June, 1874 (Vol. 1, p. 7).
12. *Manchester School of Art. Headmaster's Report for the Year 1878–9*.
13. *British Architect*, July–December, 1879 (Vol. 12, p. 252).
14. Rothenstein, William, Report on the Work of Birmingham Municipal School of Art, July 1918, given in *Drawing from Memory and Mind Picturing* by R. Catterson-Smith, Sir Isaac Pitman and Sons, London, Bath, Melbourne, Toronto, New York, 1921 (p. 46).
15. *Manchester Guardian*, Tuesday 13 February, 1877 (p. 6, cols. 5–6), Letter by George Wallis from London of 10 February. 'Art Teaching and the Cant of Critics'.
16. Macdonald, Stuart. *History and Philosophy of Art Education* (pp. 90–92).
17. *Manchester Guardian*, Monday 19 February, 1877 (p. 8, cols. 3–4).
18. *Manchester Guardian*, Mon. 26 February, 1877 (p. 7, cols. 3–4).
19. Manchester School of Art. Headmaster's Reports for 1872–3 and 1881–2. quoted in *British Architect* January–June, 1874 (Vol. 1, p. 85) and January–June, 1883 (Vol. 17, p. 16).
20. *British Architect.* January-June, 1877 (Vol. 7, p. 85), describing lunch of 9 February, 1877.
21. *Regional College of Art Centenary Diploma Day Programme 1953*, Stewart, Cecil, 'A Short History of the College', Manchester Education Committee (p. 24).
22. *Manchester School of Art, Annual Report for 1883–1884* (pp. 8, 9, 18, 20).
23. *Manchester School of Art, Annual Report for 1886–1887* (p. 9).

24. *Manchester Whitworth Institute, Annual Report of the Sectional Committee for the Management of Manchester School of Art for 1890–1891* (p. 9).

25. Crane, W., *An Artist's Reminiscences* (p. 417).

26. Rowley, Charles, *Fifty Years of Work Without Wages*, Hodder and Stoughton, London, c. 1915 (pp. 198–9), and *A Handlist of the Public Addresses of William Morris to be found in Generally Accessible Publications*, William Morris Society, London, 1961.

27. Shields, Frederick, *Letter to C. Rowley.* 13/12/1892, M.S. written from Siena House, Lodge Place, London NW, Manchester Central Library, Archives. Ref 283 Rowley, C.

28. *'A Tribute to C. Rowley'*.

29. *Report of Proceedings of the Technical Instruction Committee* (Manchester) 1890–1893 (pp. 12–16).

30. *Manchester City News 13/4/1909*, and Pilkington, Margaret, *The Whitworth Art Gallery, Past, Present and Future*, Manchester 1966 (p. 2), reprinted from Vol. 108 of Memoirs & Proceedings of the Manchester Literary and Philosophical Society, Session 1965–66.

31. *Report of the Proceedings of the Technical Instruction Committee of the City Council of Manchester*, April 1890–October, 1893 (pp. 9–10), and Pilkington, M., *ibid.*

32. Pilkington, M., *op. cit.* (p. 3).

33. *Report of the Proceedings of the Technical Instruction Committee* April 1890–October, 1893 (p. 9).

34. *The Studio*, October, 1893–March 1894 (Vol. 2, p. 36).

Crane Accepts the Manchester Job

Crane v. The South Kensington System

Crane took up the post of Director of the Manchester Municipal School of Art in September, 1893, at an annual salary of £600 on the understanding that he was in attendance for the first week in each month during term time, and delivered during that week a lecture to the day students, and a repeat performance to the evening students.

Crane's first move was to submit a paper of 'Suggestions' for a design course to the Technical Instruction Committee. The 'Suggestions' were revolutionary, especially those for broad and swift treatment of practical work. In place of the existing methods of slowly outlining and shading from lithographs and casts of ornament, Crane advised direct free-hand drawing with chalk, charcoal, or brush in solid mass (silhouette) of typical floral and ornamental forms; renderings from memory of these direct drawings; direct designing or re-combination of the forms learned in free-hand drawing, designing upon given construction lines and bases, and execution of designs in various materials. The figure in action was also to be drawn freehand from life and from memory, and adapted to architectural design or to a given space ('space-filling').[1]

Crane's course of lectures and demonstrations at Manchester, based upon these 'Suggestions', and subsequently published as *The Bases of Design* (1898) and *Line and Form* (1900), was to prove the foundation of design teaching in British Schools of Art for the next forty years.[2]

The colleagues with whom Crane had to cooperate most closely were Richard Glazier, now confirmed in his appointment as headmaster, and Henry Cadness, the second master, who was in charge of the practical work in the Design Room at the School. The headmaster was, in a way subordinate to Crane, who commanded a larger salary, and had already gleaned the part-time Director's general views on design from Crane's first book, *The Claims of Decorative Art* (1892). By a strange chance I recently purchased an old copy of this book, and within its covers is inscribed Glazier's name in his own fine hand and the date, 1893.[3]

The headmaster was in a very awkward position. That enthusiastic meddler, Rowley, had seen to it that Crane was made Director of the

School, and Glazier was aware that Crane, who was gaining a reputation in Europe for design, detested the 'South Kensington system' by which the reputation of each School of Art depended upon the preparation of successful drawings and models for the National Art Competition of the Department of Science and Art. Moreover all these works had to conform exactly to the Stages of Art Instruction approved in the annual Directory of the Department; and to ensure absolute uniformity an illustrated Supplement to this work was published. The vast majority of these 23 Stages (with numerous sub-divisions) were mere copying, and most of the work done pertaining to design was the copying of ornament, or linear analysis of ornament, called the 'Principles of Ornament', or the 'Principles of Design.'

In May 1893 just before Crane accepted the Directorship, the students at Manchester sat as follows for the annual Department's exams pertaining to design.

> 39 took Stage 3b: Outline from the cast – Ornament.
> 36 took Stage 5b: Shading from the cast – Ornament.
> 11 took Stage 22d: Studies of historic styles of ornament.
> 39 took Stage 2b: Principles of Ornament.
> 26 took Stage 18c: Modelling, Design.
> 38 took Stage 23: Design (advanced).[4]

Of these Stages only 23 could really be called designing. The Principles of Ornament paper merely consisted of a linear analysis of ornaments showing their construction lines. Stage 18c consisted of modelling from a prepared drawing. 22d consisted of executing exact 'photographic' copies, with heavy shading, of about fifteen historic pots or sculptures from the School's collection, or from a local museum – hence the nickname, 'museum studies.' For 23 however the students had to draw and paint an 'applied design' for production, saw for a carpet, for lace, for tiles, for iron gates, for calico etc.

These were the exercises which the students had perforce to continue to do during Crane's directorship.

Richard Glazier was unfortunate in having to follow R.H.A. Willis as Headmaster, for Willis had been an expert at producing studies of flowers which delighted the examiners at South Kensington with their accuracy, and the School's council with their profitability. Glazier's performance would be measured against that of Willis.[5]

It was the habit to spend several weeks upon each drawing and several months upon each design, model, or painting that was to be submitted at South Kensington in March, and from Glazier's point of view Crane's course was not only using up valuable time but was also a distraction from the kind of work required for the Competition. Indeed

Walter Crane and the Manchester School of Art which he directed in 1893

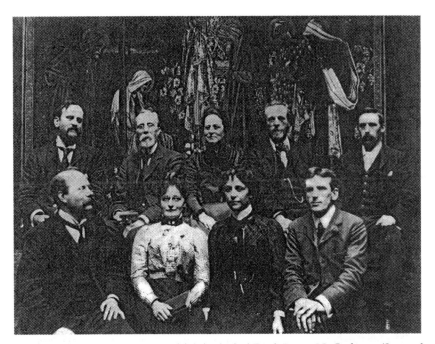

Crane's staff at Manchester, which included: Back Row: H. Cadness (Second Master), J. Reynolds (Secretary), Gertrude Lake, R. Glazier (Headmaster), F. Teggin. Front Row: J. Shields, Emma Bradbury, Emily Durst, J.M. Crook

if one studies the Annual Reports of the School and the subsequent Reports of the Technical Instruction Committee, covering the period from 1886–1896, one can see that the number of high Science and Art awards for the so-called 'Design Stages', and for all the other Stages for that matter, fell off disastrously compared with the awards received during the reign of the previous headmaster, Willis. Crane described the problem at Manchester as follows:

> I found it a little difficult to graft the kind of study I had found practically useful in my own work as a designer on to the rather cut and dried and wooden courses prescribed by the Department, or rather, to dovetail new methods with the existing curriculum. To obtain grants or to compete for prizes in the national competition certain works had to be done in certain ways by the candidates, and the rules for the exercises necessary for winning certificates had to be strictly followed. Under these circumstances it was difficult for students working with the aim of gaining the official distinctions which were supposed to qualify them for the teaching art, to give much time to experiments in or to master new methods. The best chance was with those who came to the school from the workshop to gain practice and insight, or who wished to acquire a knowledge of practical and artistic design.[6]

In this statement the most telling condemnation of the Department's curriculum was that, what Crane, a practising designer, 'had found practically useful' in his work was found equally useful for the evening students from workshops who were, or hoped to be, practising designers, but a hindrance for those who wished to teach and thus were involved in what was known as 'the South Kensington system.'

Richard Glazer and his second master Henry Cadness were products of this system, which measured a man by the number of art certificates gained, and Stages of Instruction passed. As we have seen the previous headmaster had obtained four out of the seven full Art Master's Certificates, and portions of the remaining three and perhaps Glazier even surpassed this feat, for an H.M. Inspector reported: 'Mr Glazier holds practically all our certificates, and can overlook all the various stages, being an expert in each.'[7]

Such a headmaster could hardly have been expected to share Crane's contempt for the imitation of ancient ornament carried out for Government certificates, indeed Glazier was deeply interested in the subject and was preparing his *Manual of Historic Ornament* for publication. Crane made his viewpoint quite clear:

Conscious and laborious effort takes the place of spontaneous invention, and originality is crushed by the weight of authority, is confounded and abashed by the mass of examples.

It is on the unquenchable spontaneity of this (art) instinct that I should rely to give new birth to new forms of art, even were all types and conditions of the art of the past destroyed.

After a course of examination at South Kensington of vast multitudes of designs in any and every style under the sun, I could almost bear such a catastrophe with equanimity, since no aspiring designer could then crib Persian or Chinese, mediaeval or Greek patterns, spoil them in translation, and serve them up as original designs.

All the learning and archaeology in the world will not fill us with an instinct for art, since art (to recur to our definition), being a form of vital force, must spring from life itself.[8]

This last statement was a direct attack upon the contemporary dependence of design teachers in Schools of Art upon Owen Jones' *Grammar of Ornament* and R.N. Wornum's *Analysis of Ornament*. This dependence resulted from the Victorian art teachers' belief in the Wornum's maxim: 'We have not now to create Ornamental Art, but to learn it; it was established in all essentials long ago.'[9] Both Glazier and Cadness were inclined to this view, and retained Wornum's *Analysis* and Jones' *Grammar* as the Manchester School's approved books for all design courses until as late as 1915.

Even if Glazier had been convinced of Crane's views and methods, he could not have encouraged his students to follow them without imperilling their chances of passing the Department's papers on the 'Principles of Ornament' which were entirely based on the imitation and analysis of historic ornament. The text book used at that time, and up to 1915, for this paper was James Ward's *Principles of Ornament*. Its use was almost obligatory, since its editor, George Aitchison A.R.A., Professor of Architecture to the Royal Academy, was Examiner on the Principles of Ornament to the Department of Science and Art.

Aitchison left no doubt as to his love of imitation and historicism in his dogmatic introductory chapter in Ward's book. To Aitchison originality in design was mere novelty, necessary since 'it is this generation that wants to be charmed.'

'Novelty in art is only that difference and that improvement which one instructed generation can give to the past excellence it builds on. . . . Good traditional ornament has these inestimable advantages, that it has been treated for ages by skilful men, so

that its faults have been corrected, new graces have been added to it, and it has been fitted to properly fill the requisite shapes. . . . All ornamental arts, that are not realistic imitation, must be founded on precedent art.

Although Aitchison mentioned artists elaborating 'something new and beautiful from all the knowledge they have gained,' his constant message was that students must thoroughly learn each important ancient and modern style.

> Although the young student should confine his attention to the best styles, the advanced one should have some acquaintance with all traditional ornament, even the styles of Louis XIV and XV, a grafting of Chinese and Japanese ornament on the current classic, for they are the only modern styles; except the early Renaissance, that have complete unity.[10]

Of course when a Victorian referred to ancient he meant of the Ancient World up to Roman: any Byzantine or later artefact or style might be referred to as 'modern'.

Since Crane could agree neither with the views of Aitchison, the examiner, nor with the content of the Department's papers and exercises on ornament, a compromise was reached at Manchester by which Crane's course was regarded as a parallel course to the official one run by Glazier and Cadness.

Crane endured this situation for two years, doubtless hoping that the official course would change enough to make some impact of new ideas possible, but he intimated in his report on the work of the session 1894–95, in which he called 'attention to the difficulty of reconciling the demands of the Science and Art Department, and the suggestions made by him on taking office, that after the present session he would probably be unable to continue his services.' The Report of the Technical Instruction Committee for the following session declared that: 'As intimated in the last report, Mr Walter Crane, who for three years has placed his valuable services at the disposal of the School, informed the Committee that he could not hope any longer to continue those services, and that he would therefore be compelled to terminate his engagement at the close of the Session in July (1896).'[11]

Crane's Achievement at Manchester

At the time of his resignation Crane seemed to have achieved little at Manchester during his three years of directorship, but this view was later proved superficial. Firstly he had clarified his own ideas on basic design teaching by the demonstrations and lectures which were the

groundwork for his future books, *The Basis of Design* (1898) and *Line and Form* (1900), books which ran to many reprints and established creative design in the Schools of Art, where they were required reading until the 1920s.

Secondly he had put into practice his advice that demonstration was the way to teach the bases of art, and the students and staff were inspired by seeing creative design demonstrated, as opposed to the former practice of copying diagrams of historic ornament or plants on a geometric base. 'Demonstration is the one thing needed, primarily,' he had urged. 'Demonstration, demonstration, always demonstration.'[12]

His diagrams, carried out with charcoal, chalk and brush in swift line and mass, proved an example easily adopted by design masters, and similar efforts appeared on the blackboards of design and craft rooms up and down the country. Many of Crane's works for his lecture papers appear in *Line and Form*, and he said of these papers: 'They were illustrated largely by means of rough sketching in line before my student audience, as well as by photographs and drawings.'[13] He certainly put Glazier and Cadness on their mettle as demonstrators. An inspector of the Department who visited the Manchester School in the autumn of 1896, immediately after Crane's resignation, was quite enchanted by the demonstration methods used, and reported:

> I was much pleased with what I saw, especially in the methods employed by Mr Glazier in the Architectural Lectures and by Mr Cadness in Design. Both masters appear to have their subjects at their fingers' ends, and they illustrate with the greatest facility before their students on the blackboard, or with charcoal on paper, and with colour, too.
>
> Mr Glazier has great power and skill in painting flowers and plants at once with the water-colour brush on paper without any preliminary outline, and can and does draw freely on the blackboard anything in architectural styles he may have in hand.
>
> Mr Cadness seems to have equal knowledge and skill in depicting styles of ornament or natural plant or flower forms on a bold scale adapted for ornamental arrangements.[14]

Both these teachers produced text books used for Principles of Ornament courses after Crane's departure. Glazier's *Manual of Historic Ornament* (1899) is a concise handbook of information on the history of ornament, extraordinarily well designed for its period and deservedly popular.[15]

Cadness's *Decorative Brush-Work and Elementary Design* (1902), which was intended to cover courses in practical Elementary Design, as well as the Principles course, includes many ideas taken from Crane's

books but with little of his spirit and taste. The brushwork exercises which Crane showed as rhythmical art, are reduced and petrified to stiff stencil silhouettes in Cadness' book.[16]

Crane's third claim to success in Manchester was the interest which he had aroused in the Arts and Crafts movement in education among the city fathers, notably Charles P. Scott M.P., William Simpson, Charles Rowley, and James Hoy. Crane, although a Socialist, was quite a social lion on good terms with many of the senior aristocracy and enjoyed company. He commented on his time at Manchester:

> My good friend Charles Rowley introduced me to the city worthies at the Reform Club, where I frequently lunched with him, and met leading members of the City Council, and my weekly visits to the school were often varied by social gatherings in the evenings.[17]

These gatherings not only cheered Crane to endure three years of banging his head against what he called the 'cast-iron system' of South Kensington art education, they enabled him both to encourage the Technical Instruction Committee to invite fellow members of the Art-Workers' Guild to lecture in Manchester, and to develop a scheme for forming an Arts and Crafts museum in the Municipal School of Art.

During Crane's directorship the following members of the Guild lectured at the Council's invitation at Manchester: William Morris ('Printed Books: Ancient and Modern' 21 October, 1893), T.J. Cobden-Sanderson ('Bookbinding: its Processes and Ideals' 19 February, 1894), Lewis F. Day ('The Process of Pattern Design' and 'Some Ornamental Offshoots of the Italian Renaissance' 26 and 27 February 1894). May Morris-Sparling, the poet's daughter and founder of the Women's Guild of Arts, also gave two lectures ('Mediaeval Embroidery' 18 June, 1895, and 'Dress, Ancient and Modern' 12 May, 1896).[18]

When Crane resigned his post at Manchester he had no intention of giving up his struggle against the South Kensington system. He had become passionately interested in art education and the Schools of Art and intended to continue his campaign in London with the assistance of his colleagues in the Art-Workers' Guild.

A Student's Notebook

During the first decade of this century the Schools of Art, Schools of Arts and Crafts, and Polytechnics started to appoint masters specifically for instruction in design, and to regularly invite visiting lecturers in design; and the teaching of ornament was gradually replaced by instruction in design. Walter Crane produced the most direct efforts to bring about this state of affairs, thus it was of the deepest interest to

the author of this investigation to discover a set of student's illustrated notes taken down directly as Crane spoke at Manchester when giving the original lectures (1894–1896) which formed the bases of his books, *The Bases of Design* (1898) and *Line and Form* (1900), and which initiated the movement towards design in the Schools of Art.

In 1966 the author John S. Willock (1885–), a former head of the Design School at Manchester Regional College of Art, mention in conversation that he had these historic notes in his possession, and obtained a loan of them. A complete chronological list of these lectures is given in Appendix C. The notebook sketches done by the student, Emma Louise Bradbury, and the phrases she took down are mostly identical with the illustrations and text which appeared later in Crane's books.[19]

When we read these words of Crane today they seem absolutely clear and precise in meaning, in fact his clarity of vision was one of the reasons for the great success of his books in the first two decades of this century; yet in the 1890s, when all this talk on design was new to students and staff, the flow of his new ideas seemed to have at first proved too much for many of the students. Crane commented ironically in his *Reminiscences*

> It was rather encouraging (?) to hear as I did from an assistant master who had occasional duties at the school, when I was giving up my work at Manchester (in 1896), after three years, and who, in expressing his regrets, said, 'that for the first two years he confessed he did not see what I was driving at', but now that he was beginning to understand to follow me – I was going to leave.[20]

Likewise Emma Louise Bradbury must have been rather overwhelmed at first by Crane's fresh concepts. She scribbled a message on the top left of her notes of his lecture 'Of the Collective Influence in Design' for the student seated on her left, reading: 'Can you take in what he says? I feel as though he were a mile away.'

It is not the author's intention to give a detailed account of these lectures which appear revised in Crane's books, but it is of interest to deduce what was so new about his thinking that it puzzled the assistant master, the student, and no doubt many others, namely his analyses of the fundamentals of art and design.

Rational analysis of visual phenomena for the purpose of the fine arts originated in ancient Greece, and was resumed in the Renaissance, the main preoccupation being with proportion, perspective, and anatomy. As could have been expected the deepest search for basic fundamentals was made by Leonardo da Vinci who stated:

The mind of the painter ought to be as continually concerned with as many orderly analyses as there are forms or notable objects appearing before him. . . . The first principle of the science of painting is the point, then comes the line, then the surface, and then the body bounded by a given surface.[21]

In the last sentence Leonardo seems close to the viewpoint of modern basic design teachers, but unfortunately the spirit of enquiry of the Renaissance exemplified by his words was to be stifled by the rigid rules applied to classical art by the seventeenth and eighteenth century academics as they strove to imitate the ancients. Enquiry into the bases of design virtually ceased.

In 1884, the year of the Art-Workers' Guild foundation, art educators seldom used the word 'design', but frequently referred to 'ornament'. From the establishment of public art education in Britain in 1837 until the formation of the Department of Practical Art in 1852, the work pertaining to design carried out in the Schools of Design consisted of copying engravings or casts of historic ornament, and classes for such work were called 'classes of ornament', or 'classes of ornamental drawing', the prevalent theory behind the work being that the more historic ornaments they knew 'the greater number of combinations' of historic motifs they could reconstitute as original ornament.[22]

It was not that the idea of design had not yet been arrived at. Design in its true sense, that is the arrangement of forms and colours of an artefact or natural form, had been clearly understood from Classical times; but by the time Crane came on the scene in the latter half of the nineteenth century the meaning of the word was almost forgotten, and certainly ignored.

The Roman noun 'designatio', in its meaning of arrangement or order, is the nearest equivalent in Latin to the modern word. Marcus Vitruvius Pollio, a Roman architect of the time of Augustus's reign, who derived his writings from Greek authorities, clearly understood design; for when he gave his fundamental principles he grouped together order and arrangement as follows:

Order gives due measure to the members of a work considered separately, and symmetrical agreement to the proportions of the whole. . . . Arrangement includes the putting of things in their proper places and the elegance of effect which is due to adjustments appropriate to the character of the work.[23]

In mediaeval times, before wide contact had been made with Greek art and ideas, the Italian word 'disegno' usually meant the marking out or first stages of work by a craftsman, but during the fifteenth and sixteenth

centuries, owing to the rediscovery of Greek art and the wide reading of Classical authors, especially of Vitruvius, the word came to embrace the inventive process for every type of art work, thus Leonardo called it 'the parent of our three arts.'

The rise of the academies of art in the sixteenth and seventeenth centuries led to the division of design into various categories with the result that instead of it being regarded as the basic inventive process of arrangement, design came to signify merely the art of painting, sculpture, or architecture, hence the name 'Schools of Design' given to the schools of the Royal Academy in 1768. Calling these arts 'the arts of design,' as Vasari had done, led to some loss of meaning, especially from the eighteenth century when people constantly referred to 'the higher arts of design' on one hand, and the 'lower arts of ornament' on the other, causing a division that was deepened in the nineteenth century by the enormous quantity of wretched ornament, mass-produced to satiate the industrial rich.

Sir Joshua Reynolds P.R.A. put forward the erroneous view which was prevalent until the mid-nineteenth century when he asserted that 'if the higher arts of design (the fine arts) flourish, these inferior ends (taste in manufactures) will be answered': an argument as illogical as stating that if higher mathematics at universities flourish, then basic arithmetic in the primary school or industrial applied mathematics will thrive. Crane said of the viewpoint of the Royal Academicians:

> As well expect flowers to bloom without roots and stems, light, heat, and air, as to think that beautiful pictures or statues, or the sense that produces and admires them, can exist where there is no beauty in everyday things . . . I would go further, and say that where decorative or applied art is in a wholesome condition good pictorial or dramatic art will follow on. . . .[24]

Throughout the time that Crane was lecturing at Manchester the theories of Richard Redgrave and Ralph Nicolson Wornum dominated the teaching of design in the Schools of Art. To those two could be given the credit for making the first important steps towards an analytical approach to design, but their views were narrow, and in the case of Wornum, sterile. Redgrave, Art Superintendent of the Department of Practical Art (1852), and later Inspector General for Art for the Department of Science and Art (1853–1875), included two 'Design Stages' in his national Course of Instruction, which involved, in the main, learning to analyse plant shapes in the approved method from diagrams of such analyses provided by the Department, and then arranging shapes of given flowers within simple geometric figures – a practice known as 'space filling'. Redgrave had a passion for reducing natural forms to the symmetrical and geometrical, and the principles of

design he advocated read more like science than art. His principles are explained at length in the author's *History and Philosophy of Art Education* (1970).[25]

Crane strongly attacked the type of design that resulted from Redgrave's teachings, criticizing the 'flatness of treatment' and the notion that this was the whole of the law, a notion which had produced

> the flat-ironed primulas and the genus of enfeebled flora and fauna generally, which so often, alas, do duty as decoration. As if decorative art . . . required everything in heaven and earth to be thoroughly well boiled down before it could be properly assimilated.[26]

Crane was fundamentally opposed to Redgrave's 'South Kensington system' of art education. 'I do not, of course,' he declared, 'believe in any cast-iron system of education,' and again 'Art is not science.'[27] Crane was even more opposed to the historicism of R.N. Wornum.

Ralph Nicolson Wornum had been employed by the Board of Trade in the 1840s and 1850s to give lectures, first in the Schools of Design, then in the Schools of Art. In 1856 he produced his *Analysis of Ornament*, the most widely used approved textbook in the Schools of Art until the end of the century. The chief message of the book for the students was that they should learn the 'elements' or conventional lines and shapes of historic ornaments, such as the zig-zag, the fret or labyrinth, the scroll, the guilloche, etc. The students would then know 'the standard types of all ages', and therefore, in his opinion, would have learnt to design.

In view of these pedantic theories it is not surprising to discover that the staff and students at Manchester were at first rather astonished and baffled at Crane's fundamental and creative approach. It is understandable that Emma Bradbury, who had spent much of the session previous to Crane's arrival copying fifteen historic examples of ornament for submission to South Kensington, asked her neighbour if he, or she, could 'take in what he says.'[28]

Crane had already outlined his philosophy of art and art education in his *Claims of Decorative Art* (1892), and during his first year's lectures at Manchester (1893-4) he had the opportunity to crystallize his ideas, so that by October, 1894, he could give the series of lectures that were to form the bases of his textbooks on design.

The first phrases which Emma Bradbury took down from Crane in her notes were:

> Range enormous – Art and Craft: sewing, weaving – Form and character of dwellings. Temples – tombs. Architecture mother of all arts – Art precipitation of man's soul into material shape – Patterns for walls,

floor etc. make conditions for design – *Natural* Cave – first shelter of man – incised decoration – purely graphic in this stage.

With the first phrases of his first lecture Crane had thrown the narrow view of ornament out of the window into the October gloom of All Saints. The monthly lectures which followed until July 1895, and which later appeared as *The Bases of Design* were concerned with an enquiry into 'the vast variety and endless complexity of the forms which the term (Design) covers.' Crane said that he and his student audience would investigate the following questions to give them a key to the relation of these manifold forms:

1. How and whence they derived their leading characteristics?
2. Upon what basis have they been built up?
3. What have been the chief influences which have determined, and still determine, their varieties?

Each lecture of this series, save one, was on a distinct influence in design. Crane alluded to many historic examples but also to the work of dozens of contemporary designers including Harry Bates, W.A.S. Benson, Sir E. Burne-Jones, T.J. Cobden-Sanderson, E. Onslow Ford, Alfred Gilbert, William Morris, and George Simonds, his fellow-members in the Art-Workers' Guild. The most original lectures were the second 'Of the Utility Basis and Influence,' the third 'Of the Influence of Material and Method,' the fourth 'Of the Influence of Conditions,' the eighth 'Of the Graphic Influence', and his last 'Of the Collective Influence.' The students who had been instructed in accurate imitation of historic ornament from the cast, in imitation of the structure of historic ornament according to Wornum's *Analysis*, and in the narrow method of plant design according to Redgrave, had a wide vista opened to them. Design was a living thing, Crane taught them, produced by many influences. They should endeavour to be artistic and sensitive to them: there were no fixed rules.

In the next series of lectures on 'Line and Form', from October, 1895, to July, 1896, Crane made a great step forward, moving towards the modern analytical approach of visual education. He showed the students how they could analyse the design of artefacts and nature for themselves from fundamentals, and so dispense with imitating ornament. He talked of the 'three fundamental elements or essentials of Design – Line, Form, Space.' He explained qualities of line, scale of direction, counterbalance, radiation, planes, point and surface, quantities, systems of line, organic structures of nature, and the effect of natural forces. These phrases used in his lectures show Crane clearly as a precursor of the modern search for a standard analytical terminology or visual grammar.

Another progressive feature of Crane's lectures was his insistence on the students sketching down his diagrams as he talked. Emma Bradbury's notebook is crammed with swift clear sketches in line similar to those which appeared later in Crane's books, This resulted in the students omitting many of his words, but the rapid rhythmic drawings probably made his audience feel something like professional designers for the first time in their lives. During one lecture alone (January, 1896) Emma Bradbury executed twenty-three drawings occupying seven pages. This must have been a great change from spending weeks or even months on one drawing or ornament.

Crane wrote that the lectures were 'intended to bear rather upon the practical work of an art school, and to be suggestive and helpful to those face to face with the current problems of drawing and design', and added that they had been 'approached from a personal point of view, as the results of conclusions arrived at in the course of a busy working life which has left but few intervals for the elaboration of theories apart from practice.'[29] He certainly succeeded in his intentions, for shortly after the turn of the century diagrams according to Crane began to supersede diagrams of historic ornament on the blackboards of design rooms in the Schools of Art.

Emma Bradbury, who spent the years of Crane's directorship, and some earlier years, slowly accumulating passes in different stages of the Department's Art Masters' Certificates, varying from drapery on the antique to flowers in water colour, may not have fully understood the relevance of Crane's ideas at the time, but in her later career as an art teacher she respected them enough to preserve her notebook, and to ensure that it was safeguarded after her death.[30]

The Arts and Crafts Museum at Manchester

During Crane's directorship and Rowley's chairmanship of the School of Art, both were deliberating upon a proposed museum for the establishment. The annual report for 1893–94 states:

> The Committee have under their serious and careful consideration the prime importance of establishing an Industrial Art Museum for which the land behind the School offers an available site. In their view it is impossible to carry on the work of Art Instruction satisfactorily unless there is provided an abundant and characteristic supply of suitable examples, original and reproduced, of all classes of Decorative Art, especially those connected with Architecture, Textiles, and Fictile Arts, together with Drawings, Photographs, and Chromo-lithographs of the rare and costly examples to be found in the chief Museums.

The need for a museum of contemporary arts and crafts had been felt from at least 1884 when Charles P. Scott had presented his gifts purchased from Morris & Co, but R.H.A. Willis, then headmaster, an expert at securing examination awards in the National Competition, had envisaged a museum of historic ornament, in which students could copy examples for Stage 22d of the Course of Instruction 'Studies of Historic Styles of Ornament.' Willis in his headmaster's report for 1883–84 had stated;

> You have, no doubt, observed in the Exhibition of National Competition Works that numerous awards were made to the Schools of other cities for what are termed 'Museum' studies, that is, studies of ornamentation of certain classes of object with regard to its historical and artistic development, illustrations of the differences in the style of ornamentation dependent on the technical requirements of the materials used, the uses to which the objects were applied etc. In this important branch of study we were entirely unable to compete with other Schools of Art, as the distance of the various Museums from the School, and their comparative incompleteness for our purpose, render them but slightly serviceable.[31]

Willis' reference to technical requirements and materials was a sop to the industrial-minded city fathers, in fact what the examiners at South Kensington required was an exact imitation in deep tone of objects in various distinct styles of historic ornament.

A decade had passed, and Crane and Rowley were determined that the collection would be an Arts and Crafts museum to include contemporary work by their friends in the Art-Workers' Guild, thus, during the first year of Crane's directorship, glasswork was purchased from the firm of Powell and Co and metalwork from Benson and Co. In addition the Committee obtained the loan of the fine Tapestry designed by Sir Edward Burne-Jones, Bart., and executed by William Morris, entitled 'The Adoration of the Kings'. . . . We have the great satisfaction to report that a public spirited citizen has generously undertaken to bear the entire cost of a Replica, and present it to the Arts and Crafts Museum which the Committee desire to establish,'[32]

Burne-Jones, Morris, and the directors of the above firms, namely James C. and Harry Powell, and W.A.S. Benson, were all members of the Guild. Works by W. Crane, W.R. Lethaby, R. Anning Bell, and G. Frampton, all of the Guild, were also included in the collection.

The building of the museum was completed two years after Crane's departure, and opened by the Lord Mayor on 28 October, 1898. It was the most ambitious example of an Arts and Crafts Museum in any individual School of Art, in the words of the School Calendar: 'The

whole of this interesting collection . . . forms a Library of Applied Art such as is not available in the same way, and to the same extent, to students of any other provincial school.'[33]

The Manchester City News reported of Rowley:

the beautiful Museum of the Manchester School of Art, All Saints, with its rich treasures of art and craftsmanship, stands out as the most signal example of his abounding energy in the realm which he has striven for all along and loves deepest and best.'[34]

The main hall of the museum, named the Textile Court, would be extensively used for sketching and lectures until the Second World War, The two side wings, the Italian Court and the Gothic Court were used for a permanent display of casts of historic architectural ornament and sculpture; and the corridors were used for pottery and more textiles. Since this large museum of Arts and Crafts was rather unique in a School of Art, a complete description is given in Appendix E.

The Museum is now dismantled and the Courts are use as loan exhibition galleries, a library, and a lecture theatre. The main textile exhibits such as those of the Bock Collection, secured by Rowley and Scott are now in the Whitworth Art Gallery of Manchester University. The College of Art and Design still, however, retains the Morris copy of the Exeter College tapestry of 'The Adoration of the Magi', presented by William Simpson, which Rowley described as 'one of the chief glories of our city.'[35]

The provision of an Arts and Crafts museum was undoubtedly a great advance on the previous collections of antique casts of sculpture and ornament, and the presence of contemporary works by members of the Art – Workers' Guild certainly had a beneficial effect upon the design students at Manchester up to the first World War, since it freed them from total reliance upon books of historic ornament, but unfortunately the collection was not replenished with contemporary work in later years, and so itself became historic.

Since the author wrote the above account of the history of the Museum of the School of Art, much of its collection has passed into the possession of the Manchester Metropolitan University.

The deep split between art and the crafts in education, which was manifest in the Report of the Royal College of 1911 continued for most of the century. Both the general public and the 'officials' of Government art education were disturbed by the idea promoted by Crane and Lethaby of 'the Unity of Art', and were merely amused by the artistic crafts, such as pottery and book-illustration which were dubbed 'arty crafts'. Only Woodwork and Metalwork, taught by skilled

tradesmen, were widely taught serious crafts in the secondary schools until the 1960s when these subjects were replaced by Design/Technology.

Before his death in 1942, Ashbee lived long enough to see Arts and Crafts for children develop in schools due to 'The New Art Teaching' encouraging by Marion Richardson and R.R. Tomlinson.[36] By 1935 Art seemed to be winning the struggle for its place in education, and it seems strange, looking at the artistic jewellery produced by Ashbee's Guild of Handicraft that he was against the teaching of Art. But by 1908, when the Guild failed financially, it had become clear that, as far as the market was concerned, the debate about whether the crafts should be inspired by Art had become rather irrelevant. The crafts inspired by the Morris movement had become too expensive for the general public. Though some craftsmen struggled on until the First World War, there was only a considerable market for well-designed and expensive furniture. Morris's dream of a society of craftsmen was over.

It is surprising, when we consider Ashbee's argument that training in crafts should be separate from Art education, that the jewellery and metalwork he created with his Guild and School of Handicraft is exceedingly artistic. Some of the fine work, purchased for the museum of the Manchester School of Art fro the Arts and Crafts Exhibition Society's shows of 1896 and 1899 has still survived being moved around, and is now in the possession of Manchester Metropolitan University.[37]

Also in the University collection are over 170 works of craftsmen which were originally purchased for the Manchester School of Art Museum, including the fine Burne-Jones tapestry, 'The Adoration of the Magi' which was woven by Morris & Co in 1894.

Sources

1. *The Studio*. October, 1893–March, 1894 (Vol. 2. p. 36).
2. *The Studio*, April–September, 1895 (Vol. 5. p. 104) and Crane W., *An Artist's Reminiscences* (p. 417).
3. Crane, Walter, *The Bases of Design*, George Bell, London, 1898, and *Line and Form*, G. Bell, 1900.
4. Crane, Walter, *The Claims of Decorative Art*, Lawrence and Bullen, London, 1892.
5. *Report of Proceedings of the Technical Instruction Committee of the City Council of Manchester*, 1890–1893 (p. 46) and *Supplement to the Directory of the Dept. of Science and Art*, 1891 (pp. III–IV), also *The Municipal School of Art, Manchester, List of Successes at the Examinations of the Science and Art Department*, 1892–3, 1893–4, 1894–5, 1895–6.
6. *Annual Report of the Manchester School of Art* for 1886–87, January, 1888 (p. 9).
7. Crane, Walter, *An Artist's Reminiscences*. Methuen, London, 1907 (pp. 417–18).
8. *Report of H.M. Inspector on Manchester Municipal School of Art*. Department of Science and Art, 18 November, 1896, quoted in the Report of the Technical Instruction Committee

of Manchester City Council for 1896–7 (p. 17).

9. Crane, Walter. *The Claims of Decorative Art*, Lawrence and Bullen, London, 1892 (pp. 8, 77).

10. Wornum, Ralph Nicolson. *Analysis of Ornament: The Characteristics of Styles – An introduction to the study of ornamental art*, (1856) Chapman & Hall, London, seventh edition, 1882 (p. 22).

11. Ward, James, *The Principles of Ornament*, Introductory chapter by G. Aitchison, Chapman and Hall, London, 1896 (pp. 3, 4, 9).

12. *Reports of the Technical Instruction Committee of Manchester*, 1894–95 (p. 44) and 1895–96 (p. 20).

13. Crane, Walter, *The Claims of Decorative Art.* Lawrence and Bullen, London, 1892, p. 85.

14. Crane, Walter, *Line and Form*, G. Bell and Sons, London (1900), 1902 edition (p. V).

15. *Report of H.M. Inspector, Dept. of Science and Art, 18 November, 1896*, quoted in Report of the Technical Instruction Committee of Manchester for 1896–97 (p. 17).

16. Glazier, Richard. *A Manual of Historic Ornament*, B.T. Batsford, London, 1899, and Cadness, Henry, *Decorative Brush-Work and Elementary Design*, B.T. Batsford, London, 1902.

17. Crane, W., *An Artist's Reminiscences*, Methuen, London, 1907 (pp. 419–20).

18. *Reports of the Proceedings of the Technical Instruction Committee 1894–1897*.

19. Bradbury, Emma Louise, Notebook: '*Walter Crane's Lectures*' Manchester, October, 1894–July 1896.

20. Crane, Walter. *An Artist's Reminiscences*, Methuen, London, 1907 (p. 418).

21. Vinci, Leonardo da, *Treatise on Painting* (Codex Urbinas Latinus, 1270), translated by McMahon, A.P., Princeton University Press, 1856 (Vol. 1. p. 4).

22. *Introductory address of the new headmaster of Manchester School of Design*, Cave and Sever, Manchester, 1846.

23. Vitruvius, Marcus, *Ten Books on Architecture*, translated by Morgan, M.H., and Howard, A., edited Warren, H.L. (1914), Dover Publications, N.Y., and Constable, London, 1960 (Book 1, Ch 2, 2).

24. Crane, Walter. *The Claims of Decorative Art*, Lawrence and Bullen, London, 1892 (p. 2).

25. Macdonald, Stuart. *History and Philosophy of Art Education* (1970), Lutterworth Press, 2003 (pp. 233–241).

26. Crane, W., *The Claims of Decorative Art*, Lawrence & Bullen, London, 1892 (p. 4).

27. *Ibid.* (pp. 89 and 95).

28. *The Municipal School of Art, Manchester, List of Successes . . . 1892–1893* (p. 38), includes Emma L. Bradbury's results.

29. Crane, Walter, *Line and Form*, George Bell & Sons, London, 1900 (p. V).

30. *Municipal School of Art, Manchester: List of Successes at the Examinations of the Science and Art Department*, 1892–1896 (showing the exams taken by Miss E.L. Bradbury).

31. *Annual Report of Manchester School of Art for 1883–84*, Headmaster's Report (p. 18).

32. *Report of the Technical Instruction Committee of Manchester for 1893–94* (p. 11).

33. *Calendar of the Municipal School of Art*, Cavendish Street, Manchester, 1911–1912 (p. 18).

34. *Manchester City News* 30/10/1909, Newspaper Cuttings Book, Row-Royd, Local History Library, Manchester.

35. Rowley, Charles, *Fifty Years of Work Without Wages*, Hodder and Stoughton, London, N.D., C. 1915 (p. 73).

36. Richardson, Marion, *Art and the Child*, University of London Press, 1948.

37. Davis, John, and Shrigley, Ruth, with contributions from Taryn Evans and Miles Lambert, *Inspired by Design, The Arts and Crafts Collection of the Manchester Metropolitan University*, 1995.

Lethaby and Crane in London

The Foundation of the Central School

The most important educational institution committed to the Arts and crafts movement was the Central School of Arts and Crafts opened 2 November, 1896, by the Technical Education Board of the London County Council at Morley Hall, 316 Regent St., W1 'to provide instruction in those branches of design and manipulation which directly bear on the artistic trades.'[1]

The first directors of the school were George James Frampton A.R.A. (1860–1928) and William Richard Lethaby (1857–1931), both members of the A-W.G. Both directors were of equal status, but Frampton was content to leave everything to Lethaby. The joint directorship lasted until July 1901, when Lethaby assumed sole charge, but Frampton does not get a mention from ex-students of the School. Noel Rooke, a pupil during the directorship and later Vice-Principal of the School 'declared that he never saw Frampton at the School and only met one man who said he had.'[2]

If one were asked to select the leaders of the Arts and Crafts movement, excluding its prophet Ruskin, one could choose Philip Webb for architecture, William Morris for crafts, Walter Crane for design education, and W.R. Lethaby for craft education. Lethaby was, of course, one of the five architects who founded the A-W.G. in 1884. He was at that time chief draughtsman to Norman Shaw, whom he served from 1879 until 1890 when he started his own practice: nevertheless it should be understood that Lethaby, and the four pupils of Shaw who founded the Guild, were not so much admirers of that highly successful architect, but rather of Webb and Morris, and of course Ruskin, the three to whom Lethaby referred as 'our masters.' Indeed it was the pupil who influenced the master as far as Lethaby and Shaw were concerned, notably in the New Scotland Yard building. Noel Rooke wrote: 'Lethaby understood the new quality he had seen in Philip Webb's work – the quality which comes from the careful selection of texture and colour and material.' Shaw's friend, Sir Reginald Blomfield, recalled somebody asking Shaw if Lethaby was his pupil. 'No,' Shaw replied, 'I am his.'[3]

Lethaby secured the appointment at the Central School through the efforts of Sidney Cockerell, Norman Shaw, and three fellow members of the A-W.G. Cockerell related:

This great school had just been established, and there was no obvious head for it. Sir Emery Walker, who is now sitting next but one to me was returning with me from a continental journey, and we suddenly realised that the appointment would be made in day or so, and that Lethaby was the person for the post, and we decided that he must be chosen. With some difficulty we induced him to stand. Testimonials had to be speedily obtained. Sir Emery Walker undertook to tackle Morris; and I appealed to Burne-Jones and William Richmond who willingly gave their testimonials. These with another from Norman Shaw, secured his election, and we thought that a very good day's work.

(Of these five concerned in supporting Lethaby, only Cockerell and Shaw were not members of the Guild, but they had attended meetings and were elected later.)[4]

The premises of the School, which had just been vacated by the Women's Christian Association, were rented from the governors of Regent Street Polytechnic which stood opposite, and consisted of two houses one fronting Regent Street and the other Little Portland Street, linked by a domed observatory with a leaking roof. A.R.N. Roberts wrote that he had talked 'with a pupil of these early days who remembers that in wet weather listeners to Halsey Ricardo's lectures (on architecture of all subjects) would perforce sit there with their umbrellas up).'[5]

The Policy of the Central School

The great difference between the new school and the School of Art was due to the following factors. Firstly it was not concerned with producing art teachers and thus escaped from the exercises of the Course of Instruction of the Science and Art Department; secondly it was not concerned with recruiting amateurs and painting students; thirdly: 'The special object of the school' was 'to encourage the industrial application of decorative design' and it was 'intended that very opportunity should be given for pupils to study this in relation to their own particular craft,' and lastly, and most important, Lethaby by virtue of his positron in the A-W.G. was able to persuade brother designers and craftsmen to instruct at the School.

The first Prospectus and Time Table of the School, quoting the Report of the Technical Education Board of the London County Council for 1895–6 advised that:

Admission to the school is, within certain limits, only extended to those actually engaged in these (artistic) trades, and the School makes no provision for the amateur students of drawing and painting. . . . There is no intention that it should supplant

apprenticeship – it is rather intended that it should supplement it by enabling its students to learn design and those branches of their craft which, owing to the subdivision of processes of production, they are unable to learn in the workshop.

The instruction is adapted to the needs of those engaged in the different departments of Building Work (Architects, Builders, Modellers and Carvers, Decorators, Metalworkers etc.); Design in Wall Papers, Textiles, Furniture, Workers in Stained Glass, Lead, etc.; Enamellers, Jewellers and Gold and Silver Workers. Other departments will be opened in response to reasonable demand.[6]

With all its students employed by day the School had, of necessity, to operate in the evenings and did so, from 7 to 9.30 p.m.. This made it possible for Lethaby to obtain the services of notable designers and craftsmen for lecturing and instruction. Naturally he selected members of the A-W.G., indeed the list of staff in 1876 reads almost like a roll of the Guild. Of the whole staff only five were not members and one of these was elected to the Guild later.

Although the students were all craftsmen employed in artistic trades, they were not exclusively adults. Young artisans attended, and the L.C.C. provided Junior Artisan Evening Art Exhibitions worth £5 per annum for two years for young tradesmen who had carried out successful work in an approved School of Art. The money was provided to cover their travel expenses to Regent St.

The results of the policy of employing notable craftsmen of the Art-Workers' Guild were soon apparent. At the end of its second session the School held an exhibition and *The Studio* reported:

The first exhibition of works by students of the Central School of Arts and Crafts, Regent St, fully justified the high expectation raised by the personnel of its staff. The bookbindings of Mr Douglas Cockerell's class, the lead-work by Mr Lethaby's, the colour-prints by Mr Morley Fletcher's, the stained glass by Mr C.W. Whall's, and the enamels by Mr Fisher's, to take but a few, were all not merely good when considered as the work of pupils in training, but were capable of holding their own at most exhibitions.[7]

The quality and quantity of the work of the School was a rebuke to the Royal College of Art, the central national art institution, and to the national system of the Department of Science and Art, a system which had signally failed to produce designers and craftsmen of a worthwhile standard. The L.C.C. School was outside the national system and did not provide courses for any of the Department's examinations, yet it was producing skilled

craftsmen and industrial designers, the very function that public art education had been provided for. Lethaby and his staff of Art-Workers soon established not only a reputation in Britain for the Central School, but also abroad. The period of Lethaby's reign at the Central, from 1896–1911, was the only time in which a British arts and crafts institution was regarded as the most outstanding of its kind in Europe.

The School of Book Production

It was in the field of book production that the Central School made its international reputation.

The earliest development in this direction was a book-binding class started by T.J. Cobden-Sanderson in the first session of the School and instructed by Douglas B. Cockerell, George Adams, and J.A. Adams. In the words of the report of the L.C.C. Technical Education Board (1900):

> In February 1897 an entirely new centre of instruction in this handicraft was established at the Central School of Arts and Crafts. Mr Cobden-Sanderson made a donation of skins, inspected the work for time to time and delivered a lantern lecture on March 29th.

Cockerell, who took charge of the class was the pupil of Cobden-Sanderson, Morris' close associate and binder to the Kelmscott Press, and at the time of the establishment of the Central School class was working with Sanderson at the Doves Bindery.[8]

The next development was the setting up of a class of Writing and Illumination in September, 1898.[9] Edward Johnston (1872–1944), the instructor of this class, by his own work and by his teachings was to improve lettering throughout Europe and the United States of America. The Johnston sans serif letters are still used for signs and notices of London Transport, including the Underground.

Johnston had abandoned the study of medicine at Edinburgh in 1897, and had sought Lethaby's advice about taking up a career in art. Lethaby had suggested that he should take up a craft, say lettering, for Lethaby had a deep respect for fundamental place of calligraphy, in his own words 'we might reform the world if we began with our own handwriting but we shall certainly not unless we begin somewhere.'[10]

Lethaby persuaded his friend Sidney Cockerell to take young Johnston to see the manuscripts at the British Museum and Johnston became deeply interested. Cockerell, a great authority on calligraphy, was not impressed by Johnston's early efforts, but Lethaby saw promise. We can glean an idea of Johnston as an inspiring instructor from an account given in the autobiography of his most famous pupil, Eric Gill, who said of Johnston 'I owe everything to the foundation he laid.' Gill joined Johnston's class at

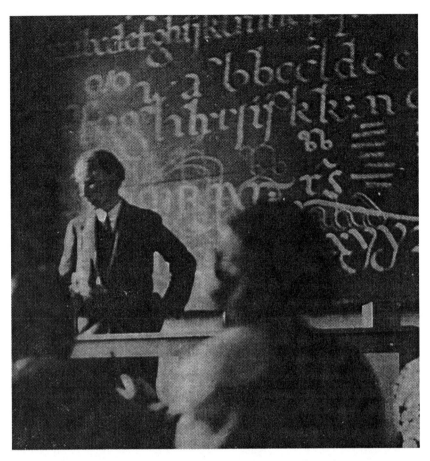

Edward Johnston demonstrates his calligraphy

Aabcdefghijkl
mnopqrstuvw
quxyz2345678

Alphabet and numerals by Eric Gill, 1907

the Central School for the first time on 21 Sept 1899, and later wrote this impression of his experience.

> It will have to be sufficient if I say that the first time I saw him writing, and saw the writing that came as he wrote, I had that thrill and tremble of the heart which otherwise I can only remember having had when I first touched her body or saw her hair down for the first time (Lord! what the young men have lost since women bobbed their hair!), or when I first heard the plain-chant of the Church (as they sang at Louvain in the Abbey of Mont Cesar) or when I first entered the Church of San Clemente in Rome, or first saw the North Transept of Chartres from the little alley between the houses.[11]

Johnston's pupils were not only inspired by his demonstrations on parchment with quill pen and Indian ink, but by his analytical talks on calligraphy and letters. From his study of manuscripts Johnston had arrived at the same conclusion as Lethaby had, namely that fine hand lettering should be the basis of typography, and, in Gill's words,

> was making it clear that fine printing was only one of a thousand forms of fine lettering. And what was fine lettering? It was in the first place rational lettering, it was exactly the opposite of 'fancy' lettering. That was the new idea, the explosive notion, and you might say the secret.[12]

Johnston had returned to basic Roman lettering and mediaeval scripts, analysing the functions of their characteristic forms. At the Central School he would devote several 45-minute talks to each Trajan Roman letter.

Johnston's rational approach to lettering is clearly shown in his classic *Writing & Illuminating* (1906), one of the Artistic Crafts Series of Technical Handbooks edited by Lethaby 'to provide trustworthy text-books of workshop practice,'[13] Gill who had spent his time at Chichester Technical and Art School 'inventing what seemed to me later the most monstrous perversions and eccentricities in the way of 'new art' lettering' said that Johnston finally rid him of 'the art nonsense' of the Schools of Art. Gill added that at Chichester

> we laboured under the tyranny of art-school fashion — a harder master because more capricious than any 'tradition' or any such rational notion as that the primary business of lettering is to be legible. Lettering was a part of art-school 'art'; its primary business was to be what they called and still call 'decorative.' It is clear that before Johnston's teachings spread to the Schools of Art, the lettering practised therein was fancy, decorative, 'arty' lettering with bad basic forms.[14]

The seed of the grass,
The speck of stone
Which the wayfaring ant
Stirs — and hastes on!

Though I should sit
By some tarn in thy hills,
Using its ink
As the spirit wills
To write of Earth's wonders,
Its live, willed things.
Flit would the ages
On soundless wings
Ere unto
My pen drew nigh:
Leviathan told,
And the honey-fly:
And still would remain
My wit to try —
My worn reeds broken,
The dark tarn dry,
All words forgotten —
Thou, Lord, and I.

Calligraphy by Edward Johnston (1874-1944), scribe of the Central School

Johnston's most distinguished pupils were Eric Gill, W. Graily Hewitt, and Noel Rooke, all, like their master, members of the A-W.G. In September, 1902 Hewitt joined Johnston as his assistant in Writing and Illumination. He would eventually take charge of the class on his master's resignation: Rooke was to become vice-principal.[15]

Eric Rowland Gill (1882–1940) first developed an interest in lettering when train-spotting during his childhood at Brighton. He wrote, 'Locomotives have names, and these are painted on them with great care and artistry. If you are keen on engines, you collect engine names (at our school it was as popular a hobby as "stamps") and if you draw engines you cannot leave out their names.' George Herbert Catt, the art master at Chichester Technical and Art School, furthered Gill's enthusiasm. 'I was,' wrote Gill, 'in a not too inaccurate manner of speaking, "mad" on lettering.[16]

At the time Gill was a student at the Central School there were few sculptors capable of designing and carving fine inscriptions and clients could hardly escape from 'the deadly corruption of the trade monumental mason,' as Gill put it. Lethaby and Johnston encouraged Gill to take up letter cutting and it was as a carver of inscriptions that he first earned his living; nevertheless his interest in calligraphy and typography remained strong and he was able, as we shall see later, to contribute to the School's reputation for book production.

In 1904 Lethaby grouped the subjects offered at the Central School into three main divisions: Building work, Work in the Precious Metals, and Crafts of Book Production. Emery Walker and T.J. Cobden-Sanderson, who had been appointed Visitors to the School by the L.C.C. from 1898, were the chief protagonists as far as book production was concerned.[17] Walker had joined Cobden-Sanderson in founding the Doves Press, Hammersmith, in 1900, a press which for the next eleven years established new high standards of design and typography, and they had found that existing trade classes in London could not produce the designer/craftsmen they required; hence a lithography class under G.S. Smithard, and a printing class under J.H. Mason, were added to the existing bookbinding and writing and illumination classes, thus forming the division of Crafts of Book Production.

J.H. Mason (elected to the A-W.G. 18/6/1926), the chief compositor of the Doves Press, was persuaded by his employers, Walker and Cobden-Sanderson, first to take charge of evening printing classes, then, in the words of A.R.N. Roberts:

The L.C.C. Committee on Book Production on which Emery Walker and Cobden-Sanderson served with representatives of the Federation of Printers and Allied Trades, the Association of

Master Printers, the London Book Binders' Association, and the trade unions, later called for the establishment of pre-apprenticeship training for young printers. Lethaby agreed that the Central School should be the home for this work and, to take charge of it on a full time basis, Mason reluctantly severed his connection with the Doves Press.[18]

The Central School had already begun to establish an international reputation. Nikolaus Pevsner informs us in his *Academies of Art* (1940) that in 1901 the Central School was described as 'probably the best organised contemporary art school' by Herman Muthesius (1861–1927), later the founder of the Deutscher Werkbund and superintendent of the Prussian Board of Trade's Schools of Arts and Crafts.

The Germans quickly grasped the excellence of the Doves Press and of the printing and calligraphy taught at the Central, and Gill, Johnston, and Mason received employment from German presses. Describing the influence of the Central School group at this time, F.C. Avis wrote:

Lecturing and advising in Germany, English artists and craftsmen, of whom Emery Walker, Edward Johnston, Eric Gill, and John Henry Mason were the most prominent, moulded much of the course of German private press work. None of these pupils was apter, or more desirous to emulate their example than the German diplomat, Harry Graf Kessler, who at Weimar, Thuringia, established his Cranach Press.[19]

All these English designer/craftsmen were members of the Art-Workers Guild at the time, except Mason who was not elected until 1926.

In 1904 Gill received his first commission from Count Kessler to produce titles and headings for the Grossherzog Wilhelm Ernst edition of the *German Classics,* of which twenty-one volumes were published over the next six years (Insel Verlag, 1905–1911). From 1910–1930 Kessler also employed Johnston, who was given the task of designing calligraphic fonts for the Cranach Press, the Count's private press at Weimar. Probably the most famous and influential work produced by this press was Virgil's *Eclogues* (Cranach Press, Weimar 1926). The work was illustrated by figure studies in black line by Aristide Maillol, a close friend of Kessler. Gill designed the initial letters for the *Eclogues* and executed the woodcuts of both Maillol's figures and the initials.[20]

Lethaby must have been very proud of his former pupils and protégés.

The division of Book Production was given the title 'School of Book Production' in September, 1908, when the Central School moved into its new premises in Southampton Row.[21] The School of Book Production was

certainly a remarkable achievement. Lethaby had gathered together a group of teachers who were internationally recognised as the leading experts in each of their particular fields, namely Douglas Cockerell for bookbinding, Edward Johnston and Graily Hewitt for lettering and calligraphy, John Henry Mason for compositing, and Noel Rooke for book illustration and wood engraving. The final stamp of distinction was achieved in September, 1914, three years after Lethaby's resignation, when the class of 'Steel Punch Cutting for Type' was started with Edward Philip Prince as instructor. Prince was then 68 years old and the most renowned punchcutter of any period. The letters he cut were the most delicate sculptures, The 'Doves Roman' fount of 1900 was a masterpiece of refined cutting, and his 'Avon' of 1902 shows amazing variation of fine line, as also does his Cranach-Jensen of 1912, cut when he was 66 years old.[22]

In the School of Book Production Lethaby had achieved the workshop atmosphere he desired, indeed complete pamphlets and books could be printed and bound in the School, and several were. However, as we will now see, his establishment was gradually drawn into the area of general art and craft for the public.

The Day Technical School

In 1905 the Board of Education authorised the payments of grants for day technical classes, classes which were provided to fill the gap between leaving elementary schools at thirteen to fourteen years of age and apprenticeship to a trade at sixteen. These classes were recognised as a distinct type of school, the Junior Technical School, by the Board of Education in its Report for 1912–13 which described them as 'definitely not intended to provide courses furnishing a preparation for the professions, the universities, or higher full-time technical work, or again, for commercial life; they are intended to prepare their pupils either for artisan or other industrial employment or for domestic employment.'[23]

A 'Technical Day School for Boys' who intended to enter the trade of goldsmithing and silversmithing was established in the Central School during the 1906–7 session under the supervision of W. Augustus Steward, who was already in charge of the evening classes for silversmiths, and of Onslow Whiting, who already took the evening classes for goldsmiths. The Prospectus for the session 1907–8 announced 'A Day School has been established to provide technical instruction for boys who propose to enter some branch of the trades dealing with precious metals. . . . The school is open to boys who are capable of doing the work of Standard VII. The fee is £1–10s a year, but the Council reserves the right to remit the fees in whole or in part in the case of boys whose parents are in receipt of not more than £2 a week.' The Day School was 'open to a limited number of boys of about 13 to 14 years of age,

AND MOSES SAID Shew me, I pray Thee, Thy glory. And He said, I will make all My goodness pass before thee, & I will proclaim the Name of the Lord before thee, & I will be gracious to whom I will be gracious, & I will show mercy on whom I will show mercy. And He said, thou canst not see My face: for man shall not see Me & live. And the Lord said, Behold there is a place by Me, & thou shalt stand upon the rock; & it shall come to pass, while My glory passeth by, that I will put thee in a cleft of the rock, & will cover thee with My hand until I have passed by; & I will take away My hand & thou shalt see My back: but My face shall not be seen.

Handwriting sheets from the Central School of Arts and Crafts

Bookbinding in green morocco done at the Central School

who can show evidence of a satisfactory general education and whose health warrants them learning the trade.'[24]

The Day School, as was usual with junior technical schools, had a curriculum which included both technical subjects of general education. The boys studied mensuration, geometry, geometrical drawing, freehand and model drawing, clay and wax modelling, heraldry, plant study, colour, elementary science, English composition, history, geography, workshop drawing, technology of metals and tools, and benchwork.[25]

The Day School for goldsmiths and sliversmiths was progressive inasmuch as it was an early example of provision for day pupils for the trade, but it was not the first in this field. There was already a thriving school for jewellers, goldsmiths, and silversmiths in Birmingham, which Lethaby had visited, which was run by Arthur Gaskin, a fellow member of the Art-Workers' Guild.

Lethaby, by virtue of his position as principal, was officially in charge of the Day School, and he now became increasingly involved in administration with regard to grants, examinations, attendance, and standards of general education: administration work he detested. Formal general education had now entered his establishment on behalf of the L.C.C., and Fine Art was to follow.

The Move to Southampton Row

A new building was proposed for the Central School owing largely to the encouragement the London County Council received from the Trade Associations. There was already a thriving Day Technical School for pre-apprentices who intended to work in precious metals, and a second Day School was planned for Book Production. A.R.N. Roberts wrote:

> A site was accordingly reserved on the east side of Southampton Row on which new buildings, adjoining each other, were to be erected for the Training College and for the Central School. The fact that the two buildings were to be contiguous and have means of communication on two floors permitted considerable economies. Since the Training College was mostly used during the day, and the Central School in the evenings, one lecture theatre and one refreshment department would serve their double purpose. A certain common use of studios, laboratories and examination halls was planned from the outset.[26]

The new premises of the Central School were opened on 21 September, 1908. The building, designed by the London County Council's architect, W.E. Riley, provided the best workshops of any school of

arts and crafts in Britain at that time.[27] The School of Architecture and Building Crafts was on the ground floor, the School of Silversmith's Work and Allied Crafts on the first, the School of Book Production on the second, the School of Cabinet Work and Furniture on the third, the School of Drawing, Design, and Modelling, and the School of Needlework together on the fourth, and the School of Stained Glass Work, Mosaics, and Decorative Painting nearest heaven 'in beautifully lighted classrooms on the top floor.'[28]

It might seem from the above information that Lethaby now had an establishment exclusively for pre-apprentices and craftsmen in trades, but the County Council had every intention, as we will see, of using the premises by day as much as possible. The Studio commented prophetically, before the School opened: 'In Southampton Row the interests of the professional student will of course be primary consideration, but the amateur will not be wholly excluded. He is in fact almost indispensable to the art school with day classes.'[29]

The Royal Female School of Art

In October, 1908, the Central School entered the orbit of the Government system of art education in a curious way. In February of that year the governors of the Royal Female School of Art had transferred the School to the London County Council, and it was decided that the School should quit Queen Square in July and move into the new premises of the Central School in Southampton Row. The Central School's prospectus for 1909–10 comments, 'This school, established in connection with the Board of Education at Queen Square, Bloomsbury in 1842, was transferred to the London County Council on 21 February, 1908.'[30]

This comment is historically incorrect. The Royal Female School had been established originally in connection with the Board of Trade in March 1842 as the Female Class at the Normal School of Design, Somerset House. Then, in October, 1848, the Class had been moved to a house in the Strand where it opened as the Female School of Design. In 1852 the School had been re-established at Gower St as the Female School of Art in connection with the Department of Practical Art. The last home of the School previous to its arrival at Southampton Row had been at Queen Square, Bloomsbury, where it had re-opened in 1861. I have written elsewhere that the School 'was a very select seminary, patronised by the Queen, and later by the Princess of Wales (afterwards Queen Alexandra).'[31]

The Royal Female School had specialised in training young ladies to draw and paint to prepare them for entry into the Royal Academy Schools

or, failing this, eventually to teach young ladies themselves. At the time of the School's move to Southampton Row its patrons were King Edward VII and Queen Alexandra.

It may seem rather bizarre that such a select school of young ladies should be shunted into the Central, which had been established for those actually engaged in trades, but the point, from the County Council's viewpoint, was that the move was a very convenient way of filling the new Central School by day. It had been said of Lethaby, in connection with his work at the Central, that 'he has conducted it with such good purpose that, since the institution was opened, not a single easel-picture has been produced within its walls.'[32] The incorporation of the Royal Female School altered this state of affairs. Fine Art came to Southampton Row, as also did the Board of Education's examinations.

The Central School's Prospectus for 1909–1910, referring to the Royal Female School, stated: 'Students are thoroughly prepared for the examinations of the Board of Education in May and June for Elementary Certificate, Art Class Teacher's Certificate, and Art Masters' Certificate.'

Although Lethaby was Principal of the whole establishment in Southampton Row, he took no hand in running the Female School. It was directed by Miss Rose E. Welby, its Lady Superintendent. Nevertheless the presence of the ladies undoubtedly speeded Lethaby's departure.

Lethaby's Resignation

'Lethaby suffered much from the education machine of the London County Council'.[33]

Professor Lethaby resigned as principal of the Central School in the summer term of 1911. His departure was speeded by increasing complexity of administration due to the growth of the School and to the demands of the committee men and civil servants of the L.C.C. and the Board of Education, a breed he referred to as 'Mr Inkpots.' He commented: 'The world has developed through the stone, bronze, and iron ages to the present paper age,' and deplored that the 'able man is swamped by details which narrow him to a withered stick.'[34]

Lethaby had liked the School in its original form, that is as an evening institution for fee-paying tradesmen. He would also have liked to make this institution more practical and useful by helping these tradesmen sell the products of these classes, as he had helped Johnston and Gill, but he knew any attempt to market the goods of a grant-supported school would not be tolerated by the representatives of the trade associations on the L.C.C. committees, nor by the politicians. Lethaby gave his viewpoint as follows in a letter to Alfred H. Powell, the pottery painter:

About Art Schools, I sympathise with your doubts although I have been 'in that line myself' both as learner and teacher.

They are British compromises permitted to exist on the understanding that they shall not actually produce anything that would be competing with wage working and profit getting, the same obstructions which prevent cottage building and so many other doings . . . the schools should be transformed into real making shops.[35]

Admittedly the School even in 1911 carried out more practical craft work than any School of Art but Lethaby found 'his' institution was being drawn too much into the mainstream of controlled education which he disliked. The first important change in this direction had been the establishment of the Day Schools at the Central School, the next the incorporation of the Royal Female School of Art, a move which brought Fine Art and Board of Education certificate exams under his roof. A further move was the appointment in 1909 of a sub-committee of the L.C.C. Education Committee to supervise the School.

On his resignation as principal in 1911 Lethaby did not quit the field of public art education. From this time onwards he concentrated on his duties at the Royal College and of Surveyor of the Fabric of Westminster Abbey.

Crane Invited to be Principal of the Royal College

In 1897, shortly after his resignation from the directorship at Manchester, Professor Mackinder of University College, Reading offered Crane the post of Director of the proposed new Art Department there. Crane agreed to accept the appointment 'as not absorbing too much time,' he related: 'The existing Reading art school was to be reorganised and to be a branch of the college. I had been instrumental in recommending the appointment of Mr F. Morley Fletcher as headmaster.'[36]

The calendar provided at the opening of the new buildings by the Prince of Wales stated:

The curriculum has been arranged with a view to making the study of the principles of art and the practice of drawing a part of general education; of training teachers; of giving assistance to those who intend to follow art as a profession; but especially for promoting the study of art as applied to handicrafts, manufactures and industries.[37]

The last aim of the curriculum must have puzzled some of the numerous university dignitaries present, for what place had the study

of handicrafts and industrial art in a university college? Certainly some eyebrows were raised when they attended the Prince to the top floor and discovered a room for woodcarving. H.R.H. was presented on this occasion with an address designed by Crane and contained in a silver and enamelled casket made by Nelson Dawson, a member of the A-W.G.

The University College building was at that time near the town hall and parish church, and included a portion of the old Abbey. Six rooms were provided for the Art Department on the top floor, one for the director, the others being for antique, life, painting, modelling and woodcarving. Crane was responsible for the attempt to establish the study of handicrafts and industrial art, indeed Morley Fletcher, the headmaster he had recommended, was himself an artist/craftsman who had taught colour block-printing at the Central School. Crane stated: 'His artistic work in the direction of the adaptation of the Japanese method of colour block engraving and printing to English subjects and treatment is well known. . . .'[38]

Crane's mind was not long occupied with this attempt to initiate the Arts and Crafts movement in a university institution, for in the following year (1898) he was offered the post of Principal of the Royal College of Art. In October, 1896, the news had filtered through to the office of *The Studio* magazine that the Queen had graciously consented to a change of title for the National Art Training School and that it was to be reconstituted as the Royal College of Art. 'It is permissible to express some surprise at the news,' the magazine commented, 'that for the future the National Art Training School is to rank as a "Royal College of Art" – when its methods and practices are being called in question with more than ordinary persistence. . . .'[39]

The reconstitution of the National Art Training School was a step towards decentralisation of the national system of art education. The post of Director for Art of the Science and Art Department, held by Thomas Armstrong, was abolished, thus ridding the Department of the only art official on the national level. It was now intended to run the central institution at South Kensington as a college under the Board of Education. Armstrong recommended Crane as principal in the belief that he would be most competent to introduce design classes at South Kensington. Crane reported:

I went up to the Education Office and had an interview with the Duke of Devonshire's secretary – the Duke was Lord President of the Council of Education, and the Science and Art Department was now to be transformed into a branch of the Board of

Education at Whitehall, I was assured that the post would allow me time to practice my work as an artist, and, on this understanding, I agreed to accept the office.[40]

Crane was not the first principal of the Royal College of Art. John C.L. Sparkes, the headmaster of the National Art Training School, whom the author had investigated elsewhere,[41] became the College's first principal when the School was reconstituted and remained in office until his resignation in July 1898.[42] Crane took up his duties in October of that year.

Crane related,

In October we returned to town, and I entered upon my new duties at South Kensington. . . . The school was in rather a chaotic state. It had been chiefly run as a sort of mill in which to prepare art teachers and masters, and supply the finished article to fill such teaching posts or masterships as might fall vacant in any part of the United Kingdom.[43]

The Royal College was certainly in a sorry state as far as design and craft education was concerned. There had been no general swing in that direction following the Technical Instruction Commissioners Report of 1884, due no doubt to Sir John Donnelly, and the only crafts practised in the College were pictorial, namely etching, engraving, and lithography, The subject of design was catered for by lectures from Hugh Stannus, Occasional Lecturer on Decorative Art, whose speciality was 'Classification' and 'Storiation' of architectural ornament,[44] and by special occasional lectures on design from Stephen Webb. Etching, engraving, and lithography were taught by the distinguished engraver and water colourist Frank Job Short (1857–1945, later Professor Sir Frank Short, R.A.). The most notable teacher on the fine art side was Edouard Lanteri, who, by lectures, demonstrations, and writings, did more than any other teacher of his time to raise the standard of modelling in our Schools of Art, and who, in Crane's opinion, 'had saved the credit of South Kensington for years past.'[45] Lanteri's method of modelling was analytical intelligent and academic, as opposed to the mindless copying from the surfaces of casts and the live model. His method is best studied in his book, *Modelling – A Guide for Teachers and Students* (Chapman and Hall, London 1902).

As far as the above well qualified staff were concerned, Crane fell among friends. They were all members of the A-W. G. , except Lanteri who was not elected until 1901, and they understood Crane's intentions. With the staff of permanent art masters it was different. Crane commented:

The curriculum seemed to my unacademic mind terribly mechanical and lifeless, but so long as candidates for art teacherships and masterships were required to have obtained certain cut-and-dried certificates, the time of students would necessarily be occupied in doing the regulation exercises for them, and, as I found at Manchester, but little time was left for experiments, or chance for the introduction of different systems and methods. . . .

The staff of masters seemed anxious to meet my wishes, and to work harmoniously, an they were all very worthy good people, but they had been hardened by long service in a system with which I was out of sympathy, and could not be expected to see any more than the Manchester teacher I have before quoted – 'What I was driving at.'[46]

Sir John Donnelly, who was still in charge of the Department of Science and Art 'could not welcome the impending changes, and believed in the old order of things,' thus Crane could do little apart from introducing lectures and demonstrations in design and handicrafts by members of the Art-Workers' Guild and a class in stained glass under J.S. Sparrow. Lectures and demonstrations were given by Alexander Fisher on enamelling, by Cobeden-Sandserson on bookbinding, by William Burton on pottery, and by Joseph Pennell on book illustration and processes of reproduction.[47]

Frustrated by the red tape and the South Kensington system, Crane resigned in 1899 after only one year in office, but not before he had drawn up a scheme for the reorganisation of art education and of the Royal College. During the following year the Department of Science and Art was finally merged with the Board of Education, and the Board appointed a Council of Advice for Art, It was by means of the Council that Crane was able to put into effect his scheme for reorganisation.

The Introduction of Crafts into the Royal College
The Board of Education's Council of Advice for Art, appointed in 1900, consisted of four advisers, one for architecture, one for painting and life, one for sculpture, and one for design. These were respectively T. Graham Jackson R.A., William Blake Richmond R.A., E. Onslow Ford R.A., and Walter Crane. The Art-Worker's Guild had made a clean sweep! All the advisers were members and ex-masters of the Guild. The Board of Education had two officials on the Council and, when business connected with the Royal College was under discussion, its principal and registrar attended. The Council directly governed the Royal College on behalf of the Board.[48]

The Council's scheme for re-organisation of the College was interesting because it pioneered the division of a College of Art into 'Schools', a system which was introduced into all Schools of Art after the First World War. A professor was appointed to each School, in every case a member of the A-W. G. , namely Beresford Pite for Architecture, Gerald Moira for Painting, Edouard Lanteri for Modelling, and W.R. Lethaby for Ornamental Design. Augustus Spencer the headmaster of Leicester School of Art was appointed to succeed Crane as principal and was duly elected to the Guild (7/11/1901). Craft classes were established as a separate part of the structure, not as part of Ornamental Design.

The crafts introduced into the Royal College were stained glass under Christopher Whall, tile painting and pottery under R. Lunn, stone and marble cutting under Anselmo Galmuzzo, writing and illumination under Edward Johnston, metalwork and enamelling under H. Wilson, embroidery and tapestry weaving under Mrs A.H. Christie, and furniture decoration and gesso work under George Jack. Etching, engraving, and lithography continued under Frank Short. All these craftsmen were members of the A-W.G. save Jack, Lunn, and Mrs Christie, Jack being elected a member in 1906.[49]

It may be noticed that the types of craft were the light decorative variety that a fine artist could dabble at, with the exception of stone and marble carving which was provided as appropriate for the fine artists of the Modelling School. Industrial crafts such as printing, book production, cabinet work, and textile design were not carried out, as they were at the Central School: Full time students at the Royal College did not learn a craft thoroughly (with the exception of the pictorial printing crafts): they were trained as teachers of fine and decorative art with a little knowledge of crafts, and it was for this reason that the College was to be attacked so savagely in 1911 by a Departmental Committee of the Board of Education and by C.R. Ashbee. It was also for this reason that Frederick Burridge, principal of the Central School at that date, claimed that his school, not the Royal College, should be the senior institution for the training of industrial designers.

It is strange to think that Lethaby, the founder principal of the Central School and the advocate of the craft workshop, spent the rest of his teaching career, after resigning from the Central in 1911, in such an atmosphere; but he was probably happier at the Royal College. The Central had become closely linked with modern industry and commerce, a bustling lively place. Lethaby's advice to students at the Royal College, paraphrased by one of them, reveals the peaceful mediaeval atmosphere he loved.

In Church, Cathedral, Cloister, Hall,
Some hours each day I spend,
And this touch of dignity
To all your work will lend.[50]

The stale and dusty gloom of the Royal College during the reign of Augustus Spencer (1900–1920) was vividly described by Sir John Rothenstein.

> The place had the look, and even the smell – not of an art school but an inferior elementary school: the members of the staff whom I happened to see resembled clerks: the retiring Principal (Spencer) wore a morning coat, and the students seemed to have sunk in apathy. Certain members of the staff occupied the spacious studios intended for the students, who were exiled to the smaller rooms intended for the staff.[51]

One can understand the apathy which gripped a College, which took the cream of the art students from Schools of Art to make them indifferent teachers of fine art (and of craft to some extent) when we consider the utter superiority of the Central School at that time in the industrial design and craft fields. The Central was going from strength to strength under Lethaby's successor, F.V. Burridge teacher from Liverpool.

Sources

1. L.C.C. Technical Education Board, *Central School of Arts And Crafts – Prospectus and Time Table*, 20 December, 1896 (p.3).
2. Johnstone, W. Mackail, J.W; Richardson, Sir Albert; Roberts, A.R.N., *William Richard Lethaby, 1857–1931*. 'Memoir of W.R. Lethaby' by A.R.N. Roberts, Central School of Arts and Crafts, London, 1957 (p.25).
3. Lethaby, W.R., Powell, A.H., and Griggs F.L., *Ernest Gimson – His Life and Work*, Shakespeare Head, Stratford-Upon-Avon, 1924. Limited edition 500 copies (p1), and Roberts, A.R.N., *op. cit.* (p.14), also Blomfield, Sir Reginald, R.A., *Richard Norman Shaw R.A. – Architect 1831–1912.* B.T. Batsford, London, 1940 (p.98).
4. Cockerell, Sir S.C. Vote of thanks and discussion following *An Impression and a Tribute* (to W.R. Lethaby). A paper read before the R.I.B.A., London, 15 February, 1932 (p.20) and Journal of the R.I.B.A., Third Series, April, 1957 (Vol.64 No.6 p.218), also Roberts, A.R.N., *The Life and Work of W.R. Lethaby*, Journal of the Royal Society of Arts 29 March, 1957 (Vol CV).
5. Roberts, A.R.N., *op. cit.* (p.26).
6. L.C.C. Technical Education Board, *Central School of Arts and Crafts – Prospectus and Timetable* 20 December, 1896 (p.3).
7. *The Studio*, October, 1898–January, 1899 (Vol. 15 p.46).
8. Blunt, Wilfred, *Cockerell*, Hamish Hamilton, London, 1964 (p.83)
9. L.C.C. *Central School of Arts and Crafts. Prospectus and Timetable*, 3rd session, 1898–99.
10. Johnston, Edward, *The House of David, His Inheritence, A Book of Sample Scripts*, (1914) H.M.S.O., London, 1966 (p.1), and Roberts, A.R.N., *op. cit.* (p.29).

11. Gill, Eric, *Autobiography*. Jonathan Cape, London, 1940 (p.119).
12. *Ibid* (p.136).
13. Johnston, Edward, *Writing and Illuminating*, Artistic Crafts Series of Technical Handbooks, Editor, W.R. Lethaby, Isaac Pitman, London (1906), 22nd Impression, 1948 (p.V).
14. Gill, Eric, *Autobiography* (p.91).
15. L.C.C., *Central School of Arts and Crafts, Prospectus and Time Table 1898 and 1902.*
16. Gill, Eric., *op. cit* (pp. 90–91).
17. Roberts, A.R.N., *op.cit.* (p.35).
18. *Ibid* (pp.35–36).
19. Avis, F.C., *Edward Philip Prince – Type Punchcutter*, Glenview Press, London, 1967 (p.53).
20. Speaight, Robert, *The Life of Eric Gill*, Methuen, London, 1966 (p.26), and Johnston, Edward, *The House of David, his Inheritance. A Book of Simple Scripts,* (1914) H.M.S.O., London 1966, also Bland, David, *The Illustration of Books*, Faber and Faber, London, 1951 (pp.92–93).
21. L.C.C., *Central School of Arts and Crafts. Prospectus and Timetable,* 1908–1909.
22. Avis, F.C., *op.cit.* (pp.63, 71, 75, and 77).
23. *Board of Education Report* for 1912–13 (p.124).
24. *London County Council Central School of Arts and Crafts. Prospectus and Timetable* for 1912–13 (p.31).
25. *Ibid.,* 1907–8.
26. Roberts, A.R.N., *op.cit.* (p.36).
27. *The Studio*, February-May, 1908 (Vol.43 p.339).
28. Holme, C., *Arts and Crafts,* The Studio Ltd., London, Paris, New York, 1916 (pp.9–10), and Roberts, A.R.N. *op.cit.* (p.37), also *L.C.C. Central School Prospectus* 1908-9.
29. *The Studio, Ibid.*
30. *L.C.C. Central School of Arts and Crafts. Prospectus and Timetable for 1909–10.*
31. Macdonald, Stuart, *History and Philosophy of Art Education,* (1970) Lutterworth Press, Cambridge, 2003 (pp.134–5, 158, and 173).
32. *Studio,* October, 1899–January1900 (Vol.18 p.37).
33. Blomfield, Sir Reginald, *An Impression and a Tribute*, Paper read before the R.I.B.A., 15 February 1932. (Vote of thanks by R.W.S. Weir) R.I.B.A., London, 1932 (p.19).
34. Roberts, A.R.N., *A Memoir on William Richard Lethaby* (pp.38–9) and *Central School of Arts and Crafts, Prospectus and Time Table*, 1910–1911, 1911–12.
35. Lethaby, W.R., *Scrips and Scraps*, gathered by Alfred Powell, Earle and Ludlow, Cirencester, 1956 (p.37).
36. Crane, Walter, *An Artist's Reminiscences*, Methuen & Co., London (September, 1907), 2nd Ed. October, 1907 (p.442).
37. *The Studio*, June-September, 1898 (Vol. 14 p.202).
38. Crane, Walter, *An Artist's Reminiscences* (p.442).
39. *The Studio,* October, 1896–January, 1897 (Vol.9 p.62).
40. Crane, W., *An Artist's Reminiscences* (p.452).
41. Macdonald, S.. *op.cit.* (pp.34, 136, 152, 165, 191, 194, 216, 218–20).
42. *Royal College of Art: Prospectus* for 1897–8, Staff List.
43. Crane, W., *Reminiscences* (pp.456–7).
44. *Royal College of Art. Prospectus* 1897–98, and 1898–99 and Massé, H.J.L.J., *The Art Workers' Guild* (p.70).
45. Crane, W., *Reminiscences* (pp.457–8).
46. *Ibid.* (p.457).
47. *Ibid.* (pp.458–459).

48. *Royal College of Art. Prospectus*, for 1900, 1901, and 1902.
49. *Royal College of Art. Prospectus*, for 1901–2, and Crane W., *Reminiscences* (p.460).
50. Lethaby, W.R., *Scrips and Scraps*, gathered by Alfred Powell, Earle and Ludlow, Cirencester, 1956 (p.12).
51. Rothenstein, Sir John, *Summer's Lease – Autobiography 1901–1938*, Hamish Hamilton, London, 1965 (p.99).

An Experiment in Liverpool

In France Architects, Painters, and Sculptors are trained together in one common School of the Arts. If Architecture in England is missing its way it is for the young men to bring her back from professionalism.

Richard Norman Shaw (1831–1912)

The City of Liverpool School of Architecture and Applied Art

The man chosen to succeed Lethaby at the Central School of Arts and Crafts was Frederick Vango Burridge, the headmaster of the City School of Art, Liverpool. Before describing this teacher's work at the Central School, it is extremely interesting to investigate the position of arts and crafts education in Liverpool during Burridge's stay in that city. A unique effort to ally education in arts and crafts with education in architecture had been attempted with the assistance of members of the A-W.G. This experiment was important because it will be remembered that the founders of the Guild were architects, committed to the creation of artist/architects who must 'knock at the door of Art until they were admitted', as Norman Shaw put it.[1]

When Frederick Burridge had finished his course at the National Art Training School and had taken up his appointment at the Government School of Art of the Liverpool Institute, Mount St (later the City School of Art), he must have been disturbed to find that there was a rival institution in which design and crafts were flourishing more strongly, namely the City School of Architecture and Applied Art of University College, Liverpool.

One of the original endowments of the University College had been the Roscoe Chair of Art, provided by the citizens of Liverpool in 1881 as a memorial to William Roscoe, the Liverpool banker, scholar, and connoisseur. Up to 1894 activities were confined to lectures on the fine arts, the Chair being referred to on occasion as 'a Chair of Aesthetics in general.' The professor at this time, R.A.M. Stevenson, cousin to the great Robert Louis, found 'his lectures on Velasquez and other masters only attended by a few old ladies.' It would seem he did his best to enliven proceedings. C.H. Reilly (later Roscoe Professor of Architecture)

related that 'Stevenson told his class of old ladies that as all painters know, a good way to see the values and composition of a landscape was to put the head down and look at it from between the legs.' The disillusioned professor eventually persuaded John Macdonald Mackay, officially Professor of History and unofficially 'the undoubted head of the university' that the Roscoe Chair should be given to a practical art – architecture, painting, or sculpture, and as a result of approaches by the Liverpool Architectural Society, the Chair was given to architecture.[2]

This development was hardly appropriate as a memorial to Roscoe, who had loved all the arts and had written a biography of Lorenzo de Medici. Mackay, and the famous art critic D.S. MacColl (elected to A-W.G. 1/7/1892) felt the situation was not satisfactory as also did the citizens who had contributed to the Roscoe endowment, consequently in 1894 a solution was arrived at which satisfied both the University College and the citizens of Liverpool. The City of Liverpool School of Architecture and Applied Art was established, supported by a grant of £1000 p.a. from the City Council, and housed at University College, Brownlow Hill. The Council and the University College had joint representation on the board of the School.

To ensure that the appropriate encouragement was given to arts and crafts or 'applied art', the new Roscoe Chair of Architecture was given to Frederick Moore Simpson, a member of the A-W.G. from its early days (elected 2/12/1887). Simpson was simultaneously appointed director of the City School of Architecture and Applied Art.

Simpson's appointment was certainly approved by Macdonald Mackay, who had announced his intention to make Liverpool a new Athens, with Brownlow Hill as its Academy no doubt. Simpson was already a leading expert on Classical architecture, in fact he was almost totally committed to scholarship. The only erection he is known to have been concerned with is the Victoria Memorial, Liverpool, for which he designed the overall setting. The sculpture of this 'great embellishment to the heart of the city' as it was described, was designed by Charles J. Allen (elected to the A-W.G. 4/5/1894).[3]

Most of the A-W.G., due to the influence of Ruskin and Morris, were historicists and traditionalists, but Simpson was a historian and scholar extraordinary, who possessed the most detailed first-hand knowledge of historic architecture of any man of his time, probably of any time. He stated in 1905 that he had first journeyed abroad in 1879 and had repeated the experience every year. During one of these tours, in 1884, he had been a Royal Academy Travelling Student. 'The object of these journeys,' he wrote, 'was to study architectural development.' The result was *A History of Architectural Development*, published in three volumes in

1905, 1909 and 1911 respectively, dealing with architecture from Egyptian to Renaissance times.[4] His vast direct experience can be deduced from his astonishing statement: 'I cannot say that I know every building in these volumes, but there are very few that I have not seen.'[5] Simpson's work were, and still are, indispensable to serious students of historic architecture, but he was hardly the correct man to appoint to what was intended to be a chair of practical architecture.

The Sheds of Brownlow Hill

To house the applied Art section of the new School, corrugated iron sheds were erected at the rear of the Victoria Building of University College on Brownlow Hill, in the quadrangle with a separate entrance from Brownlow St. 'The Sheds' accommodated the Sculpture and Modelling Studio, the Decorative Painting Studio, and the Wrought Iron Workshop. Room and equipment for the Woodcarving Workshop were provided in the Engineering Department of the College. The Architectural Studios were housed in the main Victoria Building. Both day and evening classes were organized, with half-fees for the evening artisans.[6]

Professor Reilly, who disapproved of the Arts and Crafts movement wrote of the sheds:

> They were there because of the Arts and Crafts Movement of the nineties. Mackay and his friends . . . felt fervently . . . that it was no good the University College of those days teaching the design of buildings without at the same time teaching 'the crafts'. By 'crafts' they meant the decorative crafts, wrought-iron work, hammered silver, enamel work, modelling in gesso and so forth. They felt, in short, the need of adding 'artiness' to architecture. Form, construction, and function were not enough . . . The City Council were therefore persuaded, that if University College devoted its Roscoe Chair of Art to Architecture, to grant a thousand a year to Applied Art.[7]

The Scheme of Architectural Education at University College

The bold scheme for architectural education at University College, Liverpool was devised by Simpson in collaboration with T. Graham Jackson A.R.A., a fellow member of the A-W.G. (elected 5/4/1889, Master 1896), the founder of the Junior A-W.G., an architect who wished to prevent students 'stiffening into mere narrow practitioners running blindly in a groove', and who wished them to be taught 'that interdependence of one Art upon another which results from the decorative aspect of Art.'[8]

To put it simply the scheme was to give all architects a basic training in art and artistic craftwork, through their own work and through working alongside fine artists and craftsmen, a progressive experiment anticipating the Bauhaus by a quarter of a century. It should be remembered that in 1894 the year of the foundation of the City of Liverpool School of Architecture and Applied Art, there were no full-time schools of architecture. Juniors were trained by enduring a long pupilage in an architect's office and the little knowledge of art they gathered was acquired from attending evening classes and lectures in Schools of Art, Technical Schools, Universities, or the R.A. Schools. Liverpool was first in the field for, as Simpson claimed, it was 'the first attempt made in England to put the training of architects on a sound and systematic basis.'[9]

To justify the scheme of giving an artistic training to architects, Simpson referred to the French system of training architects in ateliers (See Appendix B), where the students went 'through a course of training to fit them for admission into the Ecole des Beaux Arts' for admission into which the students had to pass an entrance examination which included design, drawing, and modelling from the cast.[10]

The School at Liverpool, which was formally opened by T.G. Jackson on 10 May, 1895, provided a two year course for youths prior to their entrance into an architect's office, classes and lectures being given in perspective, draughtsmanship, history of architecture, modelling from life and from the antique, designing and modelling ornament, drawing and painting from life and from the antique, decorative design, metalwork, and woodcarving.

Simpson invited two fellow members of the A-W.G., Robert Anning Bell and Charles J. Allen, to join the staff of the Applied Art Section. Anning Bell, who had been elected to the Guild in 1891 (Master, 1921), was put in charge of Painting, Drawing and Design, and Charles J. Allen (elected to the A-W.G. 4/5/1894) in charge of Sculpture and Woodcarving.[11]

Anning Bell had studied drawing and painting at Westminster School of Art under Frederick Brown (Slade Professor at University College, London 1892–1917, elected to the A-W.G. 7/7/1893), and had then taught drawing at Glasgow School of Art and the Royal College. His work was greatly influenced by that of his friend Walter Crane, and he was one of the leading protagonists in the Guild of applying art to architecture. To Simpson he seemed therefore the ideal choice for the experiment at Liverpool. He certainly carried out much decorative art during his stay at Brownlow Hill, including that at the University Club, Mount Pleasant, and the reredos at St Clare's, Arundel Avenue. He was probably best known for the mosaic panel on the entrance front of the L.C.C. Horniman Free Museum, the building of which was designed by

C. Harrison Townsend (elected to A-W.G. 3/2/1888, Master 1903).[12]

Charles J. Allen was recommended to Simpson by Sir Hamo Thornycroft R.A. a founder member of the A-W.G., and at the time of his appointment was assistant to Thornycroft at the R.A. Schools.

The next distinguished addition to the staff was made in 1898 when J. Herbert McNair was appointed to instruct in stained glass and decorative design, thus Art Nouveau came to the 'Art Sheds.' (McNair and his wife Frances (nee Macdonald) together with her sister Margaret, and Margaret's husband Charles Rennie Mackintosh comprised 'The Four', as these leading designers of the Glasgow Art Nouveau school were called).[13]

Naturally the presence of such talented artists as Anning Bell, Allen, and the McNairs caused the number of art students at University College to heavily outnumber the architects. A contributory cause was the fact that the combined efforts of students and staff were regularly displayed in exhibitions, including the shows of the Arts and Crafts Exhibition Society. The citizens of Liverpool now regarded the long established Government School of Art of the Liverpool Institute as second best, both for the purposes of art education and for social prestige.

The Government School of Art of the Liverpool Institute

The Government School of Art, which Burridge now directed, had its origin in the establishment in 1825 of the Liverpool Mechanics' School of Arts. For the first two years the classes had been housed in a disused chapel in Thomas St, on a site now occupied by the Education Offices, then, for the next ten years, in rooms over the Union Newsroom in Slater St. The art classes had then been provided with a permanent home in the Liverpool Institute and School of Art, Mount St, through the generosity of Philip Holt, the shipowner and donor of funds for the building.[14] Appropriately Thomas Wyse M.P., who was deeply interested in national education in drawing, had opened this new building on 15 September, 1837. The School had later received recognition from the Department of Science and Art, in 1854, as the Liverpool School of Art (South District), and in the same year John Finnie had been appointed headmaster, a position he retained for forty-two years, surely some kind of record! It was this gentleman whom Burridge succeeded in 1896.

Finnie had regularly exhibited landscapes in the Royal Academy and the School had largely become a drawing and landscape institution for ladies, of whom there were at times over ninety in the elementary classes alone. The head himself provided a Private Day Class for Ladies 'in which they are taught such branches (landscape etc.) as they may desire

to acquire without the tedium of the more disciplinary method laid down in the Art Directory.'[15] The other function of the School was to provide drawing lessons and examinations for artisans, for pupils of the secondary Boys' School, and for girls from Blackburne House.

There was an ever larger accumulation of plaster casts than of ladies, in fact, the largest outside London and Edinburgh, moreover the building, in addition to the School of Art, contained the Boys' School, the Queen's College, and the Evening School. As a result of this overcrowding one of the directors of the Liverpool Institute provided funds for the erection of a new School of Art adjoining the Institute but with its front door, as it is today, on Hope St. (The press and the public continued to refer to it as 'the Mount St School of Art' or 'the Government School of Art.') This building, which still accommodates the school (now the Liverpool College of Art and Design) was opened on 30 July 1883, its pride being the large iron staircase with 'iron balusters of very chaste design, the line of Scagliola columns rendered in imitation of Verdi antique marble,' and its collection of casts. It was into this fine art environment, crammed with antique and modern beauties, that Burridge stepped in 1896.[16]

The new headmaster, unlike most government art masters of his time was deeply interested in crafts, particularly etching, lithography, and mezzotint. He set to work to ensure that the School veered towards industrial design and crafts. Within a year *The Studio* report 'the improved quality of decorative design at the Mount St School of Art due to the influence of the new headmaster, Mr Frederick Burridge,' and, two years later: 'The new headmaster Mr. Frederick V. Burridge and his assistant master Mr. R.R. Carter have in a comparatively brief period attracted a number of promising and capable students, and created a new enthusiasm for design which had previously been scarcely recognized in this school.'[17]

By 1900 Burridge had achieved a considerable reputation. *The Studio* again selected him for special mention and reported:

The work of the students of the Mount Street School of Art . . . has obtained thirty-seven awards in the National Competition, 1900, including one Gold Medal, an increase of ten awards upon the number allotted to this school last year. There is further reason for congratulating Mr. Fredk. V. Burridge, the Headmaster, and his assistant, Mr. Carter, upon the result of their painstaking efforts to advance this school in the direction of the applied arts in the fact that out of the five gold medals awarded to Great Britain at the Paris Exhibition, Group I., Class IV. (Special Artistic Teaching), Liverpool has been awarded one, sharing the honours with London, Birmingham, and Glasgow.[18]

Burridge's success was crowned by his election to membership of the A-W.G. on 3 May 1901. Such success made it very obvious to the Liverpool City Council that the duplication of its contribution to art education was both unnecessary and uneconomic and that the classes of the City School of Architecture and Applied Art at University College and those at the School of Art of the Institute should be amalgamated.

Applied Art at University College becomes Irrelevant

Admittedly under the existing system at University College some architecture students were practising art and artistic crafts among the droves of ladies in the corrugated sheds, but the merits of such studies for architects were doubted by the gentleman of the Corporation. 'The subtle connection between making silver rings and enamelled brooches for one's girl friend with architecture was naturally not clear to them,' wrote C.H. Reilly.[19]

Simpson's scheme of architectural education was indeed foundering, mainly for sociological reasons. The School was open not only to intending architects, but also to any person in Liverpool who wished to study in any of the classes. Fees were required for attendance at each class, and the sociological group which was most willing to afford them consistent of the parents of middle-class young ladies. The last quarter of the nineteenth century was the period of the great fine art boom, and any institution which employed distinguished artists was bound to be flooded with young ladies, some with dreams of greatness, others merely in quest of something interesting to while their time away. The attraction of the School was increased by its attachment to the University College, where Sefton Park mammas were fairly certain that their daughters were not as likely to encounter the artisan class as they would have been at the Government School of Art.

The young ladies' interests were not only confined to the drawing, painting, and modelling classes. The middle and upper classes in the 1890s were passionately interested in promoting artistic crafts as manifested by the rapid expansion of the Home Arts and Industries Association and various Gentlewomen's Guilds, thus the craft classes at the School were also invaded by the females and were diverted from their original purpose.

When the craft classes had been instituted in 1894 the intention had been to follow crafts which were closely related to architecture and its decoration, such as decorative painting, wrought iron, and woodcarving, but the female element in the School with the full encouragement of the staff, especially of J.H. McNair, demanded light artistic crafts: for example brasswork and copperwork became the popular occupation in the Wrought Iron Workshop. It was significant that, in *The Studio*, review of the 1901 exhibition of the work of the School of Architecture and

Applied Art in the Walker Art Gallery, all the works commended, save two, were by young ladies.[20]

The final touch of artistic distinction was added to the School during the above year by the presence of Augustus John in the Sheds. John wrote:

> The McNairs taught what was known as *design* at our art school on Brownlow Hill, where I was supposed to teach drawing. In England alone, I believe, the functions of the two are held to be separate. In France the same word *dessin*, includes both.[21]

It was D.S. MacColl, the art critic, elected to the A-W.G. on 1 July, 1892, a relation of Oliver Elton, Professor of English Literature at Liverpool, who recommended John for the appointment. He had already praised John's first show of work in London. The position was temporary. John was merely filling a vacancy created by the departure of Herbert Jackson, the successor of Anning Bell, to serve in the Boer War. John only remained in the School for eighteen months until the return of Jackson, leaving for London in 1902. He was not keen on 'the frowsy atmosphere of Brownlow Hill,' nor on 'University people,' preferring the company of immigrant and emigrant wanderers in the City, and of gypsies in N. Wales. John Sampson, the University College librarian introduced John to the latter.[22]

Professor Reilly wrote:

> Although there were always numbers of young ladies from Sefton Park making pretty things, the presence of Augustus John teaching drawing and painting was the great event, and that was what was employing the rival school and filling the University with all the serious artists of the town.[23]

During his time at the School John was asked by McNair to give a judgment on that designer's Art Nouveau metalwork and his wife's embroidery. John wrote:

> I responded as frigidly to the curly doorknockers and rectangular tin troughs fitted with night-lights etc. of the one, as to the quaintly pretty embroideries of the other, in which bulbous gnomes or fairies figured largely in surroundings of a totally unidentifiable order . . . the honest fellow, forgetting he had volunteered a similar estimate of my own efforts, broke down, saying he would just like to swim and swim right out to sea till he drowned. Without going to these lengths he did leave Liverpool eventually to return to his native land, where I was told, forswearing Art, he became a first-class postman.[24]

The Applied Art section of the School was now impressive from an artistic viewpoint but from the turn of the century it had become increasingly

irrelevant to the training of architectural students, and the University authorities were now concerned with creating specialized degree courses in architecture. In 1900 the University College had instituted an honours course in architecture, leading to a B.A. of the Victoria University (of Manchester & Liverpool & Leeds), and was seeking independent university status.[25]

In 1902 the separation of the design classes from the architectural classes became physical as well as academic, for in that year McNair's classes were moved south to Bedford St and Myrtle St. His 'Design Shed' and 'Copper Shed' at University College were demolished. Only the fine art classes of the Applied Art Section remained namely, drawing and painting from life, modelling from life, and drawing from the antique.[26]

The City Council was now seeking a change of affairs, not only for the obvious economic reasons. There were also administrative factors. As a result of the Education Art (Balfour-Morant) of 1902, councils were required to provide local education authorities to take over the administration of education from the School Boards and School Attendance Committees. The Act required that the new local education authorities

> take such steps as seem to them desirable, after consultation with the Board of Education . . . to promote the general co-ordination of all forms of education' and to have regard to . . . any steps already taken for the purposes of higher education under the Technical Instruction Acts, 1889 and 1891'[27]

Liverpool, no doubt because of the unique type of duplicated provision in the City, was slow off the mark in municipalising the Government School of Art of the Institute and coordinating the City's art education under its direction. Other cities with large Schools of Art had taken this step during the last decade of the nineteenth century following the recommendations of the Technical Instruction Acts, and these institutions were already operating under the supervision of the Technical Instruction Committees of their city councils.

The Establishment of the Liverpool City School of Art

The Applied Art Section of the School at the University was finally merged with the School of Art of the Institute in the session of 1904–5. The first step was taken in 1903, when the members, trustees, and directors of the Liverpool Institute presented the Institute with all its schools and property to the Liverpool City Council. The schools consisted of the High School for Boys, which is still housed in the original Institute building, the High School for Girls (still in Blackburne House), a commercial school for boys, a preparatory department, and the School of Art.[28]

The City Council then considered the advantage of a single municipal

School of Art, and at a meeting of the Technical Education Sub-
Committee on 9 June 1904 the 'Scheme for the Establishment of the
Liverpool City School of Art' was discussed by which 'The whole of
the work at present carried on under the School of Art and the Applied
Art Section of the School of Architecture and Applied Art shall be in
future carried on under the title of the Liverpool City School of Art.'
On 22 June the scheme was adopted 'subject to the approval by the
Board of Education.'[29]

Thus in the same year the Applied Art section of the School at the
University was closed and merged with the School at Mount St under the
direction of Burridge to form the City School of Art. Its departure from
the University quadrangle was opportune, for Professor Simpson had
resigned in 1903 to become Professor of Architecture at University
College, London, and the new Roscoe Professor of Architecture,
appointed in 1904, namely C.H. Reilly, was opposed to the 'applied art'
concept of the A-W.G., which he associated with Ruskin's teachings on
ornamentation of architecture.

The Applied Arts' staff did not all transfer to the City School, which
they regarded as socially and artistically inferior. J. Herbert McNair, the
most gifted designer on the staff decided 'not to accept the South
Kensington yoke or to join the staff of the town Art School,' and set
up a private school, the Sandon Studios, first in Sandon St, then in the
Blue Coat Hospital building, with the assistance of Gerald Chowne.
Chowne, from the Slade, had been appointed to the City School of Art
to take over the painting classes which had been moved from the
University, but he also detested the 'South Kensington system' of
Government examinations and quit to join McNair.

Charles Allen 'went over' to the City School of Art, possibly because
he was more sympathetic to the artisan class, and certainly because he
was obtaining sculpture commissions from Liverpool society. He was
forgiven this social faux pas by the university people in view of the
fact he had a family to support. Conveniently J. Crossland McClure,
Instructor in Modelling at the School, had resigned to take up a post at
Leicester School of Art, so Burridge was delighted to give Allen, a
friend and fellow member of the A-W.G., the appointment. Allen then
acquired a skilled assistant master, J. Herbert Morcom, a former pupil
of the School, who had over ten years workshop experience of
stonecarving and woodcarving, so the future looked bright as the pair
set to work on memorials for deceased folk of Liverpool.[30]

So ended the bold attempt at Liverpool to ally architectural education
with experience of arts and crafts. The architecture students on
Brownlow Hill could now concentrate on the University's own honours

degree in architecture. (The University College had become the University of Liverpool in 1903.) We can only wonder whether the Liverpool institution would ever have developed into a progressive school of all arts and crafts and architecture as the Bauhaus did, if the Liverpool students of architecture had been encouraged to proceed with some work in arts, crafts, and design in various media.

The Achievement of Burridge at Liverpool

In August, 1903, *The Studio*, in its annual review of the National Competition for Schools of Art at South Kensington referred to 'Schools that have already established a reputation either for all-round excellence, such as Liverpool Mount St. . . .'[31]

The School continued to maintain and increase its reputation, and the exhibitions of its work had separate reviews in the above international magazine, a rare honour. Burridge had taken over an indifferent art school and had transformed it into a thriving arts, crafts, and trade school, in which over twenty artistic crafts were being practised at the time of his resignation in 1912.

The superior artistic merit of the applied art of the Liverpool School was due to Burridge's system of working from the living model, a system which made students produce designed masses and rhythmic forms relevant to design work. *The Studio* correspondent, commented:

> The conventions of the South Kensington system have been abandoned in favour of more practical and useful methods of training . . . it is the direction given by the headmaster, Mr. F.V. Burridge R.E. to the thoroughly practical study of the nude figure in the classes for drawing, painting, and modelling that forms the sound foundation upon which is reared the excellence of decorative design generally.[32]

The 'South Kensington system' of working from the figure required for the National Competition and the Board of Education's art examinations consisted of first learning to draw or model from the Antique, and then progressing to tedious outlined and shaded drawings, or careful relief modelling, from the Life. A glance at the prize lists of a contemporary School of Art reveals that far more studies were done from the Antique than from the Life. Drapery was sometimes arranged both on the Antique and the Life.

The rigid results of such work, whether from the Antique or the Life, distinctly resembled classical statuary, and were isolated studies with no relevance to contemporary environment or design.

Burridge broke away from the system by two means: bold 'time

sketches' of rhythmic poses, and stencils cut direct from the model's pose. *The Studio* correspondent wrote:

> The Liverpool students seem to be encouraged to draw the figure boldly from unconventional poses, and to create difficulties of a stimulating kind . . . the most satisfactory feature is undoubtedly the excellence of the drawing from the life, and it appreciably affects the application of the figure to the wide range of decorative work undertaken. . . . Original and distinctive design is fostered by the somewhat unusual method employed in cutting stencils from life . . . the severity of treatment required by stencil cutting tends to the simplification of detail and the elimination of what is unnecessary.[33]

Burridge's work at Liverpool eventually earned him the post of Principal of the L.C.C. Central School of Arts and Crafts. He resigned at Liverpool in January 1912 and departed at the end of the summer term to take up his London appointment in September, leaving to his successor, George Marples, the task of carrying forward his work.[34] What particularly commended Burridge to the L.C.C. Sub-Committee for the Central School was the way he had developed the book production crafts at Liverpool, namely lettering, typography, lithography, etching, mezzotint, woodcutting, book illustration, bookbinding and book cover design. This made him the ideal choice for the Central School, the pride of which was the School of Book Production. No doubt the L.C.C. authorities were also relieved to appoint an organizer who believed far more strongly in officialdom and the national system than Lethaby did.

Sources

1. Massé, H.J.L.J., *The Art-Workers' Guild*, Shakespeare Head Press, Saint Aldates, Oxford, 1935 (p. 7).
2. Reilly, C.H., *Scaffolding in the Sky*, George Routledge & Sons Ltd, London, 1938 (pp. 66, 83–84), and *University College & University of Liverpool – A Brief Record of Work and Progress* (Pamphlet), University Press of Liverpool, 1907 (pp. 13–19).
3. *The Studio*, Feb–May 1902 (Vol. 25, p. 203).
4. Simpson, F.M., *A History of Architectural Development*, Longmans Green, London, New York, Bombay & Calcutta, 1905, 1909, 1911 (Vols. 1, 2, & 3).
5. Stewart Cecil (rewritten and revised by), *Simpson's History of Architectural Development*, Longmans Green, London, New York, Toronto, 1954 (Vol. 2, p. XIII).
6. Budden, Lionel (editor), *The Book of Liverpool School of Architecture* University Press of Liverpool & Hodder & Stoughton, London, 1932 (pp. 33–34), and Simpson, Fred., *The Scheme of Architectural Education started at University College Liverpool in connection with the City of Liverpool* School of Architecture and Applied Art, D. Marples, Liverpool, 1895 (pp. 25–30).

7. Reilly, C.H. *op. cit.* (p. 83).

8. Massé, H.J.L.J., *The Art-Workers' Guild 1884–1934*. Shakespeare Head Press, Saint Aldates, Oxford, 1935 (pp. 3, 27, 139).

9. Simpson, Fred., *The Scheme of Architectural Education started at University College Liverpool in connection with the City of Liverpool School of Architecture and Applied Art*, D. Marples, Liverpool, 1895 (pp. 23–25). Pamphlet, Cohen Library X35.3.15.

10. *Ibid.*, (pp. 10–12).

11. *Ibid.*, (p. 25) and Budden, Lionel (editor), *op. cit.*, (p. 34).

12. Crane, W., *An Artist's Reminiscences* (pp. 449 and 487) and *The Studio*, October, 1901–January, 1902 (Vol. 24, p. 196).

13. *The Studio*, October, 1898–January, 1899 (Vol. 15, p. 127).

14. *The Liverpolitan*, December, 1936 (Vol. 5, No. 12, p. 33).

15. *College of Art – Honours and Prize Lists*, in Picton Local History Library, Liverpool. Ref. H373.22.INS. *Annual Report of School of Art (Mount St) 1885*, and *brass wall record* in the Liverpool College of Art and Design, Hope St, affixed 21 May, 1905.

16. Tiffen, J. *History of the Liverpool Institute School*. Tinling, Liverpool 1935 (p. 115).

17. *The Studio*, October, 1897–January, 1898 (Vol. 12, p. 192) and February–May, 1899, Vol. 16, p. 130).

18. *Ibid.* October, 1900–January, 1901 (Vol. 21, p. 135).

19. Reilley, C.H., *op.cit.* (p. 85).

20. *The Studio*, February–May, 1901 (Vol. 22, p. 276).

21. John, Augustus, *Finishing Touches*, Jonathan Cape, London, 1964 (p. 60).

22. John, Augustus, *Chiaroscuro: Fragments of Autobiography*, Jonathan Cape, London, 1952 (pp. 49, 58, 60), and Reilly, C.H., *op. cit.* (p. 85).

23. Reilly, C.H., *op. cit.* (p. 85).

24. John, Augustus, *Finishing Touches*, Jonathan Cape, London, 1964 (pp. 60–61).

25. Budden, Lionel, *op. cit.* (p. 34).

26. Bisson, R.F., *The Sandon Studios Society*, Parry Books, Liverpool, 1965 (p. 10).

27. Education Act, 1902 (2.1 and 2.2).

28. *Brass wall records* in the Liverpool Institute and the Liverpool College of Art and Design, Hope St affixed 21 May, 1905, and 'Liverpool City School of Art,' *Journal of the National Society of Art Masters*, June, 1937, also Budden, Lionel, *op. cit.* (p. 34).

29. *City of Liverpool, Proceedings, December, 1903–Oct 1904*, Proceedings of Education Committee, 22 June, 1904 (p. 164) and 'Scheme for the Establishment of the Liverpool City School of Art,' Liverpool, 1904.

30. Reilly, C.H., *op. cit.* (p. 130), and *The Studio*, February–May, 1905 (Vol. 34, p. 351) and October, 1905–January, 1906 (Vol. 36, p. 166).

31. *The Studio*, June–September, 1903 (Vol. 29, p. 257).

32. *Ibid.*, October, 1903–January, 1904 (Vol. 30, p. 50), and February–May 1905 (Vol. 34, p. 349).

33. *Ibid.* June-September, 1903 (Vol. 29, p. 257).

34. Holme, Charles (editor), *Arts and Crafts*, The Studio Ltd, London, Paris, New York, 1916 (pp. 107–109), and *City of Liverpool, Proceedings*, Decmber, 1911–October, 1912 (p. 100).

Catterson-Smith in Birmingham

*Until the accidents of time and life have once more united such
a team as was found in Morris and Burne-Jones, with Catterson-
Smith and Hooper to aid them, we are unlikely to be lucky enough
to fall in again for so rich a heritage of enduring beauty.*
H. Halliday Sparling on the Kelmscott Press [1]

From Hammersmith to Birmingham

During the production of the Kelmscott Chaucer in 1895 an artist in Morris's
workshop was rather surprised to find that Sir Edward Burne-Jones had
repeatedly changed his pencilled designs for its pages. 'You don't do everything
right off at once then?' asked the artist. 'No,' replied Burne-Jones, turning to
T.M. Rooke, 'We'll leave that to geniuses, we're only plodding coves, we're
hard-working chaps, aren't we?'[2]

The curious artist was Robert Catterson-Smith, a keen member of the
Hammersmith Socialist Society, who had been elected to the A-W.G. in
the previous year (4/5/1894).

Catterson-Smith had the task at the Kelmscott Press, Hammersmith, of
translating Burne-Jones' drawings into ink for the wood blocks being engraved
by William Harcourt Hooper (elected to the A-W.G. 13/5/1884).[3] Halliday
Sparling, May Morris's estranged husband wrote: 'The original designs by
Burne-Jones were nearly all in pencil and were re-drawn in ink by R.
Catterson-Smith, and in a few cases by C. Fairfax Murray.'[4]

Catterson-Smith's work at Hammersmith was not exclusively copying:
the colophon of the final volume of *The Earthly Paradise* (published
after Morris's death) informs us that the borders 'on page 4 of volumes
II, III, and IV, afterwards repeated, were designed to match the opposite
borders under William Morris's direction, by Catterson-Smith, who also
finished the initial words 'Whilom' and 'Empty' for *The Water of the
Wondrous Isles*.[5] J. W. Mackail wrote of this work:

> In these posthumous volumes, however, there are three borders
> which had been designed in Morris's manner by Mr. Catterson-
> Smith; these being the only instances of any letter, border, or
> ornament (with the exception of a little Greek type which occurs

in two books) printed at the Kelmscott Press and not actually designed by Morris himself and drawn with his own hand.[6]

Catterson-Smith also executed original illustrations for *The Girl's Own Paper* between 1890 and 1900.[7]

The question which the artist asked Burne-Jones is revealing. There were eighty-seven blocks to be cut for the Chaucer, each of which took Hooper a week, and some of the pages took two weeks to design. Catterson-Smith may have been wondering now normal designers could produce feasible economic works on such lines. Burne-Jones and Morris, with other means of support and a wealthy clientele, were enabled with the aid of a team of artist/craftsmen to work in that way, but an independent designer could not have done so: he would have needed to acquire rapid and direct skills to survive. Catterson-Smith's remark to Burne-Jones is evidence that he had already concluded, in the 1890s, that a designer must learn to draw rapidly, and whenever possible from memory. It was for his work in the field of 'time sketches' and memory drawing that he was eventually to achieve a national reputation during his reign at the Birmingham School of Art.

Catterson-Smith succeeded Frank Steeley as headmaster of the School for Jewellers and Silversmiths, Vittoria Street, Birmingham in September, 1901, his appointment being 'exceptionally recognized' by the Board of Education on 4 November.[8] He had worked with Morris until the great man died, having visited him during the last convalescence at Folkstone and on his deathbed at Hammersmith.[9] The Kelmscott Press had died with Morris, and, previous to his Birmingham appointment, Catterson-Smith had served for five years under Lethaby at the Central School as lecturer in metalwork, wallpaper, and textiles in the Drawing, Colouring, and Design section.[10] Simultaneously he was working in metal, executing illustrations, assisting Ashbee at Essex House with the blocks for the Guild of Handicraft's *Book of Common Prayer*, and serving as an art inspector for the L.C.C. Technical Education Board.[11] The last mentioned employment had given him ample opportunity to study the laborious and unimaginative methods of drawing regulated in the Elementary Schools by the Department of Science and Art.

At the School for Jewellers and Silversmiths

The School for Jewellers and Silversmiths, or 'the Vittoria St School of Art,' as it was sometimes called, was not the main institution for art education in Birmingham: that position was held by the Central School for Art, Margaret St. The Jewellers and Silversmiths School had originated in 1887, when the Birmingham Jewellers' Association had

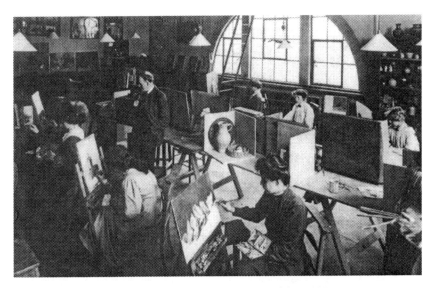

Painting Still Life at Hammersmith, c.1900

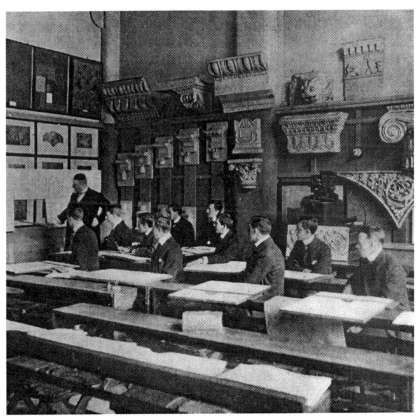

*Hugh Stannus of the Royal College of Art lectures on
Architectural Ornament at Manchester, c.1905*

been founded and had first decided to fit out a room in an existing Elementary School in Ellen St. The Association had then gone ahead and erected a new building for the School which was opened in 1890.[12] This was an historic event in art and design education, as the School was the first institution specifically built in Britain for the artistic training of workers in industrial crafts. The L.C.C. Central School of Arts and Crafts was not instituted until six years later, and was not housed in a building erected for its purposes until September, 1908.[13]

The Vittoria St School was at first governed by the Committee of the Birmingham School of Art, and financed by the Corporation, the Department of Science and Art, and the Jewellers' Association. Technical courses in jewellery and silversmithing for City and Guilds' examinations were run concurrently with the regular art courses for the examinations of the Department of Science and Art. Not surprisingly the two sets of courses had little relevance for one another. The City and Guilds' examinations demanded 'technical knowledge, including alloys of metals, with assay tests etc. and required written papers and accumulation of book knowledge,' while the South Kensington examinations were of little use to the designer, thus in 1901 the Jewellers' Association held a conference with the committee of the School. *The Studio* reported:

> The Jewellers' Committee acknowledged that, in attempting to follow the example of the more strictly technical schools, so successful in Germany, they had made a mistake, and that all the necessary technical training required by the pupils could be better taught in the employers' workshops. As a result of this conference, the Vittoria Street School was created an independent art school under the control of a subcommittee formed from the two governing bodies, the Jewellers' Association and the School of Art. The selection of Mr R. Catterson-Smith a sculptor, painter, and a draughtsman whose association with Sir E. Burne-Jones and William Morris in the production of the Kelmscott Chaucer was sufficient guarantee of his suitability from the point of view of art, and who for some years past had devoted himself to the production of metal work, marked the inauguration of a new school in more senses than one.[14]

Revolutionary changes were quickly made by the new headmaster in the practices of drawing, designing, and metalwork. Drawing the antique in outline was abandoned, and drawing flowers and stuffed and living animals substituted. Memory drawing was also introduced to encourage careful observation.

In December, 1902, Harry Wilson, an architect and metalworker who

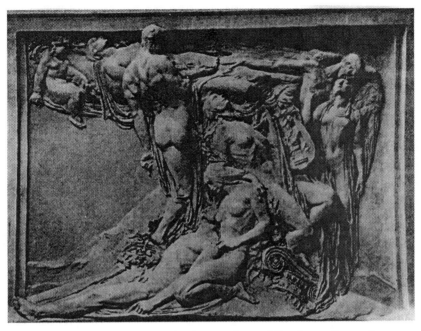

Panel modelled by C. Wheeler, student of Professor Lanteri at
the Royal College of Art

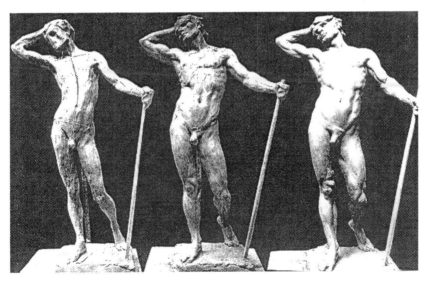

Clay models by Lanteri to demonstrate his system.

had served on the Committee of the A-W.G. (Master 1917), conducted the annual examination of work at Vittoria St and reported:

> The students are evidently very keen on their work and by the scheme of nature study so happily introduced by Mr. Catterson-Smith, they are being taught to see for themselves. This has produced results which, had I not seen them, I should have believed impossible of attainment in so short a time.[15]

The practice of making ambitious designs for metalwork first, and then trying to carry them out in metal, was abandoned. The students were taught to use the tools first. *The Studio* reported,

> Here (in Birmingham), when the student is thoroughly conversant with the use of his tools, and not until then, he is given a flat piece of metal, and set to wield it into some form and design that shall come from himself and grow as he works.[16]

Catterson-Smith was given credit for this important step forward in craft education in the Schools of Art, yet it must surely have been initiated during the autumn term of 1900 in the session previous to his appointment, since Lethaby, making the General Report on the School in January, 1901, stated: 'I was particularly interested in the new experiment of setting young lads to work directly on metal, developing their practical experience and faculty for designing legitimate metal-work forms at once.'[17] It is highly probable that Catterson-Smith suggested the scheme to the Jewellers' Committee and the staff of the School when he was first offered the appointment on Lethaby's recommendation.

Not all was perfect during Catterson-Smith's first year at Vittoria Street. The standard of modelling was poor and received a bad report. It is an interesting reflection on the times, and on the character of Catterson-Smith, that he had both the Modelling and Modelled Design Teacher and his assistant dismissed at the end of this session. Like Morris and Ashbee, and other art-socialists of the A-W.G., his brotherhood did not extend to idlers: work was sacred.

Catterson-Smith's reign at Vittoria St was only of two years duration. In February, 1903, the Museum and School of Art Committee, which governed the Municipal School of Art, announced in the Times and the Athenaeum: 'The appointment of Headmaster will become vacant in September, 1903, on the retirement of Mr Edward R. Taylor.' On publication of this, the staff of the Municipal School of Art took the extraordinary step of organizing a memorial, which was signed by 53 teachers and 448 students and published in the *Birmingham Post*, and which petitioned the School of Art Sub-Committee to retain Mr Taylor for a few years longer. This

circumstance was strange, because although Taylor had been a highly successful headmaster for the past 26 years, from the time of his appointment in 1877,[18] especially with regard to the South Kensington awards, it was known that he had reached the age of retirement demanded under the Council superannuation scheme. For this reason the Sub-Committee refused the request, and Catterson-Smith 'was unanimously elected to succeed' as headmaster of the Municipal School of Art. It is probable that the staff who organized the memorial were motivated by fear of the new broom who had revolutionary ideas about the teaching of drawing, and had displayed short shrift for inefficient staff. Only a minority of the students signed the memorial.[19]

The Vittoria St headship was given to Arthur J. Gaskin, who like his predecessor had worked for the Kelmscott Press. If one studies the corners of each illustration of *The Shepheardes Calender*, the last book completed by the Press before Morris's death (finished 14 October, 1896), one can read the initials 'A.J.G'.

It is not difficult to understand why the Birmingham art schools and appointments therein were closely associated with the Art-Workers' Guild. Sir Edward Burne-Jones (1833–1898), had been born in the City, and educated at King Edward's school, although from 1848–1850 he had spared three evenings per week per session in the Birmingham School of Design from which his teacher had reported: 'Drawing. Might do better if he exhibited more industry – Thomas Clark. Master.' But young Burne-Jones retained his affection for the School, and rising to national fame, and presidency of the Birmingham Society of Arts in 1885, volunteered to advise the advanced students of the School.[20]

Morris had also shown particular interest in the School, giving his last address there at the prize-giving of 21 February, 1894, on the occasion of the opening of the extended Municipal School of Art, Margaret St.[21] His daughter, May Morris, was invited as Examiner in Needlework for local prizes from 1900, and was given charge of the direction of the needlework classes. Following the deaths of Morris and Burne-Jones, in 1896 and 1898 respectively, it was Lethaby to whom the School looked for guidance. A brother guildsman, Douglas B. Cockerell, the famous bookbinder, was appointed director of the book production classes.

Gaskin and the Birmingham School of Book Decorators

Arthur J. Gaskin, the new headmaster of Vittoria St, was one of the former students of the Birmingham School of Art employed by Morris for work at his Kelmscott Press. Another, already mentioned, was Catterson-Smith. Morris preferred to employ them because they had been taught by the headmaster of the School, Edward Taylor, to copy in clear outline 'from

the Flat', or 'from the Round' for examination at South Kensington, where Taylor's students had been awarded a record number of national medals. The continuous fine line was ideal for bordering Morris's ornament, engraving on metal, and some styles of book illustration. Besides Arthur Gaskin, the leaders of the Birmingham School could be said to have been Charles M. Gere and Edmund H. New. Mrs. Gaskin should also be remembered for what Crane called 'her pretty quaint fancies in childlife'.

This Birmingham group, influenced by Rossetti and Burne-Jones, 'were animated by a love of the mediaeval school of N. Italy,' as Catterson-Smith put it, 'their works being decorative illustrations in precise thin line which remind one of Gothic art.'[22] Morris had said of these Birmingham artists in 1893: 'The only thing that is strictly new is the rise of the Birmingham school of book decorators. These young men – Mr Gaskin, Mr New, and Mr Gere – have given a new start to the art of book-decorating.'[23]

Morris chose Gere to draw the view of Kelmscott Manor, which appears, framed by a Morris border, as the frontispiece of his *News from Nowhere* (1891).[24]

The best known works by a member of the group were Gaskin's illustrations for *A Book of Fairy Tales* (1894), which ran to three editions.[25] A rare book illustrated by Gaskin, Neale's *Good King Wenceslas* (1895), contains an introductory note by Morris himself, of which a passage reads:

> I must not say much of the merits of the pictures done by my friend Mr Gaskin, but I cannot help saying that they have given me very much pleasure, both as achievements in themselves and as giving hopes of a turn towards the ornamental side of illustration, which is most desirable.[26]

At Vittoria St, Gaskin, 'whose sympathies' *The Studio* reported, 'coincided completely with those of the late headmaster,' continued to develop the School on the lines initiated by Catterson-Smith.[27]

The majority of the new annual intake at the School for Jewellers and Silversmiths were leavers from the Elementary Schools, who had been nominated by their headteachers as having an aptitude for drawing and an intention of entering the jewellery or metal trades. These boys, usually of 14 years of age, received Free Admission, and after attending evening classes for two terms, could qualify for an Exhibition of £4 per annum, dependent upon the result of an object and memory drawing examination, and upon their employers releasing them for two afternoons per week.

From 1906 the number of day students increased, in which year Gaskin secured the recognition of the Board of Education for Manual Training Classes at the School.[28] The boys at the Elementary Schools who were most

EDMUND H. NEW HENRY PAYNE

INIGO THOMAS ARTHUR GASKIN

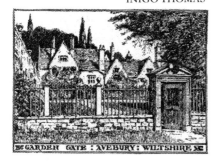

Work of the Birmingham School of Book Decorators

talented at drawing were chosen to spend their manual training periods at Vittoria St, instead of the ordinary Metalwork and Woodwork Centres in the City. A two year course was provided for the boys, who were mostly aged from 12–14 years. Day classes were also built up providing Scholarships, tenable for three years, for the best pupils of the Manual Training Classes to continue their studies for five afternoons and three evenings per week after leaving Elementary School. The final academic achievement was to pass the Goldsmith's and Silversmith's examinations of the City and Guilds of London Institute, taken annually at the School, but much advanced work was submitted for awards in the National Competition until its demise in 1915.

It said much for the excellence of the School, and for the powers of persuasion of Catterson-Smith and Gaskin that the manufacturers and tradesmen of that time were willing to employ youths who spent so much time at Vittoria St. It was also remarkable that the Birmingham Education Committee permitted the boys from the Elementary Schools to attend for two sessions a week instead of one, as was the rule at other Manual Training Centres.[29] The Vittoria St School quickly established a national reputation for silversmithing, goldsmithing, enamelling, and toolmaking. Catterson-Smith was able to say in 1911 that the School was 'honoured all over the country and beyond it.'[30] The procedure followed in the School under Gaskin was exactly that established by Catterson-Smith, namely, learning to use the material first before any working drawings were attempted, and adherence to his system of nature and memory drawing.

At the Municipal School of Art

In September, 1903, when Catterson-Smith took up his duties as headmaster of the Central Municipal School of Art in Margaret St, art education in Birmingham was more widespread and highly organized than in any other provincial city in England. All provision for public art education in the City was arranged by the Museum and School of Art Committee of the City Council, which had assumed control in 1885 after the Corporation had erected the Central School of Art in Margaret St 'upon land given for that purpose by Gregoe Colmore Esqre with funds contributed by Miss Louisa Richard and George Tangye.'[31] The early history of the School from its origin as the Birmingham School of Design in 1843 has been described by the author elsewhere.[32]

The first four Branch Schools of Art in Birmingham had been established at Hope St, Moseley Rd, Osler St, and Smith St in 1876, and a fifth at Jenkins St in 1879. By 1902, the year previous to Catterson-Smith's appointment, the Branch Schools of Birmingham Municipal School of Art, most of which were situated in Board Schools, numbered fourteen; but during that year, in the interests of efficiency and economy,

three pairs of Schools were merged and one closed, bringing the total down to ten. These, together with the Central and Vittoria St School, had over four thousand pupils on the roll.[33]

Public art education in Birmingham was not only a matter of quantity, but also of quality. As far as its official reputation was concerned, the Birmingham School of Art had won more awards in the 'South Kensington Stakes' from 1890–1903, during the headship of Edward R. Taylor, than any other provincial School. To be more specific, the quantity of awards which the School won in each National Competition, held annually at South Kensington, was greater during those years than that won by any other in the United Kingdom.[34]

Lethaby was invited to examine the advanced work of the School for the 1899–1900 session for the purpose of selecting local prize and scholarship winners, and of making the annual General Report for that session. He reported:

> The volume of work produced is enormous and its variety and quality most remarkable. Indeed the School stands so high as compared with other Art Schools known to me that, if my report were to be merely comparative, I could say nothing more than that Birmingham stood first, or amongst the very first in the kingdom. . . .[35]

Art education in Birmingham further improved during Catterson-Smith's period of office, that is from September, 1903, to June, 1920, due to his insistence upon drawing and modelling from live animals and plants, drawing and modelling from memory, and designing directly in craft materials. The fact that he held the dual posts of Headmaster and Director of Art Education enabled him to disseminate his methods at every level, in his own words:

> The boys came from the Birmingham Elementary Schools at about 14 years of age. . . . While at the Elementary Schools they were taught chiefly from plants and common objects, along with some memory drawing. When they entered the School of Art they became free admissioners, but if they progressed satisfactorily in the first year they became scholarship holders for the following three years and even for more in some special cases. They worked for about fifty-six weeks in the year, five days in the week, commencing at 9 a.m. and working until 5 p.m. with a break of two hours.
> The subjects they took were as follows, approximately:
> Drawing plant form from memory
> Drawing from lantern slides from memory

Drawing from live animals from memory
Measured drawings, coloured.
Drawing, from memory, objects seen in the Art Museum
Modelling, space filling in bas relief
Modelling animals from life, memory
Drawn lettering
Geometry
Metalwork: raising, repoussé, and elementary jewellery.

In their fourth year some students took historic ornament and drawing metal objects from memory in colour, with the aim of gaining skill in an expressive way of making 'slow drawings' for commercial purposes, i.e. abstract rather than still life.[36]

Catterson-Smith's methods proved very successful. In May 1905 *The Studio* reported that the general trend of art training in Birmingham 'bids fair to make Birmingham the Mecca of art teachers and students from all parts of the kingdom.'[37] As the years passed the reputation of the Director of Art Education increased. Two years before his resignation, a report on the Birmingham School by Henry Wilson declared 'the method of teaching evolved and elaborated by Mr Catterson-Smith, the Principal of the Birmingham School of Art is the system for which designers, workers, and educationists have long been seeking.' William (later Sir W.) Rothenstein reported in the same year of Catterson-Smith: 'The results of his methods are certainly encouraging and the standard of design and execution the highest I have met with in any School of Art.' Rothenstein singled out for special praise the memory drawing and drawing from nature of animals, plant life, and objects of art; animal sculpture and memory studies in clay, formal designs in plaster of floral, tree, and animal subjects; book illustration and cartoons for decorating, and needlework.

Working from animals was taken very seriously. 'In the School of Art,' Catterson-Smith wrote, 'a large room is devoted to animals in cages.'[38]

Memory Drawing and Mind Picturing

'This "shut-eye' drawing was perhaps Mr Catterson-Smith's greatest contribution to art education,' wrote Marion Richardson. 'It was a wonderful means of clarifying and impressing the image and of keeping it before us while we set to work with open eyes.'[39]

Certainly it was due to Catterson-Smith's example and teaching that memory drawing and memory compositions were practised and examined with such zeal at every level of art education between the two World Wars. The Board of Education had no doubt who was responsible, for

Memory drawing following a Life pose at Birmingham, c.1908

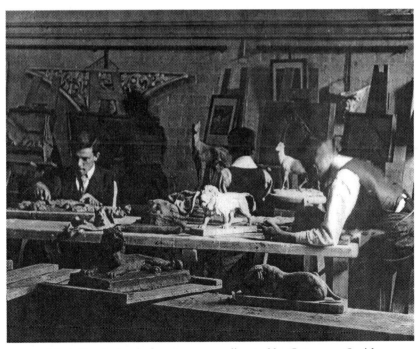

*Modelling animals from memory directed by Catterson-Smith
at Birmingham, c.1905*

in its 'Suggestions for the Consideration of Teachers' of 1927 it was argued:

> The conviction is rapidly gaining ground that the training of the visual memory is of the highest importance in Art, and the widespread adoption of this view undoubtedly owes much to . . . *The Training of the Memory in Art* by de Boisbaudran, followed by R. Catterson-Smith's *Drawing from Memory and Mind Picturing.*

Memory work had first been introduced into public art education by the Department of Science and Art in 1853, under the direction of Henry Cole and Richard Redgrave, as part of their programme for developing accurate minds, for drawing to them was 'the power of expressing things accurately.'[40] The National Course of Instruction for Government Schools of Art included 'sketching from memory' as a section of 'Stage 5: Shading from the round: solids or casts,' and of 'Stage 8. Human or animal figures from the round, or from nature.' Time sketches from memory were also included in 'Stage 18. Modelling Ornament.' At the lowest level, in the First Grade examinations one of the four papers set for the children by the Department was 'Memory: Outline from memory of a common object.' Naturally, to ensure the teaching of the subject 'Objects from Memory' formed part of the Department's courses and examinations for students in Training Schools. Papers on drawing from memory had also been set by the Oxford Delegacy and the Cambridge Syndicate for Local Examinations from 1858. What then was so startling about Catterson-Smith's theories and methods?

To put it simply, the examinations of the Department, adopted later by the Board of Education, and those of Oxford and Cambridge Universities, merely required candidates to have learned off 'by heart' certain views or designs of approved objects by repeatedly copying them previous to the memory drawing or design examination. Catterson-Smith's methods were based on immediate memory of objects and were not intended to be exact copies, but rather strong 'mental images' or 'mind pictures.' His methods were not intended to be a small part of art education, as previous memory drawing had been in Britain: they were intended as a comprehensive alternative to copying and direct drawing from objects. He wrote:

> At the Birmingham School of Art, I had an opportunity of training boys in memory drawing and in mental imagery for a period long enough to convince me that that training far excels the older method in developing observation, skill of hand and imitation.[41]

For drawing from memory at Birmingham a student would first carefully examine a plant, animal, lantern slide, or museum artefact. He would then remove it from sight, or, in the case of the museum, withdraw, and then draw from memory until he needed to look again. Sometimes only one look would be allowed. This part of his system was similar to the practice of Lecoq de Boisbaudran which has been described elsewhere by the author.[42]

Catterson-Smith's particular contribution was 'shut-eye' drawing or 'mind picturing.' For this method the student was required 'to shut his eyes and image in his mind's eye the object or design he is about to draw' and then to draw, still with his eyes shut, 'an outline in pencil on paper of the image he sees.' He would then 'make a completely finished drawing with his eyes open of the object or design he imaged.' The student was not allowed to refer to the 'shut-eye' drawing when executing this final drawing, because Catterson-Smith believed that once he had imaged with his eyes shut he would continue to visualize the same image with his eyes open. George Clausen R.A. admitted at a conference on Memory Drawing, convened by the L.C.C. in January, 1914, 'If I want to try and remember the action of a figure or an animal . . . I make my drawings with the 'shut-eye' just as Mr Catterson-Smith's boys.'[43]

'Shut-eye' methods were also used for designing. For one method a simple symbol was drawn on the blackboard and the students were then asked to shut their eyes and combine several of the same symbol into a pattern. They were then asked to open their eyes and draw out the pattern they had imaged with their eyes open.

Another variation of the 'shut eye' system was 'Dictated Model Drawing'. For this the teacher described 'some structural combination such as a cube at a given angle . . . having on each of its facets a square pyramid.' The students kept their eyes shut during this description, and while they were drawing the structure. They then drew the structure with their eyes open.

Yet another method used, one to stimulate 'mind picturing,' was for the students to look at a space filled with scribble until some idea revealed itself, a method rather similar to Leonardo's practice of studying the texture and stains of walls.

As was argued at the beginning of the Chapter, Catterson-Smith's convictions on the importance to the designer of rapid drawing from memory were probably formed during his associations with members of the A-W.G. at the Kelmscott Press. In his *Drawing from Memory and Mind Picturing* he wrote that his purpose was to train a student 'to draw objects out of his head,' a skill he could use 'when he needs it for design.' At Hammersmith he must also have been deeply impressed

with the way border designs flowed from Morris's prolific brain. 'Always think your design out in your head before you begin to put it on paper,' Morris had advised in his lecture 'Art and the Beauty of the Earth,' continuing 'Don't begin by slobbering and messing about in the hope that something may come out of it. You must *see* it before you can draw it.'[44] Talking of designing human figures, Morris had advised the Birmingham students 'What you should aim at is to get so familiar with all this that you can at last make your design with ease, and something like certainty, without drawing from models in the first draught, though you should make studies from nature afterwards.'[45] Walter Crane was of the same opinion and recommended 'that selective kind of memory which, by constant and close observation, extracts and stores up the essential serviceable kind of facts for the designer. . . .'[46]

F. Morley Fletcher, another member of the A-W.G., when referring to the work of Catterson-Smith, wrote: 'His results and his ingenious methods provide a new resource in art teaching and increase our knowledge of latent powers that may be trained to great uses in the future.' The results were certainly remarkable as can be judged from the examples illustrated in Catterson-Smith's book, and from the brush drawings of animals from memory reproduced in *Arts and Crafts*, published by *The Studio* in 1916.[47] However, although drawing from memory became very widespread at every level of art course and art examination during the 1920s and 1930s, the practice was generally abandoned in the 1940s as a result of the influence of Cizek, Marion Richardson, and the 'New Art Teaching,' together with the belief, derived from modern art movements, that training in realistic representation was unimportant.

A most concise and typical definition of the purposes of memory drawing, stated when the method was at the height of its popularity, was given by Peter Smyth of Alloa Academy as follows: 'First it develops visual imagery; second, it increases the ability to recall images readily and clearly; third, it provides a means of correcting and developing these images.'[48] The last point was a favourite one of Catterson-Smith, that is, that the pupil constantly corrects himself by going back to the object. He is teaching himself, not being told.

The author has described Marion Richardson's self-acknowledged debt to Catterson-Smith elsewhere.[49] It was a paradox that her stress on imaginative work helped to rid the schools of his methods of memory drawing. Her version of 'mind picturing' became far more important. Cizek's Froebelian concept that art is innate, and that it can spring from the child's mind, also eroded the popularity of memory drawing from nature. 'Get away from Nature. We want Art, we don't want Nature. . . . Here they draw things out of their heads, everything they feel, everything

they imagine, everything they long for. . . .' He asserted 'everything memorized is worthless.'[50]

Catterson-Smith believed on the other hand that nothing could come 'out of their heads' unless it had previously been taken in. R. Radcliffe Carter, one of his contemporaries, got down to basics when he wrote, 'Strictly speaking all drawing is Memory Drawing.' He added, referring to direct object drawing, 'It is true that the Object remains there for the immediate correction of any defects of memory, but this does not affect the truth of the proposition.'[51] One could add that not only is the object drawn from immediate memory, but also that the representation is greatly modified by past memories. Catterson-Smith believed that by increasing the time-lapse between observation and drawing, or modelling, the pupil was forced 'to secure concentration' on essentials of structure and movement, and to remember them, similarly with the 'shut-eye' system. The recognized superiority of the work of his pupils was his justification.[52]

Lecoq de Boisbaudran and Catterson-Smith

The gifted art teacher, Marion Richardson, who grasped the importance of drawing from memory, argued that 'shut-eye' drawing was Catterson-Smith's greatest contribution to art education. His book, *Drawing from Memory and Mind Picturing*, published by Isaac Pitman in London in 1921, gives a clear account of the methods of drawing he was teaching at Birmingham from 1903, but it was the ateliers of Paris that had taken the lead in memory work many years earlier due to the teaching of Horace Lecoq de Boisbaudran (1802–1897). Like several great art teachers, Lecoq was not a great artist, but among his pupils were Rodin, Tissot, Fantin-Latour, and Legros. Lecoq had three pamphlets printed on his methods from 1847 to 1879, but it was not until 1911 that Lecoq's book *The Training of the Memory in Art* was published in English.

See also Lecoq and Memory Training in Macdonald's *History and Philosophy of Art Education* (p. 272-3).

Sources

1. Sparling, H. Halliday, *The Kelmscott Press and William Morris, Master Craftsman*, Macmillan & Co, London, 1924 (p. 92).
2. Burne-Jones, Lady Georgiana, *Memorials of Edward Burne-Jones*, Macmillan, London, 1904 (p. 260).
3. Crane, Walter, *An Artist's Reminiscences*, Methuen & Co., London (September, 1907), 2nd Ed. October, 1907 (p. 262); and *Chaucer, Geoffrey, The Works of*, A Facsimile of William Morris's Kelmscott Chaucer, Introduction by J.T. Winterich. World Publishing Co., Cleveland and New York, 1958 (p. X).
4. Sparling, H. Halliday, *op. cit.* (p. 144).

5. Morris, W., *The Earthly Paradise*, Kelmscott Press, 1897 (Vol. VIII, Colophon).

6. Mackail, J.W., *The Life of William Morris* (1899), Oxford University Press, World Classics Edition, 1950 (Part 2 pp. 348–9).

7. Thorpe, James, *English Illustration: The Nineties*, Faber and Faber, London, 1935 (p. 146).

8. Vittoria Street School for Jewellers and Silversmiths, *Report of the Joint Consultative Sub-Committee* 26/11/1901, quoting Board of Education letter of 4 November, 1901.

9. Mackail, J. W., *The Life of William Morris* (1899), Oxford University Press, World Classics Edition, 1950 (Part 2 p. 346), and Henderson, Philip, *William Morris, His Life, Work and Friends*, Thames and Hudson, London and New York, 1967 (p. 362).

10. London County Council Technical Education Board: *Prospectuses and Time Tables of the Central School of Arts and Crafts* 1896-1901.

11. Birmingham, City of: *Report of the Museum and School of Art Committee* for meeting of 6 May, 1902 (p. 16), and Birmingham Public Libraries, *Catalogue Supplement 1918–1931*, para. 206887, list of works by Catterson-Smith, R.

12. Birmingham, City of: *Report of the Museum and School of Art Committee* for 1898 (p. 43), and *The Studio*, February–May, 1905 (Vol. 34 p. 324).

13. *Central School of Art and Design, Prospectus*, London 1967 (p. 7), and *The Studio*, February–May, 1908 (Vol. 43 p. 339).

14. *The Studio*, February–May, 1905 (Vol. 34 p. 325).

15. *Vittoria Street School . . . General Report of the Examiner* (Henry Wilson Esq) 29 December, 1902, affixed to Birmingham Municipal School of Art, Minutes of the Management Sub-Committee 1901–1903 (Vol. 7 p. 249).

16. *The Studio*, February–May, 1903 (Vol. 28, pp. 208–9).

17. Birmingham Municipal School of Art: *General Report on Students' Work* (by W. R. Lethaby), January 1901, affixed to Report of the Museum and School of Art Committee for presentation to the Council in May 1901 (p. 40).

18. Catterson-Smith, R., Birmingham Municipal School of Art, *Birmingham Institutions, Lectures given at the University*, Muirhead, J. H. (editor), Cornish Bros, Birmingham, 1911 (p. 290).

19. Birmingham Municipal School of Art, *Minutes of the Management Sub-Committee*, 1901–1903 (Vol. 7 pp. 278 and 287. Text of approved announcement affixed to p. 278), and *The Studio*, Feb–May, 1905 (Vol. 34, p. 325).

20. Burne-Jones, Georgiana, *Memorials of Edward Burne-Jones*, Macmillan, London, 1904 (Vol. 1, pp. 26–28, Vol. 2, p. 156).

21. Morris, William, *An Address delivered by William Morris at the Distribution of Prizes to Students of the Birmingham Municipal School of Art* on February 21st, 1894, Longmans & Co, London, 18/4/1898.

22. Catterson-Smith, R., Birmingham Municipal School of Art, *Birmingham Institutions. Lectures given at the University*, Muirhead, J.H. (editor), Cornish Bros, Birmingham, 1911 (p. 294), and Sketchley, R.E.D., *English Book Illustration of Today*, Kegan Paul, Trench, Trubner & Co, London, 1903 (p. 10).

23. *The Studio*, October, 1893–March, 1894 (Vol 2., p. 97).

24. Vallance, Aymer, *The Art of William Morris*, Chiswick Press, George Bell, London, 1897, limited ed. 220 copies, (p. 160).

25. Gould, S. Baring, *A Book of Fairy Tales*, Methuen & Co, London (1894), 3rd ed., 1912.

26. Neale, Dr. J. M., *Good King Wenceslas*, pictured by Arthur J. Gaskin with an introduction by W. Morris, limited ed. 125 copies, Cornish Bros, Birmingham, 1895 (Introductory note).

27. *The Studio*, February–May, 1905 (Vol. 34, p. 326).

28. *Birmingham, City of. Report of the Museum and School of Art Committee* for 1906.

29. *Vittoria Street School for Jewellers and Silversmiths. Programmes* for 1912–1917

30. Catterson-Smith, R. Birmingham Municipal School of Art, *Birmingham Institutions*, Lectures (p. 294)

31. *Inscribed tablet* over main entrance steps of Birmingham College of Art and Design, Margaret Street.

32. Macdonald, Stuart, *The History and Philosophy of Art Education* (1970), Lutterworth Press, 2003 (pp. 105–7, 183, 217).

33. Birmingham, City of: *Reports of the Museum and School of Art Committee for 1898–1903, and Birmingham Municipal School of Art, Minutes of the Management Sub-Committee*, 1901–1903 (Vol. 7, p. 178).

34. *Reports of the Museum and School of Art Committee*, 1898–1905.

35. *Ibid.*, for 1900 (pp. 21–22).

36. Catterson-Smith, R., *Drawing from Memory and Mind Picturing*, Sir Isaac Pitman and Sons, London, Bath etc., 1921 (pp. 24–25).

37. *The Studio*, February–May, 1905 (Vol. 34, pp. 330).

33. Catterson-Smith, R., *op. cit.* (pp. 33, 44, 46–48).

39. Richardson, Marion, *Art and the Child*, University of London Press, 1948 (p. 12).

40. *1st Report of the Department of Practical Art*, 1853 (p. 58).

41. Catterson-Smith, R., *op. cit.* (p. 24).

42. Macdonald, Stuart, *op. cit.* (pp. 272–3).

43. Catterson-Smith, R., *op. cit.* (p. 29).

44. Morris, William, *Art and the Beauty of the Earth*, A lecture delivered by William Morris at Burslem Town Hall on October, 13th 1881. Longmans, London, 1898.

45. Morris, W., *An Address at . . . Birmingham Municipal School of Art* on Feb 21st, 1894, Longmans & Co, London, 1898 (p. 23).

46. Crane, Walter. *Line and Form*, George Bell & Sons, London, 1900 (pp. 37–39).

47. Holme, Charles (ed.), *Arts and Crafts – A review of the work executed by Students in the leading Art Schools of Great Britain and Ireland*, The Studio Ltd, London, Paris, New York, 1916, pp. 136–137.

48. Smyth, Peter S., *Art in the Primary School*, Sir Isaac Pitman and Sons, Ltd., London, 1932 (p. 5).

49. Macdonald, Stuart, *op. cit.* (pp. 273 and 349).

50. Wilson, Francesca Mary, *The Child as Artist: Some conversation with Professor Cizek*, Pamphlet, Vienna, 1921 (pp. 4–6).

51. Carter, R. Radcliffe, organizer of Elementary Art Instruction in Walsall. *How to Teach Drawing Without Copies*, E. J. Arnold, Leeds and Glasgow, (not dated) circa 1910 (p. 27).

52. Catterson-Smith, R., *op. cit.* (p. 26).

Burridge's Fight for a Central and National School of Arts, Crafts and Design

Burridge v. the London Principals

In September, 1912, Fred Burridge, late head at Liverpool, was appointed the Principal of the L.C.C. Central School of Arts and Crafts, following the resignation of Lethaby. At the time the Central School was in a really strange position as far as its official status within the metropolis and within the national system was concerned, for, although the Central School was generally recognized as the most advanced institution in the United Kingdom for industrial design education, with the possible exception of the Glasgow School of Art, it held no official seniority to any local School of Art; in fact the Central was in competition with them, especially with those in London which concentrated on craftwork, notably the Battersea Polytechnic, the Camberwell School of Arts and Crafts, the Hammersmith School of Arts and Crafts, the Polytechnic School of Art (Regent St), the Shoreditch Technical Institute, the Goldsmith's College School of Art, and the Sir John Cass Institute.

As far as Board of Education studentships and maintenance grants were concerned, the Central School was only equal to local Schools of Art, the highest obtainable award being the Local Scholarship. All the senior awards, that is the most valuable and those which students were granted after leaving a local School of Art, namely Royal Exhibitions, National Scholarships, and Studentships in Training, were provided only for study at the Royal College of Art, at that time a very inferior institution to the Central with regard to industrial design and craft training, which after all was the proclaimed purpose of public expenditure on art education.

Lethaby, who wished Schools of Arts and Crafts to be workshops and 'local centres of civilization rather than for raising so many individual prize getters,'[1] had not worried abut the official status of the Central, nor about the Board's scholarships, prizes, and certificates, but his immediate successor had different ideas.

Burridge was a product of the Department of Science and Art's national system of art education, having studied at the National Art Training School, S. Kensington, from 1892 to 1895, and served there as a temporary assistant teacher from 1895 to 1896 in the last years of the

old regime.[2] He was a dedicated professional teacher and an expert at using the national system to advance the institution he directed, as had already been shown at Liverpool. It was to be a constant source of irritation to such a man that the most successful students did not progress to the Central after their studies at local Schools of Art in the same way as they progressed to the recognized senior institutions, namely the Royal College, the Slade, and the R.A. Schools.

The advantages of having in London one advanced central institution for industrial design, staffed by leading designers and craftsmen had become increasingly obvious during Lethaby's time at the Central School. The distinguished members of the A-W.G. naturally preferred to practise as near to the centre of the metropolis as possible for the pursuit of business, but this desirable educational situation was frustrated, partly by the governors and principals of the local Schools of Art. Advanced scholarship students meant prestige for a local school, and, more important, money. Additional opposition to the Central School's acquisition of advanced students came from the majority of the certificated art masters, who were, in truth, merely drawing masters, and who desired that all holders of national scholarships should continue to be given places in the Royal College of Art, where many of the existing masters had studied.

Burridge must have been encouraged in his claims for the Central School by the adverse Report of the Departmental Committee on the Royal College of Art of 1911. He stated his own arguments clearly in a private letter to R. Blair Education Officer of the L.C.C., written on 5 December, 1913. His case against the Royal College and for his own School was as follows:

> The work of the Royal College of Art will still consist largely of fine art and training for teachers, and such an environment has been demonstrated beyond dispute to be absolutely repugnant to the development of workers for crafts and trades.

Burridge urged that the Central School should provide all the

> Local and even national scholarship requirements in crafts and manufactures.
>
> The duplication of the School by the development of crafts at the Royal College of Art would appear quite an unnecessary extravagance which suggests at further possible development regarding the Royal College of Art and the Central School of Arts and Crafts which may already have occurred to you: this is that they should become jointly the colleges for fine art and the

artistic crafts, supplementing one another and receiving endowment or grant from the Council and from the Government for the purpose.[3]

Blair decided to have a conference of principals to discuss the problem of senior craft scholars and this was held at the L.C.C. Education Offices immediately after the Christmas vacation. The principal objectors to Burridge's scheme were two fellow members of the A-W.G. who were intent upon building up craft classes in their own institutions, namely W. B. Dalton, principal of the Camberwell School of Arts and Crafts, Peckham Rd, and G. Percival Gaskell, principal of the Polytechnic School of Art, Regent St.

To comprehend the arguments at this conference of 8 January, 1914, it is necessary to know the various categories of aided students in the Schools of Art at that time. There were in fact four main categories.

The largest category consisted of those aided by the local education committees. These either held Free Studentships, often referred to as 'free admissions', or Local Scholarships, which covered fees and maintenance.

The second category consisted of those aided by prizes and scholarships awarded by local philanthropists or their executors.

The third consisted of those aided by societies, institutions and the trade associations.

The fourth and most esteemed category was of those aided directly by the Board of Education, often referred to as 'government scholars.' These were usually the star pupils and, of course, they often received additional grants and prizes from the above sources.

The government scholars at local Schools of Art were either holders of the Board of Education's Free Studentships, won by high marks in the Board's annual Art Examinations or in its National Competition, or holders of the Board's Local Scholarships, won by taking the Board's annual scholarship papers. The Board's Local Scholarship holders were the advanced students whom the local Schools of Art most wished to retain. The free students merely had their fees remitted, whereas the Board's local scholars were maintained. A free student was more or less tied to his local School of Art because he could not afford to live away from home, not so the local scholars. Not that there were many local scholars, for only 24 Local Scholarships were awarded annually by the Board, each worth £20 per annum for three years, with fees remitted. There were also two Princess of Wales Scholarships awarded annually to female students.

Burridge argued at the conference that the most advanced craft

students and the Government scholars who wished to concentrate on crafts should all be placed at the Central School. Dalton, the principal at Camberwell, disagreed and urged that his School should retain its senior scholars. Camberwell School of Arts and Crafts had opened in 1896 and offered classes for many crafts, notably, cabinet-making, printing, and bookbinding, and was described as 'an institution which in size and equipment, has few rivals of its kind in the country.'[4]

Gaskell of the Regent Street Polytechnic agreed with Dalton that the senior scholars should not be moved, and Blair, the chairman of the conference, was only too happy to see it oppose Burridge's scheme to direct all senior craft scholars to his Central School of Arts and Crafts, and all senior fine art scholars to the Royal College.[5]

Burridge was not only suggesting that the government scholars at local Schools should be instructed at the Central, but also the senior scholarship holders at the Royal College who wished to study crafts. These Board of Education scholarships for maintenance at the Royal College consisted of 10 Royal Exhibitions per annum, 6 National Scholarships, and Studentships in Training for holders of the Art Master's Certificate of the 1st Group. Each Exhibition and Scholarship was worth £60 per annum for three years, each Studentship £60 p.a. for two years.

Burridge Loses His Case

Burridge had a good case. It had been constantly proclaimed by the politicians and educationists right from the commencement of public art education in 1837 that its main purpose was to train designers and craftsmen. The Central was now the outstanding School in this respect and yet at the time of the conference had only 2 government scholars, the rest being distributed in London as follows: 12 at other Schools of Art, 19 at the Royal College, and 5 at fine art institutions (the R.A. and the Slade Schools).[6] As far as the senior awards were concerned the Board's National Scholarship holders should certainly have gone to the Central School rather than the Royal College. The College was orientated towards fine art and teacher training and the National Scholars were craftsmen. The Board laid down that: 'Only students of Schools of Art who were craftsmen engaged in trades depending on decorative art may compete for National Scholarships.'[7]

Dalton and Gaskell argued that their students preferred to go forward to the Royal College, and it was noted at the conference that ladies had objected when asked to study at the Central School. Naturally the prospect of entering a School for tradesmen horrified them![8]

No decision resulted from the conference of 8 January, so the following week Burridge again wrote to the Education Officer sending

him a copy of a letter that he, Burridge, had sent to the Board of Education on behalf of the National Society of Art Masters. This letter referred to a past suggestion of the Society (18 June, 1910) that the Royal College

> needs a Craft School of an entirely practical nature. . . . It is quite possible that some of the shops in the School might not be used at all during some years, hence an argument in favour of making use of a school devoted to Artistic Trade Development, such as the Central School of Arts and Crafts is understood to be.[9]

Burridge received some encouragement for his scheme on 2 July of the same year when the Higher Education Sub-Committee of the L.C.C. noted: 'No effective measures were however taken to safeguard the Central School of Arts and Crafts as the central school for forwarding craft students thus smaller schools have come into competition with it and use its staff. 'The Sub-Committee recommended in a rather woolly manner that craft scholars might be directed towards the Central School.'[10]

The Higher Education Sub-Committee had been investigating at which crafts each School excelled and opinion seemed to be veering towards Burridge's scheme when on 9 July the Sub-Committee agreed

> that, so far as the undermentioned sections were concerned the Central School of Arts an Crafts should become the Central School to which other schools should contribute and in which should be contained the highest branches of instruction in
> c) Silversmith's work and allied crafts
> d) Book production
> f) Decorative needlework and embroidery
> g) Stained glass, mosaic, etc.
> As regards b) Cabinet work and furniture, after considerable discussion it was agreed for the present the School should maintain its competitive position.[11]

Unfortunately for Burridge this decision was rescinded after a written protest from the principals of the London Schools of Art dated 6 November, 1914. The principals had the backing of the local trade associations and the Education Committee naturally gave way.

The weakness of Burridge's scheme was that the vast majority of advanced craft students were local evening students, such as the printers at Camberwell and wanted to study in their own neighbourhood rather than to travel; but it would certainly have been beneficial to concentrate the government scholars and the most advanced day students of

industrial design and crafts instead of having a handful in each school. The appropriation of their advanced day students would have caused another protest from the principals, especially the progressive ones who believed the day classes such as Dalton, who advocated that day-release from industry should be made compulsory. Dalton regarded 'as most mischievous the idea that this further education can be acquired in the evening, after the boy has done a hard day's work.'[12]

Burridge did not get his way, but he continued to try to persuade the Board of Education and the L.C.C. to create an orderly hierarchical system which would give his School recognition at its summit instead of being in competition with local Schools of Arts and Crafts. After being mauled in his fight for a monopoly of the senior craft scholars he decided that a policy of cooperation might achieve his aim, thus in 1916 he urged

> the need of cooperation (as opposed to the present system of competition) among educational bodies, and the co-ordination of such institutions as the Royal Academy Schools, the Royal College of Art, and the Central School, to form the much-needed University of Art in this country.[13]

The closing politic pronouncement on Burridge's schemes was made on 28 February, 1918, by the Advisory Council of the Central School of Arts and Crafts which recommended no official precedence for the School in industrial art education but described it as 'its head and heart.'[14]

Burridge was right in assuming that industrial design and crafts would not flourish at the Royal College of Art. The graduates of the College were invariably fine artists, decorative artists, and teachers, many of them ladies. Many had dabbled in the more artistic crafts, those with a pictorial emphasis, but were ignorant of the useful and basic industrial crafts.

As if to prove Burridge's point, the next principal of the College, appointed by the Board in 1920 to succeed Augustus Spencer, was a distinguished painter William Rothenstein, who filled the College with a staff of brilliant fine artists and illustrators. Sir John Rothenstein wrote:

> In no time at all artists were appointed in place of pedagogues to teaching posts (then a startling innovation resented by the art teachers' organization) and a generation rich in talent was gathering in the classroom: Henry Moore, John Piper, Ceri Richards, Edward Burra, Barnett Freedman, Edward le Bas, Charles Mahoney, Albert Houthuesen, Barbara Hepworth, Edward Bawden, and Eric Ravilious, to name but a few of the most talented members of it.[15]

The new appointments were significant. They marked the decline in the influence of the A-W.G. both among progressive artists and in art education. None of the above staff were members, except Rothenstein who resigned within a year of becoming principal. The College developed a rather fashionable hothouse atmosphere. Eric Gill whom Rothenstein invited to join the visiting staff replied:

> I am not of one mind with you and the aims you are furthering at the College, and may I whisper it, I think there are too many women about.[16]

That the Central School was not given equal status with the Royal College, as Burridge wished, undoubtedly hindered the advance of design education. It was harmful to have a senior institution in which a designer was considered second to a fine artist, with an industrial craftsman a poor third.

An attempt was made to redress the balance in 1935 after the Report of the Gorell Committee of the Board of Trade (1932) which deplored 'that cooperation between Industry and Art Schools is not always so close as it should be.'[17] P.H. Jowett, a member of the A-W.G. and Principal of the Central School was appointed to succeed Rothenstein, and the Hambleden Committee was set up by the Board of Education in the following year to report on advanced art education in London with special reference to the Royal College. Unfortunately war intervened before the Committee's recommendations could be properly carried out and it was not until Robin Darwin took over in 1948 that the College finally concentrated on industrial design for which purpose it had first been created over a century earlier (Normal School of Design, 1837) – in the words of Sir Robin Darwin in 1970:

> Of the academic changes, much the most important was my decision to pursue a policy of rigid specialization in all fields of design, to discard responsibility towards the teaching profession and to provide courses of a thoroughly practical nature in all primary industrial fields.[18]

Concerning the Central School of Arts and Crafts, Burridge's fears have been proved well founded. Through not being recognized by the Board of Education as the senior institution for students of industrial design and crafts, the Central gradually assumed the same character as other Schools of Art. The fine art section increased and the main work of the School because the preparation of full-time students for diplomas, which in reality meant educating future art teachers. Recognition of complete change came in the 1965–66 session, at the beginning of which Silversmithing

and Jewellery were transferred with the staff of these crafts to the Sir John Cass College, Aldgate.[19] In May of this session the School changed its name from Central School of Arts and Crafts to Central School of Art and Design.[20] Evening classes for part-time students employed in industry were abandoned, the only evening classes being 'for life drawing, etching, and lithography only.'[21]

By September, 1967, the full-time staff for Fine Art numbered 35, as opposed to 6 for Industrial Design Engineering and Furniture (17 visitors), 7 for Jewellery Design, and 17 for Textiles. The majority of the Pre-Diploma instructors were fine artists (and still are).Graphic Design had (and has) a large staff but the Prospectus instructs: 'Fine Art students who wish to specialise in Print Making should apply to Chelsea School of Art.'[22]

The School's Prospectus, as if the writer were troubled by Lethaby's ghost, makes the extraordinary observation that 'the school is following, rather than deviating from, the precepts laid down by its founder'.[23] No comment!

In truth, the dropping of the word 'CRAFTS' from the title of the London flagship of Arts and Crafts during the session of 1965–66 must have proved a great relief for the high art students who graced the studios.

Sources

1. Lethaby, W.R., *Scrips and Scraps*, gathered by Alfred Powell. Earle and Ludlow, Cirencester, 1956 (p. 37).
2. *Report of the Departmental Committee on the Royal College of Art* (to the President of the Board of Education) H.M.S.O., 3 July, 1911, Appendix VIII, List of Staff (p. 60).
3. Burridge, F.V., *Letter to R. Blair (Private & Confidential) of 5/12/1913*, Copy, Bound in booklet of documents 'L.C.C. Central School of Arts and Crafts. Its Aims and Organization (1913–1918).' Central School of Arts and Crafts.
4. Holme, C. (editor), *Arts and Crafts*, The Studio Ltd., London, Paris, New York, 1916 (p. 4).
5. *Notes of Conference held at the L.C.C. Education Office on Thurs, 8 January 1914 at 3 o'clock*, Bound in booklet . . . Central School of Arts and Crafts.
6. *Ibid.*
7. *Calendar of the Municipal School of Art, Manchester for 1913–14* (p. 62) quoting Board of Education regulations for prizes and scholarships.
8. *Notes of Conference . . . 8/1/1914.*
9. Burridge, F.V., Letter headed from '*Mr Burridge on behalf of the National Society of Art Masters to the Board of Education*' Copy sent to R. Blair, L.C.C. Education Officer on 13/1/1914 . . . booklet, Central School of Arts and Crafts.
10. *L.C.C. Education Committee, Higher Education Sub-Committee. S.O. No. 349*, 2 July, 1914, Item 76 'Council's Technical Institutes and Schools of Art' para. I.
11. *L.C.C. Confidential Memo on L.C.C. Central School* (not dated) referring to motion, proposed by Mr Cyril Jackson of the Higher Ed. Sub-Committee and agreed on 9/7/

1914 . . . booklet, Central School of Arts and Crafts.

12. Holme, C. (editor), *op. cit.* (p. 5).

13. *Ibid.* (p. 8).

14. *Report of the Advisory Council of the L.C.C. Central School of Arts and Crafts 1918* . . . booklet, Central School of Arts and Crafts.

15. Rothenstein, Sir John, *Summer's Lease, Autobiography 1901–1938*, Hamish Hamilton, London, 1965 (p. 99).

16. Gill, Eric, extract from letter to William Rothenstein in January, 1925, quoted by Gill himself in letter to Desmond Chute, July, 1926, and published in *The Life of Eric Gill* by Robert Speaight, Methuen, London, 1966 (p. 182).

17. *Report of the Committee appointed by the Board of Trade* (under the chairmanship of Lord Gorell) *on the Production and Exhibition of Articles of Good Design and Everyday Use*, H.M.S.O., 16 March, 1932 (p. 15).

18. Darwin, Sir Robin, in *The Times Educational Supplement*, 10/11/1967.

19. *Central School of Arts and Crafts. Prospectus*, 1965–66 (p. 20).

20. *ILEA Central School of Art and Design. Prospectus*, 1967–68 (p. 8).

21. *Ibid.* (p. 16).

22. *Ibid.* (p. 37).

23. *Ibid.* (p. 7).

Ashbee versus State Art Education

Looking back on the Arts and Crafts movement I cannot help
feeling how unfortunate it is that such a lusty and promising
youngster never really grew up. This was, I think, largely because
its parents dissociated it from the main stream of life of its own
time.

Sir Gordon Russell[1]

The Guild of Handicraft Move to Chipping Campden in 1902

If any member of the Art-Workers' Guild wished to dissociate the Arts
and Crafts movement from the main stream of state education, it was C.R.
Ashbee. While Lethaby, Crane, Burridge, and Catterson-Smith were
establishing the movement in the Schools of Art, Ashbee was holding
firmly to his principle of guilds outside the State system. Ashbee, a Socialist
in the Morris tradition disapproved of State control of education, arguing
that 'this complex supervision and regulation is odious and repulsive,' nor
did he approve of the 'political socialists,' who were not in his opinion
concerned with high standards of work, but only with higher wages and
large workshops. Only through the Guild system, thought Ashbee, could
one 'humanize work' and achieve the 'Standard' of work for society.[2]

The Guild of Handicraft continued successfully at Essex House
until 1901, training its own craftsmen, and selling its wares from a shop
in Brook St in the West End; but Ashbee was unhappy with the situation.
The Guild was managing to pay the shareholders 5% on their capital
investment, but this was only being achieved with the help of some
donations made by philanthropists towards the running of the Guild
and by their purchasing of its expensive products. In 1898 the Guild
had taken over the plant of the Kelmscott Press from the Morris'
executors and several fine books were printed under the style of the
'Essex House Press.' William Strang, Walter Crane, and Paul Woodroffe
of the A-W.G. worked for the Essex House Press, as also did Reginald
Savage, Edmund New, and Fred L. Griggs, who all later joined the A-
W.G. In 1901 the Press printed the *Prayer Book of King Edward VII*
for His Majesty, and followed this up with a great lectern bible illustrated
by Strang. Upwards of fifty presses followed suit and produced cheap

lectern bibles of inferior quality, so Essex House abandoned the publication.

Ashbee had not yet reached the conclusion he reached later that 'The Arts and Crafts have as yet no economic basis, they are dependent on the whims of a few wealthy,' but he saw now that his craftsmen could not earn a satisfactory living in a city competing with modern industry, and he determined to carry the Guild system even further, to form a self-supporting and self-educating rural community such as Ruskin's St. George's Guild had intended to create.[3] No doubt Ashbee still bore in mind the words of *Fors Clavigera* which he had read to the Ruskin class at Toynbee Hall fifteen years earlier:

> No great arts are practicable by any people, unless they are living contented lives, in pure air, out of the way of unsightly objects, and emancipated from unnecessary mechanical occupation. It is simply one part of the practical work I have to do in Art Teaching to bring somewhere, such conditions into existence, and to show the working of them.[4]

Ashbee wrote of the Guild of Handicraft move that

> it was felt that for the sake of the work and the life growing out of it, some better conditions than those prevalent in a great city like London, or Birmingham, with their horrible workshop associations and the dreary confinement of their grey streets and houses, should be given a chance; and for this the move of the whole concern into the country – with some 150 men, women and children – was effected in the year 1902 . . . we went right out into the little forgotten Cotswold town of the Age of Arts and Crafts where industrialism had never touched, where there was an old silk mill and empty cottages ready to hand, left almost as when the Arts and Crafts ended in the 18th century.[5]

It was an attempt to create the Utopia Ruskin had pleaded for some thirty years earlier in *Fors Clavigera*:

> We will try to make some small piece of English ground beautiful, peaceful, and fruitful . . . when we want to carry anything anywhere we will carry it either on the backs of beasts or on our own, or in carts or boats; we will have plenty of flowers and vegetables in our gardens, plenty of corn and grass in our fields – and few bricks. We will have some music and poetry; the children shall learn to dance in it and sing in it. . . . We will have some art, moreover: we will at least try if, like the Greeks, we can't make some pots.[6]

Designs for Dress at Camden School of Art, c.1913

Poster Design at Hammersmith School of Arts and Crafts, c.1913

Ashbee was not deterred by the fact that Ruskin's St George's farms had 'produced very little except a plentiful crop of disappointments.'[7]

The spot Ashbee had chosen as the ideal centre for his rural arts and crafts community was Chipping Campden, Gloucestershire, and his Guild and School took up their new home there in 1902. Their move was a remarkable achievement. Ashbee was an idealist, but no dreamer. There was no farcical element in his scheme as in Ruskin's country experiments. Sir Gordon Russell, the distinguished designer, who was a pupil at Chipping Campden Grammar School at the time of the removal reported,

> This was a tremendous operation. There were about sixty craftsmen altogether including silversmiths, blacksmiths, enamellers, sculptors, wood-carvers, joiners, printers, etc. . . . There is no doubt at all that the Essex House group has had a constructive and beneficial influence on local workmanship. . . . All this surging activity of skilled handwork grafted on to the fine Cotswold tradition of building in the little town was highly stimulating.[8]

The activity may have been stimulating, but it was not profitable. In spite of a carefully planned rural economy, assisted by the produce of small-holdings worked by members of the Guild, the project failed financially, and in 1908 Ashbee admitted that the Guild had lost 'upwards of £6000–£7000, the money of the shareholders, many of whom are the workmen themselves, in the attempt to carry through certain principles of workmanship and life.'[9] The breakaway from direct contact with the city market was disastrous, in fact the Guild made a net loss annually after the departure from London.

The Guild did not abandon its educational work after the closure of the School at Essex House. Ashbee wrote,

> Not counting, the many hundreds of schoolmasters and others who worked in the old School of Handicraft at Essex House, we have trained or had at the Guild benches some 100 amateur workers, ladies, school masters, technical teachers, clerks, and miscellaneous people. . . . These people worked with us for varying periods of from one month to a year and though they have often grumbled at the price they have had to pay, they none of them regretted in the end what they got for it.'

Being in the country, these students had to board and the £1 per week fee made little profit for the Guild.[10]

For designing and carrying out the more artistic craftwork Ashbee

had sometimes to import some art students. As will be seen in the next section of this Chapter, he had no kind words for Schools of Art; indeed he rarely mentioned them at all: he invariably referred to 'Technical Schools' and 'technical teachers' when he was discussing public institutions or instructors for arts and crafts education. To Ashbee's way of thinking an art student should regard himself as a skilled workman studying technical work. He wrote:

> The doing of good work for us necessitated our drawing upon young skilled workmen from the towns, the country labour not being sufficiently educated, and naturally we drew from the best schools. In this way we got young scholarship holders from the Central School of Arts and Crafts in London, and the School of Art in Birmingham. The young craftsmen were only too glad to get into a good shop in the country under healthy and happy conditions and asked if they could have their scholarships transferred to the Campden School of Arts and Crafts which was recognized by the Board of Education. But it was no use, they were tied by the leg to the great town, and told by the London and Birmingham officials that if they did not return they would forfeit their scholarships.[11]

Undoubtedly it would have been advantageous for those scholarship students to have worked alongside the professional craftsmen at Chipping Campden, but Ashbee was being illogical when he poached these students; for if, as he maintained, his Guild system of handicraft education would produce an educated society of designers, why did he need outsiders from city art institutions? The fact that the students were not allowed to continue their studies at Campden increased Ashbee's antagonism towards public School of Art and Schools of Arts and Crafts.

The School of Arts and Crafts which Ashbee established at Campden reflected his whole attitude to craft education. For Ashbee crafts were not only the artistic crafts but every basic hand, home, and farm craft. He declared that the School sought

> to give whatever the existing trades and occupations most need; and it does this with the deliberate intention and hope of giving all its students, some 300 men, women, and children, such opportunity for general improvement and culture as the means at its disposal warrant . . . it combines a University Extension Centre with technical work in stenography, typewriting, work at the bench, carpentry, and the use of metals. It has country classes in farriery, farm occupations, cooking and laundry, and it gets the bulk of its

students together with music, singing, and popular lectures. There are village gardens, there is instruction in swimming, in the rights and duties of the citizens, and in the physical drill. A comprehensive view of Education, within the conditions of modern Industry, and within the limitations of a countryside, is what we aim at.'[12]

Much of the instruction was given in the workshops by practising craftsmen of the Guild, for the School was run on the following principles which Ashbee advocated for all schools where arts and crafts were studied:

I lay it down as an axiom that Education in the Arts and Crafts to be effective must be practical, and that practical education can only be got in the workshop. Hence if we are really to make our Technical Schools efficient we must have in them workshops where the best type of products shall be made and if need be sold. To put it the other way round, our Teachers must be not only teachers but also producers, and they must continue producing all through the time of their continuing to teach. This principle, denied so far as to the Arts and Crafts is recognized and regarded as essential by the Scientists, who insist that no true education in Science can be given, except where research work is always going on. Research work for the craftsman is his own continuous and inventive production. The reason of its denial to the Arts and Crafts is Commercialism, the rule of Industry by finance. . . . What the employers want is hands and occasional foremen – to this end the scope of the Technical School at present is necessarily limited.

I want however to see the Technical School very much widened. I want to see it become a sort of organization for non-competitive municipal trading, but trading in the very best work only – a university of craftsmanship – and I want to see the axiom accepted that to be a good technical instructor in the Arts and Crafts the practising workman shall be encouraged to remain a working Craftsman . . . notably should be allowed to remain a teacher unless he gave continuous evidence of productive skill.[13]

Ashbee also recommended that public galleries should be opened in connection with his ideal Technical School to sell its products.

We may wonder why Ashbee, who believed in independent communities of craftsmen, put forward any views on Arts and Crafts in the Technical Schools. Perhaps it was because, by 1908, the financial failure of his endeavours made him realize that public Technical Schools were inevitable. It is clear that he intended that communities should have local schools at least

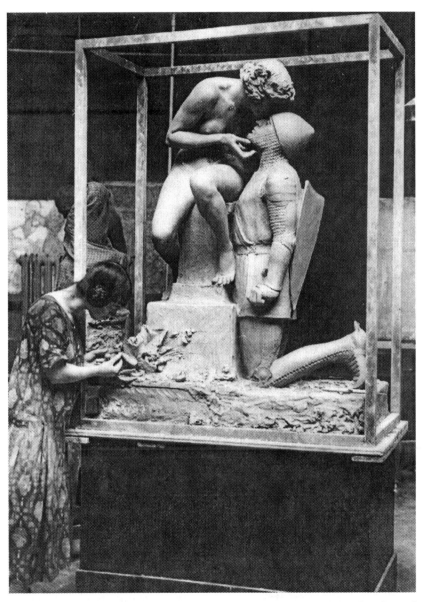

Modelling at Manchester School of Art, c.1925 – a pre-Raphaelite dream?

partly supported by the sale of their products by 'non-competitive municipal trading.' Ashbee was now resigned to the existence of public Technical Schools producing craftwork, but not to the existence of Schools of Art.

'Should We Stop Teaching Art?'

In July, 1911, the Report of the Departmental Committee on the Royal College of Art was published. The Committee, appointed by the Board of Education with E.K. Chambers of the Technological Branch as chairman, had been asked by the Board in April, 1910, to gather evidence 'for the purpose of considering and reporting upon the functions and constitution of the Royal College of Art and its relations to the Schools of Art in London and throughout the country.' The period covered by the Report was from 1900–1910 and the findings of the Committee were very unfavorable to the Royal College and the Schools of Art and endeavoured to show that very few graduates of the Royal College became practising designers. The Report stated that out of 459 students who had graduated in the last ten years: 32 had made the practice of art their livelihood, 126 had become teachers, 71 had followed other known careers, and that the careers of the other 230 were not known.[14]

These figures were challenged by many art teachers in various periodicals. Frank P. Brown A.R.C.A., headmaster of Richmond School of Art and formerly headmaster of the L.C.C. Norwood Technical Institute led the opposition to the Report, and with his fellow members of the National Society of Art Masters managed to trace 400 appointments and took delight in pointing out in a letter to the Times newspaper that in its report the Board of Education had counted three of its own instructors at the Royal College as 'unknowns.'[15]

Ashbee, for his part, was eager to accept the Report's figures and published a blistering attack on the Schools of Art entitled *Should We Stop Teaching Art?* (1911). He argued:

> The English art schools, of which the Royal College is the chief have resulted, so far, in the creation of a certain type of official who may or may not be an artist, and in the production of certain types of commodities, many of them good in their way but having little or no bearing upon the general taste of the people or upon the output of Industry.
>
> The fact that out of 459 students 126 earn their living by teaching, is an even more damaging criticism of the system; for it means the perpetuation of a type of teacher, 'the Art School Master', . . . who is divorced from the actual conditions of life and often teaches what he does not practise. . . . The Society of Art School Masters,

in their recommendations for the reconstitution of the Royal College of Art, ask among other things for letters after their names and robes to wear on their backs. The aping of academic convention is for the Arts, practically and historically unsound.

We should, on the one hand, stop the output of 'painter making' in our art schools, and we should, on the other hand, surely and consistently teach all the children in all our schools, to draw, whether with pencil, pen, or brush. . . . The Art of Painting nowadays, by virtue of its emancipation from machinery, is quite strong enough to look after itself; also great painters may always be left to shape themselves, and it is great painters only whom the community needs. . . . At present we have scores of mediocre schools of art, most of them turning out bad painters, discontented painters, and painters who become painters because there is nothing else to do. . . . Just as the making of architects should be left to the architects themselves. . . . so the making of painters should be not the work of the State-made art school, but be left to the painters themselves.[16]

Among the criticisms made by the manufacturers was the very pregnant one that the inventive designs of the students remained impractical – that they were designs in the abstract.[17]

the 'certificates for design' issued by the Department in 1911 . . . are an object lesson in bad design, bad lettering, bad typography, bad printing, and bad vellum.[18]

Ashbee's arguments were not merely destructive: he put forward his own plans. He advocated turning over the training of painters to the R.A. Schools, and of architects to the Architectural Association. The nation's art education would be decentralized, and serve local craft and machine industries,

for the decentralization of the art schools,' he wrote, 'would inevitably result in the establishment of numerous Guild or associated workshops in quiet country villages. . . . I would like to see established in connection with every provincial Art school a group of associated workshops or guilds, endowed as to their output in some such way as I have indicated.'[19]

Crane Defends the College and the Schools of Art

The Royal College and the Schools of Art found a distinguished defender in Walter Crane. The designer, then aged 66, must have felt gratitude to the staff of Schools of Art and Schools of Art and Crafts, for they had recommended and purchased his books, and followed his teachings on design enthusiastically. Frank Brown collected as much evidence as he

could to contradict the findings of the Departmental Committee on the Royal College, and published it as a book, *South Kensington and its Arts Training* in 1912, with a foreword and quotations from Walter Crane.[20]

What must have particularly offended Crane in the Report of the Committee was that it was virtually an attack on the system and structure of studies, which he and his colleagues on the Council of Advice for Art had instituted. The Report attacked the Arts and Crafts approach of preparing students as designers. Museum studies beloved by Arts and Crafts adherents were also adversely criticized.

Concerning Lethaby and his School of Design at the College, the Report stated:

> The Professor's method is an individual one, and does not appear to lend itself to the formulation of a very definite course of study.
>
> Generally speaking, students begin with a preliminary period of museum studies, of drawing from nature, and of such subsidiary matters as lettering and heraldry, and then proceed to the invention of their own designs, which, where facilities exist, are carried out by themselves in the Craft Classes. . . .
>
> Again, it is maintained that they spend too much time in making imitative studies in the Museum, and thus acquiring a 'stock-in-trade' of motives for future use, and as a corollary that their exercises in inventive design lack originality and are pieced together from the models they have reproduced. In so far as they receive a definite stylistic bent it is described as 'mediaeval'. . . . The Museum studies themselves are said, with some justice, to be too pictorial, and to lay undue emphasis upon the effects of texture and the accidents of time rather than upon the motives of the designer.[21]

So far this would not have offended Crane. As we can deduce from his books and his teaching at Manchester, he would have insisted on the students studying the lines, forms, and motives of the artefacts. The fact that they did not was Lethaby's fault.

However, the Report continued:

> The most serious criticism however, is no doubt that, in spite of the experience in 'arranging real work' which Craft Classes afford, much of the inventive design remains impractical, and may be described as design in the abstract rather than design for some actual and clearly understood technical process. This weakness is to some extent admitted by the witnesses from the College, who would remedy it by an extension of Craft Classes, and in particular advocate the addition of classes for lithography and book production, and for

textile processes, so far as these can be illustrated by hand power looms. It must however be pointed out that it is on the side of designing for manufacture rather than for handicrafts that the School is criticized, and that some of the critics believe the defect to be more in the ideal set before the students and the direction given in the teaching than in any absence of opportunity to obtain familiarity with technical processes.[22]

This passage would undoubtedly have provoked Crane who believed that the basis of training an artist or designer was in the handicrafts.

The Committee classified crafts practised in the College such as glass painting, embroidery, certain branches of pottery making and jewellery, and ornamental metalwork as 'Handicrafts.'

They appeal to a limited public' the Report continued. 'We are disposed to think that, with the exception of sculptors, it is designers of this type who derive the greatest benefit from the College of Art course as at present organized. They have the advantage of a learned and sympathetic teacher, and are directed to the finest models of those historical periods during which the methods of handicraft were of universal application.[23]

The structure, or rather the lack of structure of the course which the Council of Advice had planned for the students was also noted by the Committee. Every student had to spend his first term in the College on a preliminary course in the School of Architecture, unless already qualified in that subject, 'with a view to impressing upon him the unity of the arts.' This beginning was based upon the Art-Workers' Guild concept of the unity of the arts under architecture. Lethaby had stated that 'any real Art-Revival can only be on the lines of the Unity of all the aesthetic arts.'[24] The unity of the arts was also a favourite point with Crane. The first chapter of his *Basis of Design* is 'Of the Architectural Basis', and the first chapter of his *Claims of Decorative Art* is 'The Architecture of Art.'

So far, so good. But then the bulk of the students, those who intended to be teachers of art and design 'were to take a full course covering the work of all four Schools, finally specialising in one of them, and obtaining at the end of the course a diploma of Full Associateship. . . .' By this method the students dabbled at everything including handicrafts and learnt little, except in the Modelling School under Professor Lanteri. The Committee could find no fault with this excellent teacher. The work in the Design School has already been described. During their time in the Painting School the students first painted from casts and the head, and carried out small compositions. If they decided to specialize they spent their time in

the Upper Division of the Painting School either painting from the live model or executing decorative compositions. If however they longed for the Royal Academy Schools, Professor Moira allowed them to neglect decorative art and concentrate on Life Painting to qualify them for entrance to the Schools. Little wonder that the Departmental Committee observed, 'we do not find that the teachers of painting who come from the College are making their mark in the local Schools of Art to at all the same extent as the teachers of modelling.'[25] The Committee also noted that the Professor criticized but did not demonstrate.

The National Scholars, those scholars who had been engaged in industry, and for whom national art education was meant to be provided, pursued a 'shorter and more specialised course' and were given an inferior qualification, namely a diploma of Schools Associateship, not a Full Associateship.[26]

The members of the Committee were so disturbed about the College's irrelevance to industrial design that they recommended 'Decentralisation.' Their scheme was that 'monotechnics' should be set up in the centre of each major industry, and that a student wishing to study design for a particular industry should be given a grant to proceed to the appropriate centre. The monotechnic at Manchester would concentrate on cotton, at Bradford on wool, at Stoke-on-Trent on pottery etc.

The Committee also suggested that those who studied painting at the Royal College might as well go to the Slade or to the Royal Academy Schools. Of the Royal College the Report stated 'a gradual shrinkage or modification of its present work' might take place 'during the progress of which the question of its future destinies could be more thoroughly thought out.'[27] The Committee in its Recommendations suggested that the Royal College might be developed as a 'Post Graduate College.'[28]

Crane, with the backing of the National Society of Art Masters (who were in truth terrified of their Schools of Art being turned into industrial design schools), decided the best form of defence was attack. Here are some meaningful extracts from his arguments in Brown's book.

> We have no Minister of Art, so that our Art Schools and Art Masters may be at the mercy of any unsympathetic chief secretary at the Board of Education.
>
> The recent Departmental Committee on the Art Schools was mainly composed of men more or less hostile to the Government Art Schools and the Royal College of Art, but though the latter especially was accused of deficiency in practical relationship to the trade of the country, representatives of industrial design are conspicuous by their absence on the new Standing Committee with

the natural result that the new syllabus is more academic than ever.[29] (The Standing Committee Crane referred to was the Standing Committee of Advice on Art which the Board had just appointed to replace the Council of Advice for Art which the Board had last consulted in 1905).

Crane's criticisms of both committees were telling. His point about the Standing Committee went straight home. His point on the Departmental Committee needs some explanation. On this Committee were six members of the A-W.G., but of these Sir George Frampton R.A., Douglas Cockerell, and Halsey Ricardo owed their loyalty to the Central School where they had served for some years. They would have preferred the senior students of craftwork, the national scholars, to have been transferred from the Royal College to the Central. Frampton's loyalty was also to the R.A. Schools and he would have preferred the fine art students to have been transferred there. Another member of the A-W.G. on the Committee, Frederick Brown was Professor at the Slade and thought his School was a very suitable place for the fine art students. Sir Charles Holroyd, director of the National Gallery, was an ex-student of the Slade and his sympathies would naturally have been with Brown. None of the Committee had any links with the standard type of Government School of Art, as Crane suggested.

Crane's point about the Art Schools being 'at the mercy of an unsympathetic chief secretary at the Board of Education' was aimed at the existing Board and at the chairman of the Departmental Committee, E.K. Chambers, Principal Assistant Secretary of the Technological Branch of the Board. A letter to *The Schoolmaster* in 1912 from 'Art Organizer,' shows the fears of the art masters with regards to the Board. 'Since the fusion of the late Science and Art Department with the Board of Education, and the abolition of the post of Art Director, the Board has shown decided hostility to Schools of Art. Under the Morant regime – the spirit of which still survives and permeates the Board root and branch – the officials have done their best to disable the larger schools and destroy the smaller ones. . . .'[30]

Crane aimed another direct blow at Chambers and the Board as follows: 'Of late years the meaning of the instructions to masters and students contained in these circulars has in many instances been extremely difficult to grasp. For instance in September, 1911, a circular was issued to all Schools of Art under the Board of Education stating the exams that were to be held in 1912; at the same time it contained information that the successes of students in these examinations would probably be useless, as fresh arrangements were to be made for the following session 1912–13.'[31]

The most important recommendations of the Departmental Committee were:

1) That the training of designers for the manufacturing industries should be specialized, and should be undertaken by provincial Colleges of Art. . . .

(This recommendation must have terrified the academic drawing masters in the provincial Schools who had been trained under the National Course of Instruction. The National Society of Art Masters suggested that a 'Provincial Centre . . . might have a tendency to become 'tradey' . . . and so not be an entirely desirable centre from the educational point of view. What it is hoped is that London will supply in its Arts and Crafts specialisation. . . . The College needs a Craft School of an entirely practical nature. . . .' The art masters were quite happy to recommend that the College should become 'an assemblage of studios and workshops' then, they stated 'the idea of a school would disappear, the true feeling of higher apprenticeship taking its place.' In short, the art masters didn't mind the Royal College becoming 'tradey', so long as they were preserved from it themselves!)[32]

3) That the provincial Colleges should also be encouraged to undertake the training of teachers of Art.

9. IV.) Students intending to become teachers should receive a proper course of professional training, including actual practice in teaching both children and adults by individual and class methods under expert direction.[33]

Sources

1. Russell, Gordon, *Designer's Trade: Autobiography of Gordon Russell*, George Allen and Unwin, London, 1968 (p. 33).
2. Ashbee, C.R., *Craftsmanship in Competitive Industry* (pp. 106 and 182).
3. *Ibid.* (pp. 94–95, and 187).
4. Ruskin, John, *Fors Clavigera – Letters to the Workmen and Labourers of Great Britain*, Smith, Elder & Co., London, and G.Allen,, Keston Kent, September, 1871 (Letter 9 pp. 19–20).
5. Ashbee, C.R., *Craftsmanship in Competitive Industry* (pp. 20 and 42).
6. Ruskin, John, *Fors Clavigera*, May, 1871 (Letter 5, pp. 23–4).
7. Cook, Edward T., *Studies in Ruskin*, George Allen, London, 1891 (p. 146).
8. Russell, Gordon, *op. cit.* (p. 32).
9. Ashbee, C.R., *Craftsmanship in Competitive Industry* (p. 18).
10. *Ibid.* (p. 36).
11. *Ibid.* (p. 60).
12. *Ibid.* (pp. 192–193).
13. *Ibid.* (pp. 85–87).
14. Sess. Papers 1911, *Report of the Departmental Committee on the Royal College of Art* to Rt. Hon. Walter Runciman M.P., President of the Board of Education, H.M.S.O., 3 July, 1911 (Appendix IV).
15. *Times*, Brown, F.P., 'The Teaching of Applied Art' in the *Education Supplement*, 7/11/1911 (p. 139).

16. Ashbee, C.R., *Should We Stop Teaching Art?* B.T. Batsford, London, 1911 (pp. 15, 17, 27–28, 66–67).
17. *Ibid.* (p. 99).
18. *Ibid.* (p. 68).
19. *Ibid.* (p. 90).
20. Brown, Frank P., *South Kensington and its Art Training*, Longmans Green & Co, London, 1912.
21. *Report of the Departmental Committee* (p. 8).
22. *Ibid.* (pp. 8–9).
23. *Ibid.* (p. 16).
24. Massé, H.J.L.J., *op. cit.* (p. 8).
25. *Report of the Departmental Committee* (pp. 5 and 8).
26. *Ibid.* (p. 8).
27. *Ibid.* (pp. 19 and 21)
28. *Ibid.*, Recommendations: 37 (p. 24).
29. Brown, Frank P., *op. cit.* (pp. XIV and 21)
30. Brown, F.P., *op. cit.* (p. 63), Letter from 'Art Organiser' reproduced from *The Schoolmaster*, 4/5/1912.
31. Brown, F.P., *op. cit.* (p. 21).
32. *Report of Departmental Committee* (p. 56). Suggestions from the National Society of Art Masters.
33. *Report* . . . (pp. 22–23), Recommendations.

Glasgow Leads the Way

Charles Holme and The Studio

Walter Shaw Sparrow, who in 1899 was employed by Charles Holme to work for *The Studio* magazine observed 'when I joined his staff, the Morris movement was fading away in England. . . .'[1] Sparrow gave this view only three years after the foundation of the Central School of Arts and Crafts by the London County Council. William Morris died on 3 October, 1896, shortly after sighing his last words on pseudo-intellectualism. 'I want,' he sighed, 'to get the mumbo-jumbo out of the world'. Of course Sparrow was thinking only about fine gallery art, when he wrote of the Morris movement 'fading away'. The movement, now more commonly known as the Arts and Crafts Movement, swept on through the art schools like a tidal wave and eventually flooded city art galleries with annual exhibitions of children's work from the 1940s to the 1960s.

However, even by the start of the twentieth century the stagnant and dated character of the Arts and Crafts Movement had become increasingly obvious. In February, 1903, a review of the Arts and Crafts Exhibition Society's show appeared in *The Studio*, and contained the following ominous passage.

> Much has been hoped from the Arts and Crafts Society in the way of raising the standard of public architecture and decoration, but the present exhibition reveals but a limited progress in that direction. . . .
>
> Broadly speaking the public is not far wrong in taking the leaders of this Society to be the custodians of the Morris tradition in art, rather the founders of a living tradition of today.[2]

Why these remarks were so significant was that they appeared in an international periodical which had been the enthusiastic supporter of 'the leaders of this Society', alias the Art-Workers' Guild.

Back in 1893, as Crane was preparing to take up his appointment at Manchester, *The Studio* magazine had appeared for the first time. Owned and directed by Charles Holme, this periodical was to prove the most successful art magazine of the twentieth century, and a great asset for

the Arts and Crafts movement. Walter Shaw Sparrow, the art critic, and contemporary of Holme expressed the following opinion.

> Within his own sphere, Charles Holme was an important as Lord Northcliffe; even more important, perhaps . . . he revolutionised the profession of art-editing. It was no easy thing to produce in London an art magazine that foreign countries would buy and imitate . . . a leader everywhere of arts and crafts, challenged in many lands by imitative rival reviews. . . . There was a French edition, and American edition, and the sales in Germany and Austria were larger than in France, Belgium, Holland, Italy, and Russia.[3]
>
> Other magazines such as the *Art Journal* and *The Artist* were concerned with the fine arts: *The Studio* was concerned with arts and crafts of all kinds, with public exhibitions and with schools of arts and crafts – 'Art for the sake of everyday life among all classes.'[4]

Holme's commitment to the A-W.G. was clear from the start. The first volume of *The Studio* (April–August, 1893) includes articles by Walter Crane, H. Arthur Kennedy, D.S. MacColl, and C.F.A. Voysey; also illustrations of the work of R. Anning Bell, T. Erat Harrison, Selwyn Image, Heywood Sumner, and Voysey. In the second volume appears the magazine's first report of the Arts and Crafts Exhibition Society's show in London, in the third volume a report on the Home Arts and Industries Association. A positive educational approach was made by the inclusion in each issue of articles on designing and techniques for various crafts. Industrial art was encouraged by competitions organized by the magazine staff, the winning designs being published. Shaw Sparrow wrote,

> As a whole, the Studio's competitions were very useful, disheartening students in the schools who had no talent, and encouraging those who had gifts for design. . . . Thanks in many respects to the widespread influence of this magazine, the applied arts are better taught now than they were in the nineties. Thus the L.C.C. Central School of Arts and Crafts is a model institution.[5]

Holme regularly published lengthy reports on the Arts and Crafts Exhibition Society's shows, on the National Competition for the Schools of Art, on local shows by these Schools, on the Home Arts and Industries Association, and on arts and crafts exhibitions on the Continent. His policy was in marked contrast to that of the long lived, but fading, *Art Journal*, which concentrated on fashionable fine artists, mainly easel painters.

Holme believed all arts and crafts should be combined with the

architecture the people lived in and frequented. For Holme's own country house, his chosen architect was one of the founders of the A-W.G., Ernest Newton. Shaw Sparrow wrote: '*The Studio*'s policy, in brief, was to proclaim the urgent need of re-uniting the arts and crafts of daily life among all classes.'[6]

Holme lost his early enthusiasm for the leaders of the A-W.G., precisely when he began to suspect that they were losing contact with daily life and contemporary needs, because of their commitment to past traditions in design. His change of attitude took place during the first three years of this century, due, it seems, to two factors. Firstly, his magazine being international, he became aware of the way that Germans had adopted the Arts and Crafts Movement, yet were producing exciting modern craftwork. Secondly, Holme disliked the fact that the traditionalists of the A-W.G. who attacked any modern movement, such as that which became know as l'Art Nouveau. Holme was very fortunate when some brilliant products of the Glasgow School of Art influenced him to turn *The Studio* in a modern direction. The editor of the magazine, Gleeson White, shared Holme's progressive views.

But the hefty push needed to move Art and Craft from the influence of Morris was exerted by four students of the Glasgow School of Art, and their headmaster, Fra Newbery, particulars of whom are given below.

Glasgow School of Art

Francis Henry Newbery (1853–1946), son of a Devon shoemaker, had studied at Bridport School of Art, and taught drawing at various schools in London until 1880, when he was accepted at South Kensington as a 'student in training' by the headmaster, J.C.L. Sparkes. There, in London, Newbery admired Whistler's paintings and his 'aesthetic' interiors. Then, in September 1885 Newbery secured the post of teaching Life, the Antique, and Anatomy at the Rose St Building of the Glasgow School of Art. It was five years later that two Macdonald girls, Margaret and Frances, joined the Day Classes.

And those classes were not the only thing they joined. Margaret Macdonald (1865–1933) married Charles Rennie Mackintosh (1868–1928), and Frances Macdonald (1873–1921) married Herbert McNair (1868–1955). The two couples had become inseparable, while students at Rose St, and were to reach fame later as 'The Four'.

Art lovers in London became aware of the work of 'The Four' when some of it was shown in Regent Street at the New Gallery on the sad Saturday of 5 October, 1896, – sad because the great William Morris had died two days previously at Kelmscott Manor. The members of the Arts and Crafts Exhibition Society who had put on the show were

flummoxed by the work from Glasgow. How could such original efforts be produced by young people? Some viewers thought that the works were copied from Japanese or Egyptian sources. Gleeson White, editor of *The Studio* decided that the only way to solve the mystery was to go to Glasgow, and call in to interview the headmaster, Fra Newbery.

The Glasgow School of Art Club

Because the Glasgow School of Art took the lead in British art and crafts education from the end of the nineteenth century until the First World War, it is useful to know what the advances were made there by Fra Newbery. Before he took over the School it was controlled by the tedious 'South Kensington System', which followed the 'National Course of Instruction'.

Sir John Lavery R.A. (1856–1941) was the most famous ex-pupil of the School at that time, and described the dreadfully slow procedure in the evening drawing classes at Rose St in 1874.

> My first lesson occupied two hours drawing straight lines and curves, the second outlining a vase, the third in copying parts of the human face, and so on until a certain proficiency in what was called "drawing from the flat in outline" was attained.' These exercises were all done from copy-books, and in outlines which were much too small. . . . Complete heads came next, and then hands and feet. These were drawn in outline. After some weeks I was allowed to work on toned paper, using conte crayon and white chalk. It was pleasant to put in the lights and shade.

After this course of drawing from 'the flat', most of the Glasgow students had the choice of designing for fabrics, or 'mechanical drawings', but Lavery, being talented, was permitted to follow the 'painting' course, which involved two years at the cast, or antique, then the Life class, and 'a sense of being on the road to fame and glory'.[7]

Lavery went on to South Kensington, and Heatherley's Art School, but then escaped with joy to Paris to learn to draw from Bouguereau at l'Academie Julian, where the students learnt to make a large drawing in a week, handled in a broad and square manner, whereas at South Kensington each drawing took months of careful 'dot by dot' stippling.

Fra Newbery introduced two changes at Glasgow, which owed something to the French Atelier system, firstly the improved drawing methods, which produced work in fine clean line in contrast to the fudging and dotting at South Kensington, and secondly the open air sketching for past and present students. The annual report for 1885–1886 stated:

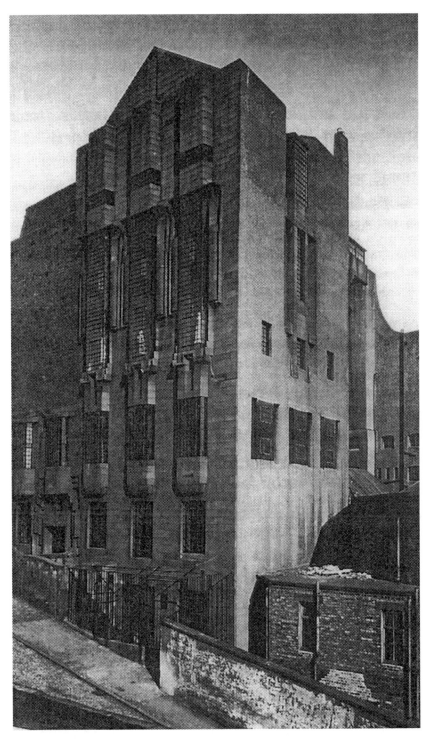

Charles Rennie Mackintosh: Glasgow School of Art, 1907-1909

The Glasgow School of Art Club, consisting of past and present Students of the School, has for its object the encouragement of the Fine Art section of the School's curriculum, more especially as regards Figure and Landscape Composition and Drawing, the means taken being the issue and the criticism of set monthly subjects, both Advanced and Elementary. The Club is under the direction of the Headmaster, but is officered and managed entirely by the students themselves.[8]

The fame of the Glasgow School of Art, and the emergence of 'The Four', were due to Newbery's backing for the Club, and for some craft workshops, known as 'the technical art studios'. So, Newbery created the right environment for his pupils, but one of them, Charles Rennie Mackintosh, was a very individual genius, who drew his precise and rhythmic lines as naturally as if created by the skates of an ice-dancer. He had enrolled at the School in 1883, and in the following year started his five-year period apprenticeship in the office of Honeyman and Keppie, who also employed McNair. It did not take long for the name of the young genius to appear on the Prize Lists of the School of Art, as follows: 'Chas. R. M'Intosh, 2 Firpark Terrace. Painting Ornament in Monochrome from the flat, 11a (for 3).' He then continued to win prizes for architectural drawings, and in 1890 won the Alexander (Greek) Thomson travelling scholarship, which enabled him to go sketching in Italy.

The Technical Art Studios

Up to 1892 'Design' at the Glasgow School, was, as at most Schools of Art, only done on paper, but during that year £387-4s-8d 'Whiskey Money' was granted to the Glasgow School, who used some of the money to pay three technical art teachers for glass staining, needlework, and carving in wood and stone. By the summer vacation of 1893, a large room had been provided for the technical art studios, entered from Sauchiehall St. Amongst the other students and staff, the Macdonald sisters worked by day and evening, and their friends mainly in the evening. Gleeson White was astonished to find some heavy pieces of wrought metal were not only designed, but worked entirely by the Macdonald sisters.[8]

The routine in the Studios was that of an informal workshop, and Mary Sturrock, Newbery's daughter, wrote of the needlework, directed by her mother from 1894 to 1908: 'Everything was easier in those days and anyone interested in doing embroidery, besides regular students, could take this class in order to enrich their home.[9] The Prospectus for 1893–94 states 'Outsiders may join at £1-1s per term.'

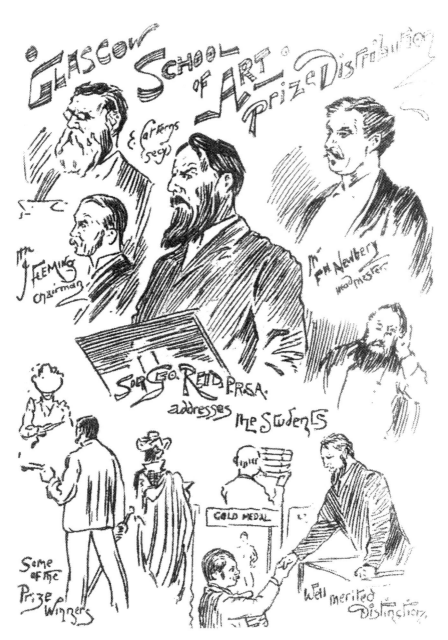

18. Sir George Reid (centre) recommends poverty to the Glasgow art
 students. Fra Newbery appears top right. Glasgow Evening News,
 23 February 1892

Advice for the Ladies

Those who are ignorant of what obsessed the minds of the Presbyterians of Glasgow during the 19th century might think that when Sir George Reid, President of the Royal Scottish Academy, was invited to address the Glasgow School of Art on 22 February, 1892, he would have dwelt on the beauties of nature; but Sir George, who could from the platform glimpse a bevy of bonny lassies in long and loose academic robes, became quite distracted and warned of the need for at least fifteen years freedom from sex for the pursuit of Art. Sir George sighed,

> If only the old monkish vow of poverty, chastity, and obedience could be observed for say the first fifteen or twenty years of the artist's professional life, it might prove of infinite benefit. . . .[10]

However, the Macdonald girls, although they took from Sir George's hands their Second Grade certificates and awards for Design Ornament, ignored his recommendation of monastic life. Frances wed McNair in 1899, and Margaret wed Mackintosh in the following year. A columnist in the *Glasgow Herald* reproached Sir George with the comment, 'A woman is not of necessity a drag upon an artist. Know then, all beautiful women that we are with you.'

The cartoon in the *Glasgow Evening News*, reproduced here shows at top left E.R. Catterns, secretary to the School, reading out the prize list, and below him, James Fleming, chairman of the governors. At top right is Newbery, the headmaster, and at the lectern is the bearded Sir George. The long 'academic' robes of the ladies, and their wavy bonnets must have completed a pretty picture.

By the end of 1893 the Macdonald girls had developed their own style of mystical painting, and in April of that year an illustrated article on Beardsley in *The Studio* had impressed the pair. Then, in November, 1894, came the first show of 'technical arts' including lithographs printed by students, and 'used', products of viable 'commercial' art, which frightened the ornament and design masters in London, and members of the Royal Academy, thus ensuring that Fra Newbery must never be given the top art teaching job in the Capital.

In March, 1895, the work from the Glasgow School was shown at the City of Liege, and included architecture, modelling, and design (including posters), and the secretary for the exhibition wrote to Newbery, 'Many of us should like to have some of your posters which are very beautiful.'

When Gleeson White of *The Studio* eventually visited the Macdonald sisters in Glasgow to investigate the origin of their 'spook style' he expected to find 'weird sisters, hand in hand . . . wither'd and so wild in

their attire', but, in his own words, saw 'two laughing comely girls, scarce out of their teens'. The pair admitted that the work of one could not be told from the work of the other. 'We have no basis, that is the worst of it,' they also confessed.[11]

The School of Art Building

The building a new School of Art began in 1897, and the first stage was opened by the Lord Provost on 20 December, 1899. It is a joy to walk round the building today, and sense how Newbery's schedule of accommodation made it the Victorian School of Arts and Crafts *par excellence*. Purpose-built Schools of Art had been built since the 1880s, for example at Manchester (1881), at Liverpool (1883), and at Birmingham (1885).

The Glasgow School was planned by Mackintosh to Newbery's Schedule with its rooms provided to meet the requirements of the National Course of Instruction of the Department of Science and Art. The most important large studios, those for the few senior students, were for the Life, Antique, and Modelling Schools. There were also rooms for Ornament, Anatomical Studies, Still Life and Flower Painting, Architectural and Mechanical Drawing, a Library, and staff rooms. The only special requirements, apart from toilets for the staff and students, were that the Life School must be on an upper floor, and partitioned for reasons modest and segregational; also that the Modelling School must be in the basement to prevent clay and plaster percolating throughout the building.

Due to the Arts and Crafts Movement, a main feature in the School of Art is the Museum, which was placed in a central position, near the Director's Room. There the students could copy examples of 'applied and decorative art' which had been loaned by Glasgow dealers, and by the V. and A., South Kensington.

The second stage of Mackintosh's masterpiece, the west wing, which sides on to Scott St, was commenced in 1907, and completed in 1909.

It was the studios of Design and Decorative Art in the east wing that showed most clearly Newbery's interest in recent developments in arts and crafts. These studios formed the Design School on the first floor, and the Technical Studios, and Studio of the Living Animal in the basement.

The Technical Art carried out was extensive and consisted of bookbinding, printing, illumination, wood block printing, lithographic designs, stained glass, mosaics, ceramic decoration, needlework and embroidery, furniture designing, wood inlay, wood engraving and carving, metalwork, and stone-carving (in the sub-basement).

At this time, the quickest way to earn money was by painting portraits or landscapes, so it was understandable that Newbery continued to encourage his students to learn to draw accurately by copying from the casts in the large Antique Rooms, and to draw and paint from the live model in one of the Life Rooms.

Like Catterson-Smith at Birmingham, Newbery regarded sketching from moving animals as part of a designer's training, and introduced drawing at the Zoo, at the Veterinary College, and at the stables of the Tramway and Omnibus Company.

Just before the east wing of the new building was completed, the Science and Art education of Scotland was removed from the control of the South Kensington authorities, and from September 1901 the Glasgow School of Art became the central institution for Higher Art Education for Glasgow and the West of Scotland.

As a result of the new control, vested in the Scotch Office, the Glasgow School of Art could progress free from the South Kensington course of Instruction and last vestiges of Cole's Payments on Results. So Newbery set about reorganizing his School. One of the early alterations was the reduction of space allocated for plaster cast of ornament.

The whole School was divided into an Upper School and a Lower School, and if a student produced satisfactory elementary work in the Lower School he, or she, was allowed to proceed to one of the Diploma courses in the Upper School, such as Drawing and Painting, Architecture, Modelling, Design and Decorative Art. The days of continuous fragmentation of effort caused by the stages of the former course of instruction were over.

Despite his enlightened encouragement of craftwork, Newbery, a disciple of Lavery and Whistler, was at heart a painter, and saw to it that his School employed visiting professors from the Continent. The School of Art building astonished them, as it had no equivalent here or on the Continent. It is still today a joy to walk round and appreciate Mackintosh's use of light, space, and the texture and pattern of building materials. As homage to 'The Four' I was careful to visit the Flower Painting Room, the delightful rooflit studio on the top floor, close to the Professors' Studios, which is provided with a small conservatory, cantilevered 80 ft above the ground in Howarth's words, 'a most daring and exciting innovation'.[12]

Mackintosh's exterior style was based on solid cliff-like stone masses, inspired by Scotland's tower-houses, contrasted with daring expanses of glass. His genius can be grasped if we stand on Scott St just below the School, and look up at its soaring south-west corner.

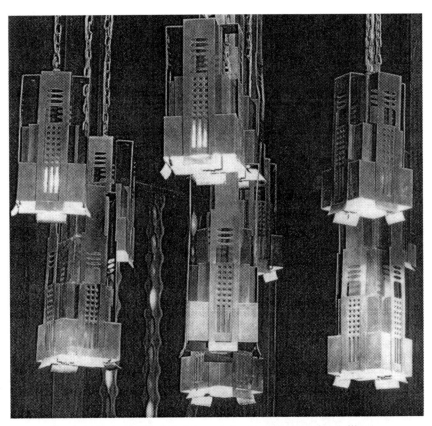

Lamps designed by Mackintosh in the School of Art library.

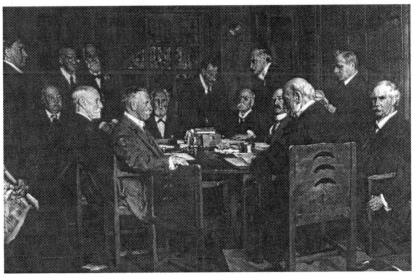

*The Building committee of the School of Art painted
by Fra Newbery with Mackintosh standing at left.*

Newbery versus the Art-Workers' Guild

William Morris died in Kelmscott House on 3 October, 1896, just before the Arts and Crafts Exhibition Society held their private view at the New Gallery in London. Amongst the exhibits within that gallery were some notable works of products of Glasgow School of Art, namely C.R. Mackintosh, J.H. McNair, the Macdonald sisters, Talvin Morris, and Mrs F.H. Newbery.

The efforts from Glasgow amused the members of the Art-Workers' Guild, who were blinkered by their admiration of historic styles, and loath to see that crafts in the Morris tradition could become relics of the past.

Open war between the Guild and Charles Holme's staff on *The Studio* followed, stimulated by four articles by Gleeson White, published in 1897 and 1898. Support for the Glasgow designers spread to Europe through the Magazine, and increased in Austria by their furnished room in Olbrich's daring Secession House of 1900. Then, in the following year, further praise was given to the work of the Glasgow School at the Glasgow International Exhibition of 1901, especially to the needlework of Mrs Newbery, Ann Macbeth, and their pupils.

The increasing fame of the School then earned Newbery an invitation to organise the Scottish Section of the International Exhibition of Modern Decorative Art, which was to be shown at Turin the summer of 1902. For the Exhibition, one room was furnished by Mackintosh and his wife, another was shared between the work of McNair and his wife together with some of the School's best embroidery, and a third room displayed the work of past and present members of the Glasgow School of Art.

This exhibition was crucial for the careers of Newbery and 'The Four'. It ensured fame in Central Europe, but jealous exclusion in London, where Crane and his brothers in the Art-Workers' Guild had now seen to it that there was no room for the works of the Glasgow School in the recent shows of the Arts and Crafts Exhibition Society.

Crane himself had exhibited a collection of his decorative art in Hungary, Austria, and Germany, and appealed to the Arts and Crafts Exhibition Society to put on a show at Turin. The conclusion of the business was a disaster for the reputation of Crane and the English Section of the Exhibition, and a triumph for Fra Newbery, who was awarded the Grand Officer's Cross of the Italian Crown, while his School, including the Mackintoshes, received diplomas of honour. It was significant that Crane in his autobiography devoted five pages to the Turin Exhibition, but omits all mention of Newbery and the Mackintoshes.

Of course, by that time Crane must have been aware of the fact that compared with the Scottish Section of Turin Exhibition, the room of the Arts and Crafts Exhibition Society of London, and Crane's own

three rooms looked positively historic. As if to emphasize the funereal note, Crane arranged for a Morris tapestry to be shown with some photographs of Madox Brown's grim 'English Worthies'.

The Studio's review of the 1906 show of the Arts and Crafts Exhibition Society confirmed Holme's opinion of that Society in the following condemnation:

> It has failed to participate in the great renascence of art which is now making such giant strikes on the Continent, and now especially in Germany and Austria; nor does it indeed adequately represent the best work now produced in the British Isles.[13]

Of course, the review mentions the best work 'in the British Isles' as a rebuke to the Society for ignoring Glasgow's Art Nouveau.

If one studies the Glasgow School of Art Building in detail, one may come to the conclusion that Mackintosh was the most original and artistic British architect of any period, but he never obtained such a major commission. What a shame it was that he did not get the architect's job for one of the Liverpool cathedral churches. In 1914 he and his wife moved south to Walberswick, Suffolk to stay next door to a house, which the Newberys rented for sketching holidays. Mackintosh had worked for Keppie until the previous year, until deserted by his clients who included Catherine Cranston. In 1923 the Mackintoshes settled in France, and Charles produced some delightful landscape paintings before his death in 1928.

Glasgow architects then set about forgetting Mackintosh as quickly as possible, partly as a defence of their own dull work, partly in condemnation of the disappointed man's increasing addiction to alcohol. The authorities at the School of Art invariably referred to 'Honeyman and Keppie' as the architects of the School. As late as 1940 a comprehensive official history of the School, published as a centenary souvenir gave no account of their greatest graduate. Only his name is mentioned, once with Honeyman & Keppie, once in a list of notable students. Fortunately in that same year Thomas Howarth, a young member of the staff, began to investigate Mackintosh and to seek out his work.

War intervened, then in 1945 Glasgow University bought Mackintosh's former home, 78 Southpark Avenue, from the Davidson family, and, due to the resulting publicity Howarth was able to persuade Henry Y. Allison, acting director of the School of Art, to start a Mackintosh Collection. With the enthusiastic support of the next director, Douglas Percy Bliss, Howarth and H. Jefferson Barnes arranged the collection in the old board room.

Long, long ago, when students were all bonny lads and lassies, the

School's club sang songs. The author learnt the words of the Glasgow ditty below from Ian Grant A.R.C.A., Senior Painting Master at Manchester College of Art.

> Mackintosh he built the School
> An' Newbery he filled it full
> Wi' painters and sculptors and architects
> Of various ages and every sex
> Singing dumble dum dearie
> Dumble dum dearie
> Dumble dum dearie
> Dum dumble dum de

Sources

1. Sparrow, Walter Shaw, *Memories of Life and Art,* John Lane, The Bodley Head, London, 1925 (p. 240).
2. *The Studio,* February–May, 1903.
3. Sparrow, Walter Shaw, *op. cit.* (pp. 235, 237, and 240).
4. *Ibid.* (p. 240).
5. *Ibid.* (p. 249).
6. *Ibid.* (pp. 239 and 250).
7. Lavery, John, *The Life of a Painter,* Cassell & Co., London, 1940 (p. 32).
8. Glasgow School of Art, *Annual Report* 1885–1886.
9. Sturrock, Mary, *The Costume Society of Scotland,* 1970 (Bulletin 5).
10. *Glasgow Evening News* 23/2/1892.
11. White, Gleeson, *Some Glasgow Designers and their Work,* Part 1, published in *The Studio,* June–September, 1897. Vol. 77, p. 231.
12. Howarth, Thomas, *Charles Rennie Mackintosh and the Modern Movement,* Glasgow University and Routledge, Kegan Paul, 1952 (p. 76).
13. *The Studio,* 1903–1906.

Arts and Crafts to Conceptual Art

The Board of Education divides up the Schools of Art in 1913

Wandering not far from the heavy gates of our old Schools of Art, we may notice the War Memorial, upon which are inscribed the names of the students and staff who dropped their pencils, picked up rifles, and died in the ghastly slaughter of battle. During the grim years of 1914 to 1918 another struggle was being fought on the home front at the London County Council Offices on behalf of the Central School of Arts and Crafts. The defeat of Burridge and his School has been dealt with, but the reader may not fully realize that this struggle of 1914 to 1918 was extremely important for most of the following century of art and design education. The victors, still at 'the top of the art education tree' were the Royal College, the Slade, and the R.A. Schools.

The dream shared by Burridge and Holme of *The Studio* that the above institutions would combine, and form a much-needed university of art, crafts, and design was finished.

At the time the Great War commenced, there were many schools of arts and crafts, particularly those in London areas, which were providing classes for drawing from the live model, and for practising many crafts, such as bookbinding, cabinet-making, textile designing and needlework, lettering, and book illustration, and there were also 'trades' classes in painting and decorating, plastering, graining, sign-writing, and heraldry.

It is interesting to note that the trades classes survived in the Colleges of Art and Design until the late 1950s, though it should be said the size of the paint brushes and paint-pots used by the tradesmen quite horrified the sensitive Fine Artists. Back in Burridge's time, his ability to recruit craftsmen did him little good. The Art 'Masters', armed with their certificates and medals from the Government, and done up in Whistlerian garb, were *gentlemen*, and some old photos of staff rooms full of walking sticks and trilby hats show their status which entailed a horror of being considered 'tradey'.

The great shake up in art education began in 1913, for in that year the dread National Course of Instruction, which had been operated from South Kensington for over sixty years, received notice that it was shortly being discontinued. In its place the Board of Education established a two-stage

examination, Part One being an examination in Drawing for those over sixteen, who had completed two years of study, which was followed by two years study of either Painting, Modelling or Pictorial Design. The Schools of Art were following the example of the Royal College when they turned away from the National Course of Instruction, and divided the College into four Schools in the years 1900 to 1901. The four main schools of the college were Mural and Decorative Painting under Gerald Moira, Sculpture and Modelling under Lanteri, Architecture under Beresford Pite, and Design under Lethaby.

The name 'Pictorial Design' chosen by Board of Education for one of the senior sections in 1926 was probably appropriate at that time for 'design' was usually done on paper with pencil, pen, and paint brush, not by using the materials of a craft. Illustrations for books, and posters for holiday resorts proved popular, and from the 1950s poster designing became a main option for examinations of pupils in Secondary schools. For the lettering on their posters many of these pupils followed the style of Eric Gill, attempting to produce Gill Sans-serif.

While the Design Schools in the Schools of Arts and Crafts turned towards modern work from the 1920s onwards, especially towards the work of Austrian and German designers, our Modelling students seem to have fallen into a time-trap, while trying to imitate some romantic Pre-Raphaelites and Lanteri of the Royal College. Plaster casts taken from the Antique, and from clay models of the live nude occupied much of the time. It would take the work of Henry Moore in the 1940s to bring these modellers the vision of 'modern Art.'

It was at this period, the 1940s, that the progressive methods which had been practised by the teachers of the Arts and Crafts Movement were incorporated by examination into the intermediate and final examinations of art and design students. An essential principle behind the new examinations was that, unless students were taught to work accurately from memory, they would be useless as teachers. It is interesting to contemplate that, even today children expect their teachers to draw all manner of things from memory.

Examining the Memory

The progress of English and Irish art students was hindered by the belief that you can learn best to design by copying from historic works of art and craft, which were exhibited for the students' convenience in galleries of their Schools of Art. Up to the First World War, students could be seen dragging chairs around these galleries, often accompanied by their 'design' teacher. William Morris himself had firmly approved of such copying of 'historic ornament'.

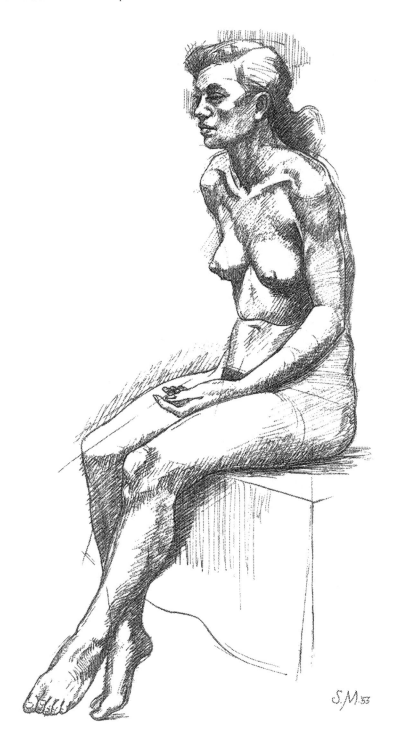

A student's Life drawing, National Diploma in Design course, 1953

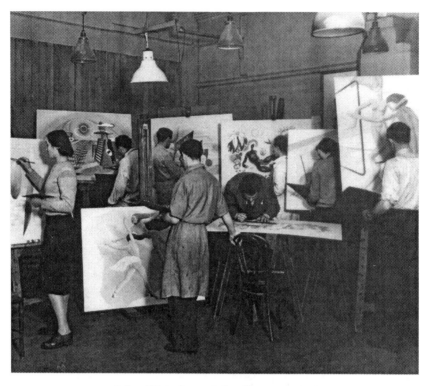

Mural Painting at Manchester c.1946

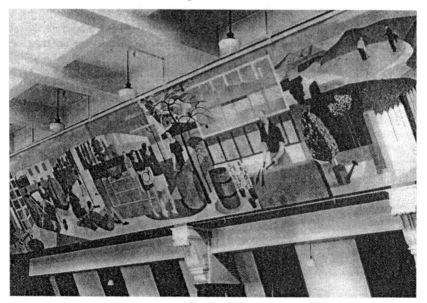

Students' mural for The Guardian *1953*

Modelled and cast figure for N.D.D. course 1951

Students' show of Arts and Crafts for Art Teacher's Diploma of 1954.

Ballerinas, *a memory composition painting 1952*

But, following the First World War, many teachers of the Arts and Crafts Movement, such as Catterson-Smith and Marion Richardson, insisted that their students and pupils drew 'from memory'. It was to be expected then that in 1946, when, at the high tide of the Arts and Crafts Movement, the Ministry of Education introduced its *Intermediate Examination in Arts and Crafts*, students' memory was tested by an excruciatingly complex set of papers, before being allowed to proceed to third and fourth year National Diploma courses.

The nature of the examination papers is of particular interest because they show details of the visual knowledge the teachers of the Arts and Crafts Movement expected their students to draw *from memory*. For example, there was a section in the general knowledge paper which required drawings of an historic building, such as the Parthenon, or a front of a Gothic church. Another section asked for drawings of ladies and gentlemen in the costumes of their specific period.

Candidates for the Intermediate Exam were also required to draw a memory composition of figures in a landscape, or within a room, carried out in pencil or pen-and-wash.

Other 'papers' included a life drawing from the nude, and one from costumed life. Anatomical knowledge was also covered in the Exam by the set tasks of making an exact drawing from memory of two human figures, one showing the skeleton within on view, and one showing the muscles within another view.

It was to the credit of that great craftsman Edward Johnston (1872–1944) that a question on the general paper asked all candidates to write some words using Roman lettering, and some using Gothic script. Also in the Intermediate Exam students had to specialize in three of the following crafts – lino printing, lithography, pottery, modelling (with casting), calligraphy.

At the larger central and provincial schools such as Liverpool, Manchester, etc. there was normally a specialist who taught lettering. A large drawing of letters in Trajan Roman could take an entire morning, and if a student was writing calligraphy, hours would be spent repeating the letters and discarding them until the desired perfection.

It could be claimed that the Ministry's Intermediate Examination was a legacy of the many ideas handed down by the teachers of the Arts and Crafts Movement. Students were being made to learn systematically about their subject, and pass on that knowledge. It was intended that they would in the end become 'complete' art teachers. It is interesting to contrast this object with the view some of us have heard expressed by modern fine art students who claim they feel they would be trapped if they had to teach, as they had learnt not a thing they could teach.

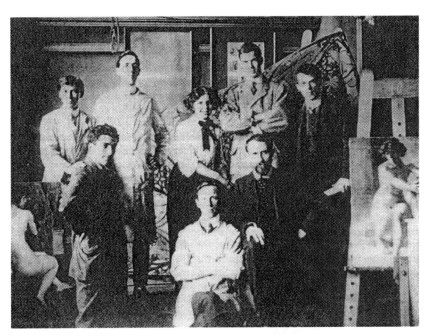

Adolphe Valette and model with his Life class in 1910

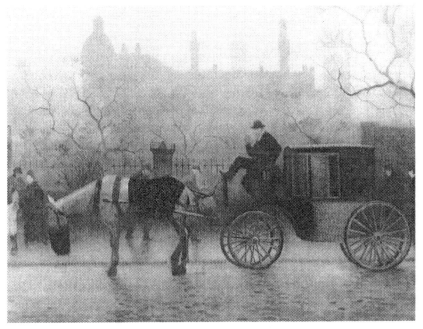

Adolphe Valette: Old cab at All Saints *Manchester, 1911*

During their last two years the students studied the special subject they had chosen for the National Diploma in Design, which could be Painting, Modelling, Illustration, Pottery, Fabric Printing, or Dress Design.

Painting was considered to be the most desirable subject, and one had to achieve a high mark in Life Drawing in the Intermediate Exam to be allowed into the Painting School. Therein one drew and painted in oil from the nude live model on two days per week, and 'memory compositions' with figures on two days per week. An example of each was eventually dispatched for final examination to the Ministry of Education in London.

The 'compositions' could be defined as the fruition of the 'memory' work encouraged by the teachers of the Arts and Crafts Movement and the masters of the French Ateliers. Large paintings were being produced of town streets, railway stations, pub interiors, markets, and children's playgrounds. Each of the paintings had to include six human figures. The painting itself was mainly in the Impressionist tradition, with Sickert and Fitton and Minton of the Royal College strong influences. Some wags christened the style 'the gloom school.' The Ministry classified all these as 'easel painters'. Candidates could choose to take 'mural painting' as an alternative.

Following the completion of their course for the National Diploma in Design, students usually took their pedagogy year to qualify for the Art Teacher's Diploma. During that year, they received a few lectures on education and had two periods of Teaching Practice. They also had to practice two more crafts in addition to those taken during earlier years.

The drawing from memory that was practised for the set tasks of the Intermediate Examination proved an essential skill for training an art teacher to draw objects and figures from memory, when in the company of pupils in the art room, or classroom; so it was a disaster in 1963 when the demanding courses for the Intermediate Exam in Arts and Crafts were replaced by the more 'creative' Pre-Diploma Courses. The whole range of what students learnt to draw was reduced, and many lost souls drifted into 'Fine Art'.

Meeting 'Mister Lowry'

If one had to choose a painter whose work clearly shows the benefits of memory compositions from the contemporary scene, Laurence Stephen Lowry would do very well. The author of this book, Stuart Macdonald, first met Lowry, probably in 1947, in the pokey cellars below Mosley Street, Manchester, which held the Mid-day Studios. Macdonald will now tell of his experiences as he remembers them, with the help of his notes.

I walked down the steps, and was greeted by the curators, Margo Ingham and Ned Owens, standing next to their cats, Modigliani and Hobbema, who had been highly trained to gobble up any mouse daring to nibble mounts or frames.

Once inside the gallery, I found myself next to Lowry, who turned on me with a smile.

'Do you not think, young man,' he asked me, 'that pictures should have glass over them?'

'I suppose so,' I replied, as he went off, scratching his head, and moving towards Margo.

Margo Ingham was a young artist's dream. Obviously Ned, her husband, thought so, and was quite willing to serve her by sitting watching the pictures all day, while she shone among the society of the city. In those days, some women were expert at the 'arty crafty look', as indeed Margo was, with her dark hair, ballet mistress's figure, and self-designed costumes, set off by brilliant strings of necklace. It is surprising to recall that the dour Lowry owed the successful promotion of his work to the stunning glamour of Margo. I admit I was among those stunned, but so were three captivated swains who popped a ring of gold on her finger. Of more importance to this history, Margo in 1948 persuaded Reid of the Lefevre Gallery to back a one-man show for Lowry in Manchester. She also persuaded Eric Newton, the leading art critic of the time, to open Lowry's show.

Some four years onwards, in 1952, I met Lowry again, and reported as follows –

I hurried through a crowd of eager fellow students up the steps of Manchester College of Art and Design. We were all in a rush to get upstairs into the Painting Studio, as the bus from town had come late. I had only just time to sit down on the edge of the model's throne before the door of the studio opened, and a reluctant Lowry was marched in under the close escort of two of my painting tutors, Ian Grant and Harold Williamson, who were obviously under strict orders to stick by the great man.

Of course, Lowry knew the studio he had just been marched into. It had been the Gallery of Classical Casts in 1905, when he had enrolled for evening classes in drawing at the age of eighteen, as his fond mother thought he was only fit for a career in art. To her surprise her lad had proved her right just before she died in October, 1939, the year of his London exhibition at Lefevres.

Now, when Lowry was sixty-five, he was the most famous former student of both Manchester and Salford Schools of Art,

and his friend, Ian Grant, had taken the trouble to ask him in so that we could fire questions at him, so here sat the great man twiddling his grey trilby hat between his fingers, and staring at an empty wall of the studio. He cut an odd figure, not one bit bohemian or artistic, but rather appropriate for a business clerk, with its dark suit and tie, and its white pocket handkerchief, though the black boots spoilt the middle-class effect.

'Some of you will have met Mr Lowry in the Art Gallery at the Spring Exhibition', started Ian Grant. 'He has agreed to come here today to answer any sensible questions you may wish to put to him about his work.'

'Yes, yes,' responded Lowry, who was still staring at the empty studio wall. 'But where has all the Antique gone?'

Nobody answered, mainly because we were not certain what an antique was. But Ian Grant saved the situation. He suddenly remembered that two rooms at the Glasgow School that contained plaster casts were called 'Antique Rooms'.

'I believe Mr Lowry means the collection of classical casts that were put down in the cellars by order of the Principal,' said Ian Grant.

Lowry looked shocked. 'But that wasn't right,' he complained. 'To draw from the Antique is the only way to learn to draw with true accuracy. It does not move like the live model does. Mr Valette told me that.'

'Who was Mr Valette?' asked the girl sitting next to me.

'Adolphe Valette was my teacher' answered Lowry. 'He was a French artist and, like most French art teachers was far better than English teachers. We called him 'Mister Monsieur'.

By this time I had my notebook out and was taking down every word Lowry was saying.

'Why do you think Mr Valette was better than English teachers?' I asked.

'Mr Valette put his easel out here, and worked in the middle of us, so we could see how he drew, and he showed me drawings by the great masters, prints, I mean. Mr Glazier was Headmaster at that time.'

'But I thought you were a Salford artist?' said Doreen Smith who was sitting behind me.

'Well,' said Lowry, 'I was living with my parents in Victoria Park, quite a posh suburb of Manchester, when I first came here to draw the Antique. We had to move to Pendlebury, a gloomy suburb of Salford. My mother, who was a good pianist, hated the

Margo Ingham who promoted Lowry's work

Lowry painting in his studio

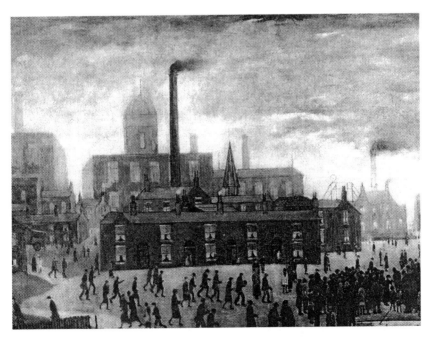

Lowry, An Accident, *1926, Manchester City Art Gallery*

gloom, and I did at first, but slowly I began to love to paint the gloomy old industrial buildings. The kids always used to gather round and watch as I drew them in pencil. They'd always ask the same question, 'Are you an artist Mister?'

There was a pause, then Ian Grant volunteered, 'Some of your gloomy buildings are now in the Tate Gallery, Mr Lowry'.

'That's right,' agreed Lowry. 'A great lump of decayed building in Ordsall Lane.'

'But, do you like that kind of picture best?' I asked. 'Who is the painter you most admire?'

Lowry gave a wide smile. 'It seems to surprise everybody, but I like the Pre-Raphaelites, especially Rossetti. I'm really a Victorian.'

Mr Williamson then rose to his feet and announced our thanks to Lowry, and informed him that there were a few of our paintings in the next studio which he might be kind enough to look at.

Lowry's visit was instructive. Our own paintings were 'memory compositions' of the contemporary scene, and the oil painting technique we used was cleverer than Lowry's, and in the case of the Glasgow and London trained painter, Ian Grant, far cleverer. Lowry, who admired academic painting, must have realized this, but he believed in his original style, which eventually brought him the honour of R.A.

We did not know at the time of Lowry's visit how great an influence Valette had been upon his work. Few people in England had, until 1994, when Manchester Metropolitan University published *Adolphe Valette, A French Influence in Manchester* by Sandra Martin. In the book are several prints of Valette's paintings of the Manchester Ship Canal, the River Irwell, the River Medlock, Oxford Road, Albert Square and All Saints, all painted during the years 1906–1913, and all painted with the gloomy grey skies which Lowry might have painted.[1]

Richard Glazier, who had been headmaster of the Manchester School of Art in 1893, at the time Walter Crane was Director of Design there, saw that to raise the standard of an English School of Art, one had to form a Life Class from advanced students, preferably with a French tutor. Eventually Glazier got the tutor he wanted, and the Antique and Life Class earned a high reputation from 1907 until 1928 under Valette's tuition. A photograph taken in 1910 of the Life Class showed Valette with six of his students and the model.

A grim shadow fell on the happy Life Class in 1919 when a sour man, lately headmaster at Belfast, was put in charge of the Manchester School, due to the sudden death of Glazier. The new broom, R. A.

Costumed Life Class at Salford School of Art with Lowry standing at easel

Lowry Mid-day Studios *1951*

Dawson, was deeply disturbed to find that the mature students, working alongside Valette in a studio atmosphere, were actually enjoying work, and were capable of drinking coffee and smoking quite shamelessly with the nude model when she was taking a break. Such things could never have happened in Belfast, and Dawson saw to it that both coffee breaks and smoking were forbidden. As for Valette, he stuck it out for a year, then resigned.

Valette, after a short break in Paris, returned to Manchester and took a part-time job as Master of Drawing in the Architecture Dept. of the University, and followed this with teaching at the Technical College and Bolton School of Art, resigning in 1927, and leaving for France in 1928. It certainly seems he did not continue to paint in the gloomy style of his Manchester period, and returned to the lighter Impressionist colours he liked better. However from 1922–1926 paintings by his pupil Lowry appeared in Manchester, paintings which clearly show Valette's influence, titled, *A Manufacturing Town, Street Scene* and *An Accident.*[2]

Lowry was still painting similar industrial subjects in 1946 when the Ministry of Education introduced its National Diploma in Design, and the Painting students were encouraged to execute large memory compositions in oils of the contemporary industrial scene.

So, from 1946, until 1961 when the National Diploma in Design was replaced by the Diploma in Art and Design, all art and design students in regional colleges were still following courses and qualifications set by the Government in London, as had been the case since the start of our national system of art education which started in 1837.

The Pyramid of Qualifications

The step by step climb up the pyramid of Art and Design qualifications was firmly established from 1852, when Henry Cole and Richard Redgrave erected the twenty-three Stages of the National Course of Art Instruction, and so initiated the concept of a national Art and Design course being created and examined by the Government, a practice still approved as late as 1946, when the National Diploma in Design was introduced into our Schools of Art.

At that date, the summit of the pyramid was still occupied by the Royal College of Art, the reconstituted National Art Training School at South Kensington, and, just below the Royal College were rated the Slade School and the Royal Academy Schools, then beneath these, the scores of local Art Colleges and Schools of Art, bulging with students who had endured several years of war-service in the armed forces.

Graduation from the Royal College, or from the Slade or the RA Schools, did in those days secure one a warm corner in the Life Room

of the local School of Art, where one could drape oneself against the radiator at the back of the working students, and maintain a dignified and impressive silence. Every Painting School in Britain had to have one of these elite teachers of Life Drawing employed on their staff, so it was to be expected that entrance to the above institutions was strictly competitive, and straight after the War it was the candidate's practical work in Art, especially in drawing from the live model that was considered important.

Written work was usually confined to essays and notes on the history of art and architecture, but the whole nature and content of written work was expanded by studies that originated in departments of Art teacher training. Lecturers were appointed who could talk about Freud and Froebel, and Child Psychology. One such lecturer made his presence known to pedagogy students at Manchester on one memorable day in 1954 by giving a skein of wool to the males, and asking them to try knitting, and though the first part of this unisex experiment produced only knotted lumps, two of the students entered into the spirit of the unisex experiment, and finding the College cook in the basement, asked her to show them how to bake a cake. But the cook just glared, and dashed upstairs in the direction of the Principal's office to complain. Not only was she sure that baking was a woman's job, but she had spotted that one of the students had a hairy unhygienic beard.

Such short experiments in practical Psychology were fun, but long essays on the subject were not. At the time a meaningful word became a favourite word for Art examiners, or Art diagnosticians, and that word, you may have guessed, was diagnosis. Almost as if Art was a disease, some examiners seemed sure its symptoms could be diagnosed in a student's written work. It was not the student's knowledge of Art that had to be shown in an essay, but his, or her attitude to Art.

From the 1950s onwards students of Art and Design were expected to convince their examiners by their written work that they had enlightened and adventurous notions. A diagnostic type of essay was introduced for entrance candidates to the Royal College. One searching question which occasionally cropped up asked: 'What use would you make of £50, if you were given it?' An honest girl might have replied with gleeful anticipation. 'I'd blow the lot on some kooky gear from the West End during a trip with Daddy to swinging London.' A more cunning female would have impressed the examiners if she had explained her essay that she intended to use the money as a share of the cost of travel to a tent near Kathmandu, which she would share with her boy friend, and look out from their tent upon the bright green of the Tibetan valleys and the deep indigo of the haunted mountains.

The fact that it was really the students' attitudes to life that were being diagnosed, rather than their knowledge of Art, could be explained by the drift in the Royal College from studies in the history of art and architecture towards 'General Studies' which took place under the direction of Basil Taylor, who lectured at the College from 1951 to 1961. It was largely due to Taylor, who broadcast his views on *The Critics* programme for the BBC, that Colleges of Art introduced written work for students in 'General Studies' or 'Liberal Studies', or 'Complimentary Studies', all designed to ward off the sharp knives held in the hands of members of the Summerson Council of 1962. It may have looked by 1962 as if there was no escape for the students at the Royal College from the flood of compulsory essays, set by Taylor. Even Robin Darwin, the Principal, backed Taylor's plan to turn painters into philosophers. But one stubborn lad in Painting was backward and behindhand enough to claim he was there to paint.

Hockney versus Hocus-pocus

David Hockney (b. 1937) entered the School of Painting at the Royal College in the autumn of 1959, and quickly made a name for himself by exhibiting his paintings with the *Young Contemporaries* in 1961 and 1962. During his schooldays at Bradford Grammar he had picked up from his companions that blunt Yorkshire honesty, which now caused him to declare that, since he had chosen to join a School of Painting, he would devote all available time to drawing and Painting, and not waste his precious time writing essays on General Studies, which had been set by Basil Taylor, a lecturer in the History of Art. Hockney was not alone in his dislike of the written work for Taylor's Department, which the students dubbed 'The Department of Words', but he was bold enough to risk the award of his College Diploma. On 11 April 1962 he received a letter from the College Registrar which informed him

> you have failed the Final Examination in General Studies which means that irrespective of the result of your professional work you will not be eligible for the award of the College Diploma. . . .

The Registrar, who was complying with the instructions of the Academic Board was probably very sure that the matter, and Hockney, were finished; but academics, though tyrants with young students, are cravens when challenged, and could not endure the ridicule heaped upon them for failing the best student at drawing and painting, and conspired with the Principal to pass Hockney on the excuse that his marks had been miscounted.

So Hockney got his Diploma and a Gold Medal, but did not show the gratitude expected from him by the Principal and the Academic Board, indeed he mocked them by showing up at the Convocation in July resplendent

in a gold lamé jacket to match his medal. Not content with this show of disrespect, Hockney later exhibited his Diploma with a sketch imposed upon it of the Principal, Robin Darwin, complete with moustache and Old Etonian tie, caught in the act of supporting Hockney on one hand, while a group of students bow and grovel below. The triumph of Hockney is well described by Professor Christopher Frayling on pages 161–164 of his book *The Royal College of Art* (1987).

Armageddon

In January, 1959, the Bureaucrats in the Ministry of Education, shocked by the thought that too many students were receiving a grant for Art Education, took the first step towards abolishing our national system by appointing a National Advisory Council on Art Education chaired by Sir William Coldstream, a fine artist from the Slade, who was relieved to hand over the coming butchery to an architect, Sir John Summerson, who was ideal for the nasty job, since he was an authority on the history of architecture about which the average art student knew little. The Summerson Council's team commenced visiting the Colleges of Art and Design in February 1962 to find out which, if any, were fit to run the courses for a new Diploma in Art and Design.

The slaughter of art and design education which then followed must have brought a smile to the lips of every Philistine. Over 200 courses, for the new Dip. A.D. were applied for by 87 colleges, but only 61 courses were approved, involving 29 colleges. So, with supreme contempt, the Council had swept away what remained of the systematic national system of art education, the progressive methods initiated by the teachers of the Arts and Crafts Movement, and the network scheme of approved Regional Colleges. The Council arrogantly reported in 1964 that it had no concern 'either with the number of courses . . . or with the geographical distribution of Colleges.'

A Working Party of the N.U.S. reported

some large areas of the country had now no provision whatever. East Anglia, Mid and North Wales, still have no Dip. A.D. courses, and the failure of Stoke-on-Trent College to obtain recognition for its pottery course has now become a legend.'

The absurdity of the situation slowly dawned upon the public when they discovered that the condemned Art and Design Colleges had not been condemned for their art and design courses, but for their courses on the history of art and 'Complimentary Studies'.

However, pliant principals managed to find rooms for the lecturers on 'Complimentary Studies' whose open minds were intended to make the

students 'intellectual', and not to worry about throwing a pot. But the students were simmering towards open revolt against the cuts in provision for art and design education, so by 1969 the Summerson Council was so alarmed that it agreed to approve forty colleges for Dip.A.D. courses. Students had already come out with their placards in the autumn of 1968 protesting at the delayed opening of Hornsey College of Art.

But, by now, the Government had decided that they must no longer be vexed by the problem of art and design education, which had been a nuisance for over 130 years, and thus, in 1966 a white paper proposed that 30 Polytechnics take over the task.

The sought-for benefit of all these moves was recognition of *real degree status* for art graduates and this was eventually achieved in 1974 when the Dip. A.D. was replaced by the BA (Hons) Art and Design. The way then became clear for graduates to proceed up a 'paper' trail to Masters' degrees and Doctorates.

By no means is everybody happy with the situation in which so many skills, and so much visual knowledge, have been sacrificed in favour of philosophising.

E. J. Milton Smith, lately Subject Leader in Art at Leeds Poly, writes:

> Successive Education Secretaries have not only appeared to ignore the valuable contribution Art, Craft and Design makes to Education as a whole, but seem determined to undermine and then dismantle a highly successful system, painstakingly built up throughout the twentieth century and generally acknowledged to be the best of its kind in the world.[3]

What was disturbing Milton Smith was the destruction of the highly successful ATC and ATD courses, which had contained plenty of courses on the theory and practice of art and various crafts, including the teaching of such, in favour of purely academic work as required for the Post-graduate Certificate in Education. Most of us, like Milton Smith, may not have seen how academic qualifications would become more and more needful during the climb up the pyramid of Art and Design qualifications.

The most remarkable symptom of the dismantling of the national system occurred in the 1950s when the discipline of Life Drawing from the living model was demoted. Certainly, when both the National Diploma in Design, together with its preceding Intermediate Exam in Arts and Crafts were replaced in 1960 by the new Diploma in Art and Design, the threads of traditional learning and skills in arts and crafts, even in drawing, were broken. The introduction of the varied Departments of Foundation Studies was not really a success. Stroud Cornock of the

Fine Art show Leicester 1978

BA (Hons) Sculpture show at Manchester 1980

School of Fine Art at Leicester Polytechnic, writing about this period tells us that it 'was one in which the student was called upon to organise his own programme of study, which would entail the production of artefacts showing that individual's progress, or "personal development".'

A great difficulty for tutors with the new courses was that their students were expected to give learned explanations for most things they were doing, and so were reluctant to embark upon new work and to verbalise it. Still, the students now raised their top qualifications from the humble diplomas of the 1960s to the lofty BA (Hons) which beckoned in the 1970s. Some sympathy must be felt for the students who were asked to explain their works which were partly based upon the Abstract Expressionism, which had flooded in from the galleries of New York and London, Many students played safe by reducing forms and bounding them within 'hard edges'. For Art, 'Reduction' is a dangerous procedure, as Herbert Read realized before he died.

The Rise and Rise of Sir Herbert, 'The Pope of Modern Art'

In September, 1953, when I enrolled in pedagogy at Manchester to train as a teacher of Art and Design, I found that a B.A. in Art History had been installed to lecture to us about anything involving written work. At the time, almost the only book devoted to the theory of art education was *Education Through Art* by Sir Herbert Read. One awkward student friend of mine complained Read was a mixed-up Yorkshire bard whose main published work was poetry, but our tutor, who was convinced that all art students were illiterate, instructed us that Read must be read, and was being put on the compulsory reading list used for our examinations, whether we liked to read Read or not. Most did not. We found Read pedantic and very, very dogmatic.

Certainly Read's book, and his other books which followed, had no great influence on us immediately, but slowly and surely his ideas opened a great divide between the practice of teachers, who continued to require students to work mainly from natural forms, and their environment, and other teachers, who encouraged the production of 'modern art'. Read was not aware, when he took the road to modern art, that it was very dangerous, and would eventually 'reduce' art by a flight from depicting an object to a mere idea or 'concept'.

Some of Read's dogmas in *Education Through Art* seem like firm commands. The book ordains that art education 'should more properly be called visual or plastic education', and should form two aspects of the total scheme for aesthetic education. In that scheme, visual education is for the eye, plastic education for the touch, musical education for the ear, kinetic education for the muscles, verbal education for speech, and

constructive education for thought.

Read's passion for classification causes him to separate 'thought' from most of the activities. He pairs design with sensation, music and dance with intuition, poetry and drama with feeling, and craft with thought – all rather meaningless divisions, as each mental process mentioned can be combined equally or unequally when performing each technique.[4]

Rosalind Billingham describes Read as

> one of the most dominant voices in literature, art criticism and aesthetics in the inter-war period and after 1945, who shaped public attitudes to the arts through his writing as President of the Institute of Contemporary Arts, and as editor of The Burlington Magazine. He was probably the most convincing exponent of Henry Moore's work except Moore himself, and he was extremely influential as the author of *Education Through Art*. Yet, after his death, he went out of fashion almost immediately.[5]

'O, what a fall was there, my countrymen!' By 1970 most of Read's books were gathering dust on library shelves with the exception of his books on modern painting and sculpture, which were still widely read. *A Concise History of Modern Painting* (1959) remained his most popular work, but most of Read's enormous output of articles and books were forgotten as quickly as the author who had been honoured by the title 'The Pope of Modern Art'.

The author Stuart Macdonald must confess, for him, Read's reputation for logical philosophical argument was shattered for ever by his acceptance of a knighthood from Buckingham Palace in 1953, in spite of the fact he was, in truth, a pledged anarchist, described by one admirer as 'the Angel of Anarchy', the author of published articles on 'the necessity of Anarchism' and 'the philosophy of Anarchism'.[6]

Truly although Read spoke out at times as if infallible on the dogma of Modern Art, the public were mistaken in assuming that he had been honoured as pope of art. His knighthood had been awarded 'for services to literature'. A brief biography is helpful.

Sir Herbert Read (1893–1968)

Herbert Read, the eldest of four children of Herbert and Eliza Read was born on the family farm at Muscoates Grange, Kirkby Moorside, North Riding of Yorkshire on 4 December, 1893. In 1903 his father died leaving the family penniless. Herbert had already developed a taste for books, including the works of Sir Walter Scott and Rider Haggard. His mother then sent him to school in Halifax, then to Leeds

and Headingley, where he joined the Conservative Party and a Territorial Unit of the Royal Army Medical Corps. Next, in 1909, he secured a job as a bank clerk in Leeds. Then in 1911 Read was 'adopted' by a Leeds tailor, one W.P. Read, who introduced Herbert to the works of master poets including 'above all, William Blake'. Herbert matriculated in that year, gaining him admittance to Leeds University in September, 1912, where he became a member of the class taught by Arthur Greenwood who introduced him to the writings of Marx and the anarchists Bakunin and Kropotkin. The Vice-Chancellor of the University at that time was Sir Michael Sadler, one of the early collectors of modern painting, and Read, who made friends with Sir Michael's housekeeper, managed to inspect the collection at his leisure.[7]

Read joined the University O.T.C. and was commissioned as 2nd Lieutenant in the Green Howards, having been granted his degree without taking his finals. His War Service was distinguished by the award of M.C., in 1917 for the capture of a German Officer, and the D.S.O. in 1918 for his gallant conduct during a retreat. In October of that year Charles Read, younger brother of Herbert, was killed at Beaurevoir, and was mourned in a poem by Herbert himself, *Auguries of Life and Death*. Read's experience of slaughter on the Somme made him a pacifist.

Read was constantly composing poems and his first book of poems *Songs of Chaos* had been published in 1915, though in 1916 he thought he would not go back to Leeds University but would 'study Art in London and Paris for a year or so'. However, Read finally left the army in January 1919, and saw Arthur Greenwood, his former tutor at Leeds, who was now Secretary to the Ministry of Reconstruction about a job in the Civil Service. Read then took a post in the Ministry of Labour, but was transferred to the Treasury in August 1919. He was noted as a very young poet by Arnold Bennett at a dinner party given in London by Osbert Sitwell. In August 1919 he married Evelyn Roff, who had been his friend at Leeds, and removed with her to Croydon.

The great change in his career came in 1922 when he was transferred by the Civil Service to a curatorial post in the Department of Ceramics at the Victoria and Albert Museum, and began from 1923 to publish articles in *The Burlington Magazine*, *The Connoisseur* and *Apollo*. In 1924 Read, together with Bernard Rackham, published *English Pottery*, and Read alone followed this with his own *English Stained Glass* (1926) and *Staffordshire Pottery Figures* (1929). Read became personal assistant to Sir Eric Maclagan, Director of the V. and A. Museum who introduced him to Henry Moore, and during 1930 had many articles published on art, and a few on poetry.[8]

In May, 1931, Read took up the post of Professor of Fine Art at

Sir Herbert Read (right) with acolyte

Edinburgh University, and advised the removal of the plaster casts of architecture. His views were too controversial for the University, so he decided that his friends were more modern-minded in England.

In 1932, Read was lent Henry Moore's studio to live in until he found another in Hampstead, which became his base for his defence of modern art. He had been introduced to Moore by Maclagan of the V. and A. Now, as he had left his museum post, Read took the job of editor of *The Burlington Magazine*. Hampstead becomes a fortress of Modern Art. The following year, Read's *Art Now* appeared, then in 1937 his Art and Society, taken from his Sidney Jones Lectures at Liverpool.

In February, 1936, a popular front government was elected in Spain, consisting of Republicans, Socialists, Communists and Anarchists. Chaos followed in the form of over a hundred general strikes and over a hundred church burnings. By July, 1936, Spain was split by civil war. On one hand stood the forces of the Republic, on the other, the Nationalists. A race began between the Russian Communists and the German and Italian Nazis and Fascists to arm the belligerents.

Unfortunately for the Republican cause, it was supported by Marxists and anarchists who murdered ten bishops and thousands of priests in cold blood. However these atrocities did not deter young British students, who had been educated to think of the Spanish Armada and the Inquisition, from joining in the struggle on the Republican side in the ranks of the International Brigade. Read, as a pledged anarchist, could not accept that the Republicans were as murderous as Stalin's friends. George Orwell could. In those ranks was the true idealist, George Orwell, who quickly found that his side, in the Stalin mode, were utterly treacherous and murderous.

In 1946, Read made his important U.S.A. breakthrough, when he delivered four Memorial lectures on the grass roots of Art at Yale University. Then, in July, 1947, he announced in *The Times* the creation of the ICA, of which he was the first President.

From 15 February–6 March, 1948 *Forty Years of Modern Art* exhibited by the ICA, was shown at the Academy Hall, Oxford Street, including work by Braque, de Chirico, Dali, Matisse, Bacon, Hepworth, Moore, Nash, Nicholson, Paolozzi, and Sutherland, etc.

From 1953–1954 Read was Professor of Poetry at Harvard, also co-director of the Museum of Modern Art, New York. He continued to write and lecture on Art, aesthetics, and poetry, and by 1965 had reached the topmost branches of the academic tree, being elected an honorary member of the American Academy of Arts and Letters. His *Art and Alienation* was published by Thames & Hudson in 1967, and he died on 12 June, 1968.

Rosalind Billingham is quite correct when she tells us that, after his death, he went out of fashion immediately.

Read's sudden fall from grace was astonishing. Books on art and design education had never had a great sale, although Walter Crane's three books on the subject were in print from 1900 until the Second World War, and Marion Richardson's *Art and the Child* (1948) was a great success.[9] But the authors of these books were very clear-minded, and were aware of the limits of what they were writing about. Because of this their writing had conviction. On the other hand, Read seems to have tried to cram into his writings every philosophy and art movement he could name as 'Modern', until he ended up trapped in the cul-de-sac he reached at the end of Chapter Seven of his *Concise History of Modern Painting*, when he was faced with the task of describing Pop Art which he detested, and the 'reduction' of Painting to mere written ideas and concepts. He was worried about the disintegration of form, even its eventual disappearance. The idea of mere 'Conceptual Art', and later surely 'Post-Conceptual', suggested Art was vanishing down a plughole, and that the people, in what Read called 'their massive ignorance and stupidity' would laugh at all his convoluted theories of modern art movements.

The son of the author, Benedict Read, handed the task of adding a last chapter of the book to Caroline Tisdall and William Feaver, who unlike Read were quite happy to write on about Conceptual Art, and the descent into mere words, which Sir Herbert had feared.[10]

'Wider still and wider, shall thy bounds be set'
One problem for Read, as pope of modern art, was defining the dogmas the disciples should respect which would avoid the disintegration of the movement, the meaningless production of work considered to be modern. He criticized the ICA in 1954 for its indiscriminate commitment to 'contemporary art' which description in his opinion covered a multitude of sins.[11] He considered artists to be the limited cream of an intellectual world that confronted 'vulgarity and impotence'. As a champion of Moore and Hepworth he became aware of the disintegration of form in modern art. Pop Art was dismissed by Read as vulgar and tedious. For him copying comics could not be Art. He and Hepworth were among the trustees of the Tate who in 1966 objected to the purchase of Roy Lichtenstein's Pop painting 'Whaam!'

So, Sir Herbert Read's crusade to found a disciplined modern art movement disintegrated as the concept of what art actually was grew. His death in 1968, was only five years before Art, as he knew it began to disappear from the paintings of the leaders of the modern movement. Paintings had been reduced to bare essentials by Marcel Duchamp, on his principle of 'Reduce, reduce, reduce,' and in 1967 Barnett Newman had

produced Who's Afraid of Red, Yellow and Blue III, which was almost entirely a large rectangle of red with small bands of other colours running down two of its edges. But the continuous reduction of Art beyond Minimal Art continued until 1973 when Ad Reinhardt produced the *Ultimate Black Painting*, a square of Black, five feet by five. Learned Americans have argued that the plain black used by Reinhardt was the acclaimed end of Painting, but other experts claim that plain white, as used by Rauschenberg in the 1950s, was less painterly, and more negative than plain black.

The excruciating problem for Art intellectuals was that, with Art reduced to nothingness, as Herbert Read had forecast, what words could be used to describe Art, since painting and sculpture were no longer the 'things' as understood by Eric Gill, but merely ideas, or concepts. Critics give Joe Kosuth credit for the reduction of art to printed words which marked the start of 'Conceptual art'.

There has been a long struggle by some writers on Art to make the subject as incomprehensible and impenetrable to rival the writings on the Universe produced by Professor Stephen Hawking.

The concluding chapter of *A Concise History of Modern Painting* is not by Read, but is an unfortunate addition by Caroline Tisdall and William Feaver, which starts with the warning words 'Sir Herbert Read's account of modern painting ends with the gloomy picture of lost values and self-indulgence', but then carries on with favourable descriptions of the movements of modern Art right up to the time when it became merely printed words. Read may have imagined the end of the artefact, or work of Art, but we may doubt he would believe a modern Conceptual charlatan who told him to study the vacant space around an artefact or the clear empty water in a clear glass tank.

One could judge that Sir Herbert aimed too high and sought to be not only pope of modern art, but also of all modern culture, even of philosophy. His audiences in U.S.A., were quite overwhelmed by all this. Certainly Read was fully aware of the drift in USA towards Aesthetic theories, a drift that helped his own reputation, but we know that he feared that art itself might be reduced and even disappear. Arguments about Art seemed to have reached the point when the experts were asked to criticize the design of the Emperor's clothes, whereupon a very brave but simple man shocked the learned experts by replying 'but the Emperor has no clothes on'. It was a pity that Sir Herbert did not pay more heed to the advice of Eric Gill, who advised that Art was about 'things', from pots to paintings, not philosophy.

By the 21st century 'Art at the top', that is, Art as shown at Tate Britain and the ICA, has – as Read feared that it would – drifted from its moorings and gone 'conceptual', and the Turner Prize of £2000 has been awarded in

Martin Creed, The lights going on and off –
Turner Prize for December, 2001

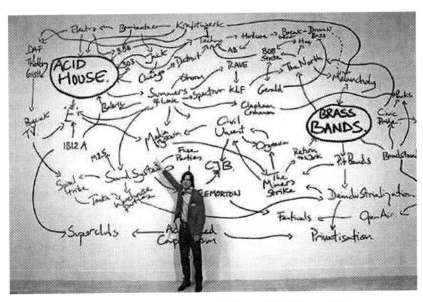

Jeremy Deller in front of his graffiti.. Photo A.P.

December, 2001, to Martin Creed, who exhibited an empty room above which lights were going on and off. Nigel Reynolds of *The Daily Telegraph* commented,

> Even by the standards of a prize that has been contested by Chris Offili's elephant dung paintings, Tracey Emin's soiled bed and dirty knickers, and Damien Hirst's sliced and pickled animals, Creed's work is widely considered exceptionally odd. . . .[12]

Creed's reward was presented to him by the world-famous pop star, Madonna, and he nobly stated, 'It's just a stupid prize.' I don't think many would disagree.

The ICA Loses Its Head

Many of the ICA did not support what was going on, in fact its chairman, Ivan Massow, dared to suggest that most concept art he sees is 'pretentious, self-indulgent, craftless tat – the product of over indulged middle-class bloated egos.' Massow also dared to suggest that the wealthy collector, Charles Saatchi and Sir Nicholas Serota, the director of the Tate, had conspired with Philip Dodd, the Director of the ICA, to enforce Conceptualism as the official art of the Government, and to discourage other trends.

Massow quickly found that nobody can be as ruthless, when their comfortable seats are threatened, than the dictators of culture. On Monday evening, 4 February, 2002, he was accompanied to the ICA and informed that its ruling council had 'unanimously demanded' his immediate resignation.

Today our universities have no central institution which appoints various distinguished artists to be examiners of students, as used to be the practice in the days of the Regional Colleges of Art, so an increasing proportion of the Fine Arts students have looked to the Tate and the ICA for leadership, quite dazzled by boxes of pills, lights bulbs, and knickers. Perhaps we can only save Art by returning to studies of natural forms as the great Morris advised. The great man's last words were 'I want to get the mumbo-jumbo out of the world.' Was he dreaming of Conceptual Art?[13]

Some art teachers complain that there are now 'art officials' who wish to impose Conceptual Art as the State Art, using the power and control of directors of galleries and their committees. Above all, the exhibits must be startling and sensational.

From the nature of the works short-listed for the Turner Prize of 2002, the advance in favour of Conceptual Art became very clear to interested observers. Dalya Alberge of *The Times* reported drily

> The Turner Prize did what it does best yesterday by short-listing a photograph of a urinal, a recording of a porn script, a glass of water

placed on a floor and a lead cast of a Kentucky Fried Chicken meal
... Photographs of urinals were said to make us rethink 'place we
know', even though Marcel Duchamp did just that by showing an
actual urinal as art as long ago as 1917.'

Of the exhibitors considered worthy of the award of the Turner £20,000
prize money were Catherine Yass, who favoured camera images of baths
and toilets, Fiona Banner, who reduced sculpture to punctuation marks and
lettering, Liam Gillick, whose huge maze-like construction, resembled a
bus shelter, and lastly Keith Tyson for his *Tiny Bubble of Complexity
2001*, a glass sphere which changes colour. To add sensation to the work of
Yass, she showed her film footage shot from a crane 500 feet up on Canary
Wharf, while Tyson was happy with the effect of dropping a thimble-full
of paint from a skyscraper.

No painters were put on the short-list for the Turner Prize of 2002 by
Sir Nicholas Serota and his panel of judges. Stephen Deuchar the director
of Tate Britain stated that the Turner prize 'is drawing attention to cutting-
edge art.' Talk of 'cutting-edge art' reminds one of the French guillotine,
and how the last chairman of the panel lost his head because he opposed
Serota, and considered that a Turner Prize should be about serious painting.

Sir Nicholas was careful to place the responsibility for picking the
people on the short-list on to the jury who, he said, wished to bring the
artists selected to a wider public 'and they didn't include a painter.' Perhaps
the jury were selected because they agreed with the basic rule for Conceptual
Art, that Art is about an idea not about the artefact or painting produced.
One of the jury, Susan Brades, director of the Hayward Gallery, echoed
the Conceptual Art maxim, when she informed *The Independent*, 'The
artistry is in the idea.'

All those short-listed for the Turner Prize were well over 30, and it has
been said that Sir Nicholas wishes to increase his position as a patron of
Conceptual Art, and a power in the wealthy international art gallery game.

By way of contrast, Ivan Massow, who resigned, rather than back
Conceptual Art, has supported the Barbie Prize for child artists. But to
balance the present situation, one must not ignore the pressure recently
exerted by students taking degrees in Fine Art in favour of creating
Conceptual Art, inspired by a startling idea.

Damien Hirst has made a name for himself by virtue of his stuffed
sheep, and Thomas Grunfeld has now shown his 'dogsheep' at the R.A.,
also, as has been noted, the Turner judges have approved of Yass's urinal,
though the Urinal by Duchamp was shown long ago, so, perhaps, the
sculptors of Ancient Greece who pioneered Conceptual Art by carving
the Centaurs over 2000 years back should not be forgotten.

A Challenge for the Art and Design in Each University

The close of the twentieth century marks the final break from the central, or national, control of Art and Design qualifications, inasmuch as universities were at last freed to award their own honours degrees in this area, certainly an advance on the situation that existed way back at the start of the First World War, when the highest awards the local art aspired to were good marks in the Board of Education's Grouped Drawing Examinations.

The independence lately given to universities for awards of their honours degrees has created a great challenge, that is, if one believes that competition between independent Art and Design institutions produces a high level of work.

For the teachers of the Arts and Crafts Movement, whose careers are given in the early chapters of this book, art and design education was about learning visual knowledge and practising skills, and by 1946, when the Intermediate Exam in Arts and Crafts was introduced, together with the National Diploma in Design, the accumulated knowledge was severely tested. A fifth year taken for the A.T.D. demanded coursework in extra crafts one might need in school. The courses were, added together, what Milton-Smith of Leeds has praised as a system of Art, Craft, and Design Education 'generally acknowledged to be the best of its kinds in the world'. His words from the recent past express a challenge for today.

Will the new freedom granted to education in arts, crafts, and design be of any real benefit? The extreme range and diversity of the area covered by the subjects make this a very difficult question. Fine Art has recently reached away from its disciplines of drawing, painting, and modelling from Life, and veered toward 'reduction', abstract expressionism, word-painting, and happenings to provide 'sensation', whereas design subjects have been more influenced by the discipline of the crafts, which Walter Crane proclaimed over a century ago were the true root and basis of all Art.

'Children of the Screen', Freehand Work, and the Crafts

Belief in the vital educational value of producing practical art and craft, which had been produced 'by hand', reached a peak during the years 1930–1960, partly due to a crusade for arts and crafts in schools waged by two art inspectors of the London County Council, namely R.R. Tomlinson and Marion Richardson, a crusade that caused a great burst of exhibitions of school work in arts and crafts, much of which was based on freehand drawing and painting.

In the twenty-first century, many years after the work in those exciting exhibitions has faded away, we must still keep in mind that evolution, or God, has created *homo sapiens* the only creature capable of producing with his, or her, hands the finest and most original freehand drawing and

modelling. It is sad to hear that evidence from OFSTED and independent research show that craft and design activities are in decline in schools, but we must remember that all art, crafts, and design methods carried out by hand consume time, and that the ideal pupils, as reported in the national press, are fast workers of eleven years old, who, armed with rules and computers, have already grabbed eleven full A grades at A-level in mixed media and computing studies.

Susan Greenfield of the Royal Institution aptly describes the pupils who squat before the computers in our schools as 'the children of the screen'. This would be an exact description of these said pupils, if they were truly present, sitting in front of the screens assigned to them; but dull and pragmatic realists suggest that many thousands of these children, after pausing to register at their schools, have now fled, not only from their screens, but from their schools, and are now 'children of the streets'.

A classroom packed with gleaming computers may create the vision of useful and *'vocational'* education by machine, which could be contrasted to education by hand and eye in writing, freehand drawing, modelling, and many skills used in the crafts.

'Creativity', Craft and our new University

The Turner Prize, described by Ms Kennedy of *The Guardian* as 'the most presitigious and rancorous' in the art world, was awarded in 2003 to the transvestite potter, Grayson Perry, and in 2004 to Jeremy Deller who claimed he was never good at art, 'not even at school', and surely must have fulfilled the fear of Herbert Read of the eventual 'reduction' of art to mere lettering. Struggling teachers of art may have been consoled by the opinion of Sir Nicholas Serota that the prizewinner 'could release creativity in others'.

It seems that Ivan Massow was asked to resign as Chairman of the ICA after calling Conceptualism 'craftless tat', an opinion shared by Kim Howells the Culture Minister, who called the same: 'cold mechanical conceptual bullshit'. The word 'mechanical' implies there were no freely executed craft skills. Hockney reported that at Bradford Grammar where he *'did'* art 'their attitude to art is that it is something to do with your hands'. Eric Gill and Walter Crane would have agreed.[14]

It is hoped that the universities which have now been recognized for awarding degrees in art and design will follow the example set long ago by the Schools in London and Glasgow, which deeply impressed the Germans and Austrians by their work in design *and the crafts.*

'All's Well That Ends Well', wrote our greatest bard circa 1604, and the same could be written of the battle for status of art education that has been waged from the days of Henry Cole, and had been continued while Lethaby and Burridge dreamt of the Central School of Arts and Crafts becoming a

university, a dream that has now been fulfilled by the merger of five colleges of the London Institute, under the direction of Professor Sir Michael Bichard, comprising Camberwell College, Central Saint Martin's, Chelsea College, London College of Fashion, and London College of Printing.

Today we exist at a time of extreme ideas intended to create shock for the general public and the compliant art journalists, who attend our shows. The shock may be caused by the sheer size of the works exhibited, or by the unpleasant and unhygenic substances which form them, but for serious students, shock is not enough, and it is to be hoped that, as the study and practice of art, crafts and design advance in our universities, they will be seen as essential parts of both our aesthetic and useful education.

The 'Triumph of Painting'

It was with joy that students of art, crafts and design greeted the news that the London Saatchi gallery exhibition in 2005. Charles Saatchi must be given much of the credit for his attempt to restore Painting to its former leading position in art education. Perhaps the time is now ripe for the restoration of skilful crafts, such as modelling, pottery and fabric and dress design, and the consignment of millions of words to the 'memory basket'.

Sources

1. Martin, Sandra, *Adolphe Valette. A French Influence in Manchester,* Manchester Metropolitan University, 1994.
2. Rohde, Shelley, *L.S. Lowry, a biography,* Lowry Press, Salford Quays, 1999, (p. 187) and Leber, Michael & Sandling, Judith, *L.S. Lowry,* Phaidon Press, 1987, Plate 7 and p. 69.
3. Milton Smith, E.J., 'Art Teacher Training in Britain (1852–1985)' in *Journal of Art & Design Education,* Vol. 4, p. 103–143, and Cornock, Stroud, 'Towards a Methodology for Students of Fine Art', *Ibid.,* Vol. 2, p. 81–98.
4. Read, Sir Herbert, *Education Through Art,* Faber & Faber, London, 1943.
5. Billingham, Rosalind. 'A review of Herbert Read's *Formlessness and Form*' by David Thistlewood in the *Journal of Art & Design Education,* Vol. 3, 3, 1984.
6. Bradford Art Galleries, 1975, *A Tribute to Herbert Read 1893–1968,* (pamphlet) Paras. 78, 82, 134.
7. Thistlewood, David, *Biographical Notes on Herbert Read,* and *A Chronology & Select Bibliography of Herbert Read,* pamphlet compiled by Terry Friedman and David Thistlewood at Bretton Hall.
8. Friedman, Terry, and Thistlewood, David, *A Tribute to Herbert Read,* published pamphlet at the Manor House, Ilkley, 1983.
9. Richardson, Marion, *Art and the Child,* University of London Press, 1948.
10. Read, Herbert, *A Concise History of Modern Painting,* with preface by Benedict Read, and concluding chapter by Caroline Tisdall and William Feaver, Thames and Hudson, London, 1974 edition.
11. Friedman and Thistlewood, *op. cit.* (p. 165).
12. *The Daily Telegraph,* 5 February, 2002, p. 4.
13. McAlister, Bill; Nairne, Sandy; etc., *William Morris Today,* ICA (p. 151).
14. Frayling, Christopher, *The Royal College of Art,* Barrie & Jenkins, 1987, p.162.

Table of Dates

1884 Art Workers' Guild founded.
 Reports of the Royal Commission on Technical Instruction.
1885 Woodwork Class set up in Beethoven St. School, London.
1888 First exhibition of the Arts and Crafts Exhibition Society.
 Society of Art Masters founded (now National Society for Art
 and Design Education).
 Guild and School of Handicraft founded by Charles Ashbee in a
 warehouse on Commercial Street, Whitechapel.
1889 Technical Instruction Act.
1890 Government grants for manual training (woodwork and
 metalwork).
1892-1900 Walter Crane's books on Design published.
1893 School leaving age raised to eleven years.
1894 Morris begins work on the Kelmscott Chaucer.
1896 Morris dies 3 October at Kelmscott House.
 National Art Training Schools reconstituted as Royal College
 of Art.
 L.C.C. establishes the Central School of Arts and Crafts in
 Regent Street.
 From 5 October the work of the students of the Glasgow School
 is shown in the display of the Arts and Crafts Exhibition Society.
1898 Walter Crane appointed Principal of the Royal College where he
 introduces craft work.
1899 Department of Science and Art put under the Board of
 Education.
 School leaving age raised to twelve years.
1900 The Board of Education appoint the Council of Advice on Art,
 and this Council, all four being members of the Art Workers'
 Guild, in 1901 divide the College into four schools; Architecture,
 Painting, Sculpture, and Design. This division was followed by
 the Schools of Art, although most could not provide Architecture.
1902 Education Act (Balfour-Morant). Schools of Art put under the
 newly created local education authorities.
 End of Payment on Results, art masters now on full salaries.
1908 Central School of Arts and Crafts removed from Regent St. into
 fine large building in Southampton Row.
1912 The last year in which exams for the Art Master's Certificate and
 the Art Class Teacher's Cert. were taken.
1913 Board of Education's Grouped Drawing Examinations replace
 the many categories of drawing which had been required for the
 Art Master's Certificate.

1915 National Competition for Schools of Art abolished.
Design and Industries Association founded.

1919 Bauhaus founded by Walter Gropius in Weimar.

1926 Hadow Report suggests that Practical Instruction (handicraft) should be linked with Art.

1930 Marion Richardson's appointed District Art Inspector by London County Council.

1933 Board of Education's Teaching Certificate for Teachers in Schools of Art renamed Art Teachers Diploma (A.T.D.).

1946 National Diploma in Design introduced by the Ministry of Education, and the Board's examinations in drawing replaced by the Ministry's Intermediate Examination in Arts and Crafts.

1947 Raising of the School Leaving Age to fifteen years.

1961 First Report of the Coldstream Council. Diploma in Art and Design (Dip.A.D.) introduced to replace the National Diploma in Design. National (Summerson Council for Diplomas in Art and Design appointed).

1962 The inspections by the panels of the Summerson Council commence to see which Colleges of Art were fit to take the Dip.A.D. The new courses required from Colleges consisted of one year basic courses plus three-year courses in one of the following:- Fine Art, Graphic Design, Three Dimensional Design, or Textiles/Fashion.

1967 The Royal College of Art granted university status by Royal Charter. The College's M.Art and M.Des. are instituted.

1968 Art students demonstrate about the lack of provision of art and design courses caused by Summerson.

1970 Polytechnics formed from the amalgamation of art and design colleges with colleges of domestic science and commerce etc., in response to the White Paper of 1966 which proposed the formation of some 30 Polys.

1972 Raising of the School Leaving Age to sixteen years.

1974 The Council of National Academic Awards (CNAA) merges with the National Council for Diplomas in Art and Design (NCDAD), and *degrees are now awarded*, the former Dip Ad now becoming BA(Hons) Art and Design.

1992-93 Universities (such as Manchester and Central England) validated to award their own degrees.

Appendices

Appendix A

The Committee of the St. George's Society, 'The Fifteen', and the Original Members of the Art-Workers' Guild (Drawn up from Walter Crane's 'An Artist's Reminiscences' pp. 223–4, and H.J.L.J. Massé's 'The Art-Workers' Guild' pp. 133–4 and p. 7, footnote).

The Committee of the St. George's Society
Gerald C. Horsley, W.R. Lethaby, E.J. May, Mervyn Macartney, Ernest Newton, E.S. Prior.

Original Members of 'The Fifteen'
E.F. Brentnall, Sacheverell Coke, Walter Crane, Lewis Day, T. Erat Harrison, Henry Holiday, H. Arthur Kennedy, James D. Linton, Henry Page, H.M. Paget, G.T. Robinson, T.M. Rooke, J.D. Sedding, George B. Simonds, Hugh Stannus.

Founders of the A-W.G.
Gerald G. Horsley, W.R. Lethaby, Mervyn Macartney, Ernest Newton, E.S. Prior.

Members at the Time of the First Meeting, 11 May 1884
John Belcher, W.A.S. Benson, G.H. Boughton, Basil Champneys, Somers Clarke, Walter Crane, Alfred Dawson, Lewis F. Day, C. Downing, D. Downing, Onslow Ford, F. Garrard, E. Matthew Hale, J. McClure Hamilton, Henry Holiday, Gerald C. Horsley, Walter Horsley, F.W. Lawson, W.R. Lethaby, Sir J.D. Linton, C.H.H. Macartney, Mervyn Macartney, W.B McGuinness, H. Stacy Marks, W.C. Marshall, J.T. Micklethwaite, E. Roscoe Mullins, Ernest Newton, Alfred Parsons, A Beresford Pite, Sir W.B. Richmond, G.T. Robinson, Edward S. Prior, John D. Sedding, Herbert Schmalz, G. Blackall Simonds, Hugh Stannus, Heywood Sumner, W.R. Symonds, Hamo Thornycroft, Ernest Waterlow, and T. Blake Wirgman.

Appendix B

The French System of Training Architects in the 1890s
 – as described by Professor Fred M. Simpson of University College, Liverpool in 'The Scheme of Architectural Education started at University College, Liverpool, in connection with the City of Liverpool School of Architecture and Applied Art' (Liverpool, 1895)

In France, or at all events in Paris, all work is done on the atelier system. Each atelier has its visitors, or patron as he is called, a well known architect who, at the first starting of the studio, was invited by the students themselves to visit and criticise their work. There are many of these in Paris, and the new student commences by joining one in which there is a vacancy. He pays a small entrance fee, a subscription of twenty or thirty francs a month, which goes to the patron, and an additional four or five francs towards studio expenses. At these ateliers the students go through a course of training to fit them for admission into the Ecole des Beaux Arts, or, if already students of that school, work out the different studies set there from time to time. In both cases all work is done under the personal superintendence of the patron. For admission into the Beaux Arts students have to pass an entrance examination which includes design, drawing, and modelling from the cast, mathematics up to simple equations, descriptive geometry, history of architect etc. Once admitted, a series of examinations called 'concours" are held, which the students has to pass before he can proceed from the lower to the upper school. Concours are held in the above subjects, as well as in stone construction, iron and wood construction, etc. One or two months are allowed for the different subjects, each forming a separate concours. . . .

The 'esprit de corps" in these studios is very strong. Studio competes against studio. . . .

Appendix C

Chronological list of lectures by Walter Crane at Manchester Municipal School of Art. The Bases of Design' *and* Line and Form *spring from these.*

The list is taken from the original illustrated notebook of Miss Emma Louise Bradbury, a student at Manchester Municipal School of Art 1890–1897 and a member of staff at the School until July 1926. This historic notebook is now (2005) in the possession of the author, Stuart Macdonald.

Since the notes were taken down as Crane was speaking, only some of the following titles were given for each lecture, but it was a simple matter to title the rest, as each lecture conforms to a chapter in one of the above books. The words and illustrations in Miss Bradbury's notebook are usually the same as those in the books. Dates are not always given fully. The corresponding chapter numbers to are given at the end of each line.

Series 1: The Bases of Design

October 1894	Of the architectural basis Ch.1
November 1894	Of the utility basis and influence Ch.2
7 December 1894	Of the influence of material and method Ch.3
January 1895	(Miss Bradbury missed this lecture – Ch.4 of *Bases of Design*)
5 February 1895	Decorative spacing of figures within geometric boundaries (an extra lecture, not on the bases of design, it appeared later as part of Ch.4 of *Line and Form*.)
8 February 1895	Of the climatic influence in design, Ch.5
8 March, 1895	Of the racial influence in design, Ch.6
3 April 1895	Of the symbolic influence in design, Ch.7
15 May 1895	Of the graphic influence in design, Ch.8
12 June 1895	Of the individual influence in design, Ch.9
3 July 1895	Of the collective influence in design, Ch.10

Series 2: Line and Form

October 1895	(Miss Bradbury missed this lecture. It was obviously Ch.1: Origin and function of outline etc.)
9 November 1895	The language of line etc., Ch.2
December 1895	Of the choice and use of line etc., Ch.3
January 1896	Figure compositions as in Ch.6. No text – all sketches.
January 1896	Of the choice of form etc., Ch.4
February 1896	On the influence of controlling lines etc., Ch.5
5 March 1896	Of the fundamental essentials of design etc., Ch.6
April 1896	Of the relief of form etc., Ch.7
May 1896	Of the expression of relief in line-drawing etc., Ch.8
June 1896	Of the adaptation of line and form in design in various materials and methods etc., Ch.9
July 1896	(Miss Bradbury missed this lecture. It was obviously Ch.10: Of the expression and relief of line and form by colour etc.).

Appendix D

Staff of the Central School of Arts and Crafts
(Membership of the A-W.G. is indicated where applicable after each name)
1896–1897

Directors: G. Frampton, A.R.A. (A-W.G.) and W.R Lethaby (A-W.G.)
Visitors: H. Bates, A.R.A. (A-W.G.) and J. S. Sargent, A.R.A. (A-W.G., 1898)
Teachers and Lecturers:

 Architecture: Halsey Ricardo (A-W.G.)

 Drawing, Colour and Decoration, and Design for cabinet makers, metal workers etc: W. H. Margetson (A-W.G.), R. Catterson-Smith (A-W.G.), A. Christie.

 Modelling and Ornament as applied to Architecture and allied crafts: E. Roscoe Mullins (A-W.G.).

 Enamelling: Alexander Fisher (A-W.G., 1904)

 Silversmithing: W. Augustus Steward (A-W.G.).

 Lead Casting and Ornamental Lead Work: F.W. Troup, architect (A-W.G.) and W. Dodds, registered plumber.

 Stained Glass: Christopher Whall (A-W.G.).

 Stone Working for Architects: R. H. Hook.

 Mechanics of Building: R. B. Molesworth

Later Appointments
Among other distinguished staff who joined the School before Lethaby's resignation in July, 1911, were: Emery Walker and T.J. Cobden-Sanderson, visitors, F. Morley Fletcher (coloured woodcuts: later head of the art dept. at University College, Reading, and principal of Edinburgh School of Art), Douglas B. Cockerell (bookbinding), Edward Johnston and W. Graily Hewitt (lettering and illumination), Noel Rooke (book illustration), J. H. Mason (printing), Richard Garbe A.R.A. (modelling and ornament as applied to architecture and industrial crafts), and Miss May Morris (director for embroidery). All these, save William Morris' daughter were members of the A-W.G., though Mason was not elected until 1926.

Appendix E

Description of the Arts and Crafts Museum at Manchester Municipal School of Art
(From Reports of the Technical Instruction Committee 1896–97 and School Calendars 1911–15)

Entrance Corridor:
'a vestibule panelled in green-tinted tiles, the gift of a member of this Committee, which have been designed and modelled by Mr J. R. Cooper, a student of the School, and made by the Pilkington Tile and Pottery Co., of Clifton Junction.'

'In this corridor are shown examples of Della Robbia ware, being reproductions in facsimile by Cantigalli of Florence, a stained glass panel by Sparrow of London, and a characteristic example of hammered copperwork by Smithies of Manchester.'

Textile Court:
The noble Tapestry, the gift of William Simpson, Esq., illustrating the 'Adoration of the Magi', designed by Sir Edward Burne-Jones, Bart., and executed by William Morris, occupies a position on the south wall specially arranged to receive it. Five original cartoons for stained glass windows by F. W. Shields, A.R.W.S., are also placed on this wall. Three of the windows are in St. Ann's Church, Manchester, and two are in Stoke Park Church, Guildford. Twelve original cartoons for stained glass by Ford Madox Brown, an original cartoon for stained glass by Sir E. Burne-Jones, Bart., the gift of Sir Edward Donner (of the School's Council), are also placed on the south wall, together with a sketch for a panel in Eaton Hall, and a figure, part of the decoration of the Chapel of the Ascension, London, by F. W. Shields, A.R.W.S. The Textile Court also contains selected examples of textiles from the 'Book Collection', a case of Greek vases dating from the seventh to the third century B.C.; examples of modern French medals; two cases of selected examples of modern craftsmanship, including silverware, jewellery, pottery, porcelain, and metalwork, some of which are the gift of Councillor Royle, selected from the Arts and Crafts Exhibition; selection of Tiffany Favrile glass; a case of glass by James Powell, London; and a case of electrotype reproductions of a portion of the treasures of Hildesheim and Bernay-Roman work of the first century A.D.; examples of printing and bookbinding; electrotypes of English, Italian, and Greek historical medals and coins, together with casts of ivory carvings; a Persian silk rug, the gift of Mrs John

Royle; three cases of craftsmanship and six pieces of furniture from the South Kensington loan collection; a fine set of Turner's *Liber Studiorum*, comprising seventy-one examples, the gift of Jesse Haworth, Esq.' and a copy of a fine specimen of Flemish tapestry.

Italian Court (East Wing):
In this Court are displayed illustrations of Italian monumental and decorative art, including casts of Donatello's statue of 'St George,' and his celebrated work 'The Annunciation' in the Medici Chapel at Santa Croce, Florence, and the Singing Gallery at Florence; The Organ Gallery at Florence, by Luca della Robbia; Orcagna's 'Death and Ascension of the Virgin'; 'The Virgin and Saints' at Santa Croce, ascribed to Andrea della Robbia; Ghiberti's 'Shrine of St. Zenobius'; The Tomb of Ilaria della Carretto, by Jacopo dell Quercia in the Cathedral at Lucca; a tabernacle, or ciborium, by Mina de Fiesole, from Santa Croce, Florence; casts of sculptures by Michaelangelo; and from the Parthenon an archaic statue of Aphrodite's throne; a cast of the 'Lansdowne' Amazon; and photographs of Italian Renaissance sculpture and architecture.

Gothic Court (West Wing):
In this Court are arranged three casts of the Monastirboyce, Ruthwell, and Irton Runic crosses, and of the great Romanesque doorway from Clermont-Ferrand; also examples of French Gothic architecture and ornament of the XI, XII, XIII, XIV, and XV centuries, from the cathedrals of Bourges, Chartres, Amiens, Rheims, Notre Dame, St Denis, Evreux, and Bordeaux (cast in Paris in 1896 from casts in the old Trocadero palace collection), and reproductions in plaster of woodwork and bookbinding. Also typical examples of English Gothic works from Westminster Chapter House and Lincoln Cathedral, and photographs of Gothic sculpture and architecture.

East Corridor.
Reproductions of majolica ware; a selection of embroideries, lace, and woven textiles from the 'Bock Collection', a reproduction of a 'Mirador' in the Alhambra, and a Byzantine foundation of Grecian marble, the gifts of William Simpson, Esq.; also modern work in coloured plaster by Frampton, Anning Bell, etc., and a case of stained glass examples from the loan collections from the South Kensington museum.

West Corridor.
A selection of Chinese porcelain; a few examples of Old Blue and White Nankin, circa 1650–1750, the gift of George Agnew, Esq., and some specimens of Blue and White china, lent by Charles Rowley, Esq., reproductions of Hispano-Moresque, Persian, and other pottery; also a case of Japanese bronzes and Oriental work; a marble mantelpiece by W.R.

Lethaby: examples from the 'Bock Collection' of woven textiles; and copies in watercolour of a part of the fresco by Giotto in the Lower Church of S. Francis at Assisi, and a rock-crystal cross which is kept in the sacristy of the same church.

Modelling Room:
Casts of typical examples of Egyptian, Assyrian, Greek, Renaissance, and other sculptures are placed upon the walls.

Upper Corridor:
Many examples of artistic workmanship, including some beautiful examples of modern textiles the gift of Neville Clegg, Esq.

Arrangements were made on Monday and Wednesday afternoons for school children in charge of a responsible teacher to visit the Museum.

Appendix F

Board of Education awards available to students of Schools of Art in the session 1913–1914

National Competition
For the best works 12 gold, 60 silver, and 200 bronze medals, also National Book prizes were awarded. To be eligible a student had to have previously passed a Personal Examination of the Board in the same (or analogous) subject as the work submitted. (Note: These awards ceased after the last National Competition held in 1915)

Local Scholarships (£20 p.a. for 3 yrs)
For the highest marks in the Board's Scholarship examinations held in Schools of Art 24 Local Scholarships were awarded. Restricted to day students, attendance of 30 hrs per week made student eligible. Holders of Local Scholarships entitled to compete for a Royal Exhibition or National Scholarship.

Royal Exhibitions at Royal College of Art (£60 p.a. for 3 yrs)
10 annually on results of Personal Examinations of the Board.

National Scholarships (at R. College, £60 p.a. for 3 yrs)
6 annually, only for those in trade. Abolished 1934.

Free Studentships (remission of fees for craftsmen at Schools of Art)

Studentships in Training at R. College (£60 p.a. for 2 yrs)
Open to those with Art Master's Certificate of 1st Group

'*Princess of Wales' Scholarships* (£25 or £11 p.a. for 3 yrs at School of Art)

(Note: The system of scholarships and studentships for study at the Royal College awarded by the Board of Education operated for the last time in the session 1936–1937, i.e. on the results of the Board's examinations of May 1937. From May 1938 such awards were administered by the Royal College and granted on the results of the College's entrance examinations.)

Appendix G

A student's show of Arts and Crafts for the Art Teacher's Diploma, 1954

Top left: Screen and block fabric prints
Top centre: Life drawing and oil paintings
Centre left: Coloured lino prints
Centre – on table: glove puppet of 'Landlord Hawk', coiled pot, marionette of Toulouse Lautrec, plaster carving, and soap carving.
Below right: Mural painting of Stockport viaduct in the school hall, and an illustrated study of a Spanish building
Below left: Leather book binding, bookcraft, and basketry

Index of Subjects and Places

Index of People